MR STUBBS THE HORSE PAINTER

The Prince of Wales' Phaeton. $40\frac{3}{8}in \times 50\frac{1}{2}in$.
Reproduced by Gracious Permission of Her Majesty the Queen.

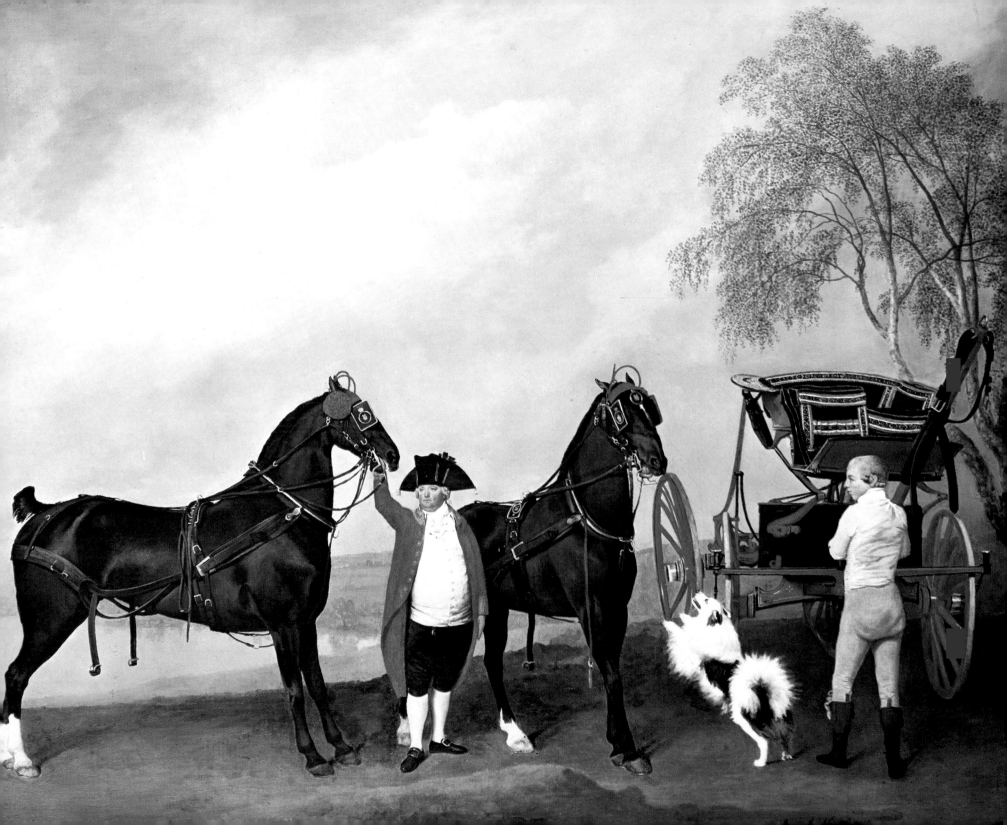

Constance-Anne Parker

Assistant Librarian, Royal Academy of Arts

MR STUBBS
THE HORSE PAINTER

J. A. Allen & Co Limited

1 LOWER GROSVENOR PLACE LONDON S.W. 1

First published in 1971
by J. A. Allen & Co. Ltd
1 Lower Grosvenor Place, London S.W.1

SBN 85131 123 7

Printed in Great Britain
by W & J Mackay & Co Ltd, Chatham, Kent

Contents

List of Illustrations

Acknowledgements

I would like to record my deep gratitude to all the many people who have answered my queries. In particular I would like to thank Thomas Agnew & Sons Ltd for the use of their blocks; the Picton Library, Liverpool, for allowing me to quote from the Mayer papers and Humphry MSS; the Royal Academy of Arts for allowing me to consult the archives of the Society of Artists and the R.A. Council and General Assembly Minutes; the Witt Library; the Courtauld Institute.

I am greatly indebted to all the owners who have so generously allowed their paintings to be reproduced: Her Majesty the Queen; Sir Martyn Beckett; Lady Mairi Bury; The Marquess of Bute; Mr Jack R. Dick; The Earl Fitzwilliam; His Grace the Duke of Grafton; The Trustees of the Grosvenor Estate: The Trustees of the Goodwood Collection; Lord Irwin; The Stewards of the Jockey Club; Messrs Leggatt Brothers; Mr and Mrs Paul Mellon; The National Trust; Lieut-Colonel R. S. Nelthorpe; The Hon Mrs Pearson and Mrs P. A. Tritton; Miss Clara J. Peck; Mrs Aileen Plunkett; The Duke of Portland; The Viscountess Ward of Witley; Anne, Duchess of Westminster; Josiah Wedgwood & Sons Ltd; Lord Yarborough.

I am also most grateful to the Trustees for permission to use works from the following public collections: the British Museum; Brown, Picton and Hornby Libraries; Herron Museum of Art, Indianapolis; Holburne of Menstrie Museum of Art, Bath; Lady Lever Art Gallery, Port Sunlight; Manchester City Art Galleries; National Gallery, London; National Gallery of Art, Washington; National Gallery of Victoria, Australia; National Portrait Gallery; Royal Academy of Arts; Tate Gallery; Victoria Memorial Hall, Calcutta; Walker Art Gallery, Liverpool; Worcester Public Library, Massachusetts; Yale University Art Gallery, Newhaven, Connecticut.

I would like to express my appreciation of the great interest and care taken by Mrs Julie Wood in her layout and design of the book and, finally, my sincerest thanks to Mrs Evelyn Martyn of J. A. Allen & Co. Ltd, without whose kindness and help *Mr Stubbs* would never have reached book form.

Foreword

In working on this book I have consulted a number of works and sources. There is, unfortunately, very little material, contemporary or otherwise. The main source of information is the memoir by Stubbs's friend, Ozias Humphry. This is a very roughly scribbled account of certain incidents in Stubbs's career, and forms the basis for most subsequent work on him. It is prefaced with this note, 'These particulars of the life of Mr. Stubbs were given to the author of this Memoir by himself'. From the rather vague dates and the few inaccuracies that can be proved, it would appear to have been compiled from memory of conversations held with Mr Stubbs at various times, and fairly late in his life.

This manuscript was never published, nor were the two transcripts that were made from it. These two differ very little from the original. Humphry's manuscript is 98 pages long, though in one or two cases, he has rewritten pages. One of the transcripts is in the hand of William Upcott, Ozias Humphry's illegitimate son, and the other is in an unidentified hand. These are all in the Picton Library, Liverpool, but were in the collection of Joseph Mayer, who wrote the first published work on Stubbs, in 1876. This is in the form of a biographical essay, closely based upon the Humphry account, and including certain stories that were pasted into the transcript written by Upcott. They are presumably by Mary Spencer, for, in a letter to Upcott, dated Monday July 31st, Humphry says 'The Copy which I have of Mr. Stubbs's Memoir is the first and imperfect one, and therefore unfit for the perusal of Miss Spencer'. He follows this with a second letter dated Wednesday Aug. 2nd 1809, 'I recd. your letter last night— The corrected Copy of Mr. Stubbs Memoirs should be sent me'. From this, it would appear that after Miss Spencer's 'perusal' she added such stories as she felt necessary, mostly dealing with occasions when animals had been deceived into thinking that what they saw in Stubbs's work was flesh and blood and not a painted representation. There is also in the same writing, the very touching account of the old man's death, which must have been written by someone in his household.

There are useful references in the archives of the Society of Artists and in the General Assembly and Council Minutes of the Royal Academy of Arts. Farington's Diaries and the Correspondence of Josiah Wedgwood and Thomas Bentley contain material relating to Stubbs, as do the 'Reminiscences of Henry Angelo' and 'Enquiry into the Royal Academy' by Sir Robert Strange.

Short biographical articles appear in the *Gentleman's Magazine* in 1806 and in the *Sporting Magazine* in 1808 and 1809, and there are a few references to him in press-cuttings of the period.

Following Mayer's privately printed essay, came the *Life of George Stubbs, R.A.* also a private and limited edition, by Sir Walter Gilbey, in 1898. He was an enthusiastic collector of

Stubbs's works and owned a very considerable number of paintings of widely varying subjects by him.

Walter Shaw Sparrow gives quite a substantial amount of space to Stubbs in his two books, *British Sporting Artists* (1923), and *A Book of Sporting Painters* (1929). His *George Stubbs and Ben Marshall* (1929) has a large number of illustrations and is the longest study of Stubbs to be published in book form for public circulation.

Apart from these, a very valuable appreciation of Stubbs is given by Geoffrey Grigson in an essay in *The Harp of Aeolus* (1947). Other articles have appeared in *Country Life* and the *Burlington Magazine*, particularly useful is that by H. F. Constantine on Stubbs's work for Lord Rockingham, from the Wentworth Woodhouse documents, published in July 1953.

No one who studies Stubbs can help feeling a deep gratitude to **Mr Basil Taylor** for all his sympathetic and scholarly research over many years. It is to be hoped it will not be too long before he produces a monumental work to do real justice to this great painter-scientist.

For the deficiencies in this book I would hide behind Dr Samuel Johnson's excuse, when he was asked by a lady 'Why, in your Dictionary, do you call a horse's pastern its knee?' and he replied 'Pure ignorance, dear lady, pure ignorance'.

Introduction

George Stubbs has been one of the most underrated painters of the eighteenth century in England, in fact in Europe, for he should surely be considered as a great man not only in his own country but internationally. His name appears very infrequently in histories of art. Even in surveys of English painting he is dealt with in a few meagre lines, while painters like Gainsborough, Reynolds, Turner, and Constable command a respect that gives them practically a chapter each.

Unfortunately, the sporting or animal painter used to be put very low on the list, far below the history or the portrait painter, and this tendency has somehow survived to the present day. Yet animal painting in England is as truly English in character as the development of landscape painting through Gainsborough and Constable. The title 'Horse Painter' much annoyed and distressed Stubbs, and he was never able to get rid of it, though his portraits and conversation groups are very fine and are comparable to any being done at the time. It is difficult to realize the implied artistic insult in the description, particularly when one looks at his inimitable paintings of horses. It is easy to overclaim genius, but it is impossible to deny the qualities which place him so very high among the painters of his time.

To these aesthetic qualities, add his extraordinary scientific research work, and there is no doubt that one can begin to compare him to Leonardo da Vinci, the greatest of painter-scientists.

Stubbs's scope was enormous; he was a superb designer and draughtsman, and he approached his work from a scientific attitude, with a very individual and inquiring mind, and a searching and unprejudiced eye.

His most interesting work can be divided into themes and projects. Quite apart from his normal commissions, which were mainly portraits of horses, and were a kind of creative observation rather than imaginative creation, he had a number of pet themes on which he worked out many variations. The first, which he worked on soon after his return from Horkstow, was his theme of a frieze of mares and foals. This was composed of a group of horses—usually mares with their foals—arranged in a long composition like a frieze, against a park-like landscape. These are some of his most delightful and lovable pictures, as well as being some of his finest work. He knew so well the irritable expressions of the brood-mares, with their deeply curving bellies, already in foal again. Unlike his other two themes, all the paintings of mares and foals belong to a fairly short period in his life. Much of this work was being done at the same time as he was engraving the plates for *The Anatomy of the Horse*.

His second theme was perhaps his most interesting and original, that of the Lion and Horse series. It continued to intrigue him for over thirty years and he interpreted it in all sizes and methods. It was an excursion into the Romantic, where drama, movement,

1

and emotion took over from his usual calm, serene compositions.

His final theme of farming or agricultural subjects interested him for about fifteen years, from the 1770s to the mid-1790s. He painted haymakers, reapers, and labourers, in a number of versions, in oils and in enamels, and he also made mezzotint engravings of them. These pastoral scenes have a quiet, almost nostalgic quality about them, very different from his second theme.

During his life Stubbs was occupied with enormous projects of a scientific nature, which were completely outside, though related to, his normal work as a successful painter. It seemed as though he must always have some other interest besides that of painting, something to inquire into, to work at and to experiment on, after he had finished painting for the day.

In his early twenties he became extremely involved with his anatomical studies, which led him on to lecturing and to the research work for Dr Burton, which in its turn led on to learning to etch and engrave, by trial and error, and by experiment.

In the second half of the 1750s he was busy with his incredible labour for *The Anatomy of the Horse*, and once he had finished the work on the dissection and drawings at Horkstow, he started to work on the plates. He even took the work away with him to wherever his commissions led him, working in the evenings in the various stately homes that employed him at that time.

It was about 1770 that he began to become really interested in painting in enamels. Not content to perfect the technique, he had to delve into deeper matters. He became involved in chemical experiments to produce a better palette of colours suitable for enamel painting—colours that would remain the same after firing. He refused to accept the limitations imposed by the normal grounds used, and he prevailed upon Wedgwood to experiment with large ceramic plaques. These experiments lasted him for about twenty years, into the 1790s.

Not so long after this period, in 1795, Stubbs began his final project. This was the even more daunting task of producing *The Comparative Anatomy*; it was a vast and more than full-time occupation, but he intended to carry on his researches into the vegetable world as well.

All this, in addition to his large output of paintings, of a quality that is outstanding, makes him one of the most extraordinary and interesting men in the history of British Art.

One · Liverpool, Early Life

Stubbs's parents were Lancashire folk. John Stubbs had a prosperous little leather-dressing business in Liverpool, which brought him in a comfortable income. He was known in the town as 'Honest John Stubbs' and was said by friends and dealers to be a man of great integrity, candour, and moderation. These admirable characteristics he passed on to his son, George, who was born on 25th August 1724, in Dale Street, Liverpool.

George had five sisters and a brother, all younger than himself, and of the six only two sisters survived. The eldest sister, Jane, was baptized at St Nicholas's Church in 1727, but a second sister, also called Jane, was born in 1730, so the earlier one must have died before she was three. Anne was born in 1734 and again did not survive childhood, being buried in St Peter's in 1738, the year after the fourth sister, Elizabeth, was born. John and Mary only appear in the burial register at St Peter's on 14th May 1754.

George Stubbs was christened on 31st August 1724 at the Church of St Nicholas. His father, John Stubbs, was called 'currier' on the birth certificate; he has been described as 'farmer', 'doctor', and 'surgeon' in various accounts of Stubbs's life.

As soon as he was old enough to hold a pencil the little boy began to amuse himself by scribbling. At the age of five he was making his first attempts at serious drawing with the portrait painter, William Caddick. He was friendly with Caddick's son, Richard, who was a little older than himself. There is a portrait of a youth by Caddick in the Walker Art Gallery, Liverpool, which is said to be a portrait of Stubbs. It is not very like his later portraits, though it has a slight resemblance, and could possibly be a portrait of him as a very young man.

The family moved to Ormond Street when Stubbs was about eight years old. His father had a tanner's shop and other workrooms built next to and over an archway into Chapel Yard, which was about half-way between Lumber Street and Bixeth Street. The part of Ormond Street that the Stubbses lived in is now a car-park, though it is still possible to trace the entrance to Chapel Yard. The rest of the street runs between Victorian warehouses, farther up the road. It was here that he must have seen a good deal of the work of tanning and dressing leather, for his father was anxious for him to go into the family business, which was doing well. There was plenty of work for a tanner in the eighteenth century, when horses were practically the only form of transport, and leather was needed for harness of all sorts.

Mr Stubbs senior, while approving of drawing and painting as a pleasant hobby and a rewarding amusement for his only son, was not at all keen on the thought of him becoming a painter and throwing up a settled job with comfortable prospects, and he resisted the idea strenuously.

Stubbs must have been very familiar with the techniques of skinning carcases of animals and treating hides, as well as the

softening and dressing of the skins and the dyeing and colouring of the tanned leather. He would have had an insight into coping with dead animals and must have become very used to the unpleasant sights and smells attached to the tannery. This early environment helps to explain how, years later, an apparently fastidious and meticulous man could work for many weeks on dissecting and anatomizing a putrifying animal.

It was soon after they moved to Ormond Street that a local doctor, Dr Holt, became interested in the little boy who liked drawing. He lent him bones to draw from and 'prepared subjects' that had been dissected, to 'amuse him and promote his Improvement'. Stubbs continued to study in this way, in his spare time, till his father died, about eight years later. Humphry writes on the back of one of the pages of his Memoirs, at this point, 'at Liverpool he dissected horses and some dogs'. It seems as though he was quite seriously working away anatomizing anything that came his way.

Stubbs's father's intention was to have 'kept him at home and brought him up in his own line of business'. In fact, the boy worked in the tannery office as a clerk till he was fifteen, though so unwillingly and 'in a temper so half-hearted and negligent that he received some whippings'. However, his father was by no means hard-hearted with him, for 'he was fondly caressed and greatly entrusted for his years'.

When he was quite a child he came across some of his father's workmen having a drink at the Half-way House, near Liverpool. After they had offered him a sip from their glasses, he 'became enlivened' and told them that they might have drinks on him to the amount of half a guinea—no small sum in those days, and considerably more than a child's pocket money. When his father heard about this he went to the Half-way House and inquired if his son had settled up and had been able to pay the bill, because if not he would pay anything that was still owing, but the account had been completely paid by the boy, so Mr Stubbs 'never mentioned a word of it to his son'.

By the time Stubbs was fifteen it was obvious to his father that he would never be happy as a currier and tanner, and that his obsession with drawing was not just a childish whim, 'denoting wantoness and caprice, rather than any prudential scheme for a creditable settlement in the world'. His father had nothing against the professional artist, in fact he rather admired them and their work, but he told his son jokingly that he might just as well learn to play the fiddle and by joining a company of strolling players or a puppet show might paint their scenery for them and so earn his bread and cheese. However, eventually his father relented, and though in bad health he told him to go ahead and find an instructor of merit—'some eminent character in the Arts'—to teach him. Money was to be of no object, as Mr Stubbs senior believed that 'to excel in the profession was difficult and required every aid: and that with less than excellence, a competent income was hardly to be hoped for'. Stubbs was lucky to have a father and mother able and willing to support him during this apprentice or training period, and sensible enough to realize the need for it.

Stubbs had been working quietly by himself for the better part of ten years, even though he was still only a boy. If the *Sporting Magazine* of May 1809 is to be believed, he had even won a gold medal for the statuette of a horse that he had modelled. This horse was sent to a society that encouraged the arts in Liverpool and was exhibited in the society's rooms, where it was given a medal. He went back to sculpture again, some forty years later, when he was working for Wedgwood, but at the time it appears to have been an isolated event.

He must have reached quite a high standard of competence by himself, with only a little help from friends like the Caddicks and

Richard Wright, who were painters of some consequence in Liverpool. This meant that even before he found the 'eminent character in the Arts' that his father advised he felt he was well able to cope with quite difficult subjects. He finally settled for a portrait painter who practised in the north of England and had been a pupil of Kneller, an artist called Hamlet Winstanley. He was said to have the doubtful habit of painting his portraits on a small piece of cloth—just the face—then pasting it on to a larger canvas and sending it to the drapery painter, Mr Vanaken, in London. Winstanley was painting in Liverpool at that period, and had also worked for the Earl of Derby at Knowsley Hall. He had been engaged for some years in copying and etching the pictures there. Before Stubbs could obtain an apprenticeship, he had to paint a study from a copy of a painting that Winstanly had made at Knowsley. This was so that his standard of work could be judged, and Winstanley must have been considerably impressed by his skill and promise, for he arranged that Stubbs should work for him at Knowsley. This was only a few miles from the centre of Liverpool, and was a most convenient plan. Stubbs was to copy any picture he liked, and, in addition to being given instruction, he was also offered a shilling a day, 'by way of encouragement', as pocket money.

As Lord Derby's collection was the only one of such quality and size in the neighbourhood, it was likely to be a very helpful arrangement for young Stubbs, who was barely sixteen, to be able to study there. Unfortunately, the arrangement did not last long— probably fortunately for Stubbs, who had no time to become influenced by his master's style. This might easily have happened, almost unconsciously, through working closely with Winstanley, even though Stubbs was not a man to let others think for him. His was an extremely individual and inquiring mind, even at this early age, and it remained so to the end of his life. The agreement broke down almost at once. Winstanley had offered him the choice of all the pictures at Knowsley to copy from, and Stubbs, characteristically independent and undaunted by difficulties, chose for his first effort the 'Cupid' by Vandyke. This was a complicated painting full of technical problems for a young and very inexperienced student. The figure of Cupid, as a youth, is reclining under a tree, surrounded by emblems and symbols of the Arts and Professions. These were painted by Snyders with meticulous detail, while Cupid's naked flesh was painted by Vandyke. It was a painting full of various textures—the metal of armour and ornaments, musical instruments, antique casts, and all kinds of decorative bric-à-brac—and it would have been an interesting exercise for Stubbs to have embarked upon. The trouble came when Winstanley objected to the choice, saying that he wanted to keep the Vandyke for himself, and that there was no point in having two copies. In fact, he had etched this particular painting for a large plate in a book of etchings, that he had published quite a few years before, of the paintings at Knowsley. Stubbs, who had expected complete freedom to choose for himself what he wanted to copy, was somewhat surprised and concerned. However, he decided upon Panini's 'Ruins of Rome' as his second choice. But again this did not please Winstanley, who informed Stubbs that he intended to copy this one as well. Stubbs was furious and told him he could copy the lot; as it was obvious that his word could not be trusted, he would have nothing more to do with him.

He decided, quite definitely, at this point, that he was not going to study any more by copying other painters' works, or by copying old masters, but from now on was going to devote himself to studying from nature only. This decision, taken when he was still such a very young student, seems to have been a source of pride to him always, and he remained adamant in his determination that nature was the only true source of knowledge.

After this encounter with Winstanley, he did not even try to find another instructor, but set about a vigorous course of study from nature, intending 'by everything he did, to qualify himself for painting rural, pastoral, and familiar subjects in History, as well as portraits'. He continued to work in this way, studying by himself, and completely determined to become a painter competent to carry out any commission that should eventually come his way. During these next four or five years he was living in Liverpool 'at the expense of his mother'. His father died in 1741, so he was financially dependent upon his mother. Even so, Stubbs must have been able to keep himself—in pocket money, at least. If he was skilful enough at fifteen or sixteen for Winstanley to offer him a shilling a day—more or less the pay of a labourer in the eighteenth century—then his work would have been easily saleable to friends and neighbours. Particularly at a period when the only means of recording a face or place was by a painting.

Two · York and the Midwifery book

When he was 'near twenty' Stubbs went off to Wigan, where he stayed with a Captain Blackburne, who had recently lost his son; as Stubbs looked rather like him, the Captain immediately took to him. In fact, he became so attached to Stubbs that he stayed on for seven or eight months, and was treated most kindly. During this time he was painting hard, mostly portraits, presumably. Unfortunately, the paintings of this early period in his career have not come to light, though there may well be portraits in the North of England waiting to be identified.

From Wigan he went on to Leeds, where he was said to have 'practised portrait painting only'. He received a number of commissions from a Mr Wilson,[1] painting his family and his friends, as well as himself.

When he left Leeds he went to York, 'to execute some commissions', which sounds as though he was already beginning to make some sort of local reputation in the North and was becoming known as a portrait painter. It was in York that he began to study anatomy really seriously and professionally. He worked and studied with the surgeon Charles Atkinson and also attended anatomy lectures. Atkinson was instrumental in getting Stubbs his first subject for dissection. This was probably the body of a murderer or even a thief, who had been hung, as this was one of the few sources of corpses.

It was extremely difficult to get hold of a cadaver for dissection —even at the University of Leydon, where Albinus taught at the Anatomy School, and where students came from all over Europe, they had to make do with one human body for a whole year.

It was considered a very disreputable and unnatural occupation to anatomize a man's corpse. St Bartholomew's Hospital had only started lectures on anatomy some ten years before this, and it was not till the beginning of the nineteenth century that anatomy could really take its place as a desirable subject for study in the medical profession instead of a practically criminal one.

Stubbs was leading an extremely busy life at this point, for not only was he painting portraits and devoting himself to his anatomical studies, he was also learning French and had taken up fencing. According to Humphry, while he was in York he had 'a rencontre with the Dancing Master, Mr Wynne.' Unfortunately, no details of the 'rencontre' are given though in one of the transcripts of the Memoirs, it says in brackets, '(state particulars)'— what a pity no one ever did. Stubbs painted Mr Wynne, for the name appears in the list of his works, but did he also learn dancing from him? He may have done, with a view to preparing himself for a move into the more socially cultured atmosphere of the capital, or even for the society of the wealthy Yorkshire patrons.

He was now able to keep himself by his painting and was no longer dependent on his mother. He rapidly became known for his anatomical knowledge and was asked to give lectures on anatomy to the students from the hospital. This would have been done privately, as anatomy was not usually taught in hospitals.

[1] Illus. p. 16

Stubbs had come a long way for a young man in his early twenties, and was already respected for his anatomical learning. This respect was not from would-be painters, but from knowledgeable young medical students, whose profession was closely connected with the subject.

At the time when Stubbs was working in York the founder of the hospital there, Dr John Burton, the well-known physician and man-midwife, was busy with his book on obstetrics *An Essay towards a Complete New System of Midwifery*. Burton was immortalized as Dr Slop in Laurence Sterne's *Tristram Shandy*, and was described somewhat unkindly as a 'squat, uncourtly figure of about four feet and a half perpendicular height and a sesqui-pedality of belly which might have done honour to a serjeant in the horse guards'. Dr Burton was anxious to have clear and accurate illustrations to his book and therefore a painter of some considerable skill, who was also an anatomist of repute, was the obvious choice. It was an opportunity not to be lost and the doctor was absolutely determined that Stubbs should do the drawings for the plates.

Stubbs, who was not a man to be daunted by the difficulties of a subject, nor by the amount of work involved, agreed to prepare designs for the plates. This involved him in the most hair-raising and extraordinary adventures of an almost 'Burke and Hare' variety. As it was necessary to dissect and study, and then make drawings of the parts of the human body particularly concerned with midwifery, the pressing problem was to acquire a suitable subject. Humphry describes how Stubbs's pupils from the hospital heard of a woman who lived some sixteen miles from York, and who had died in childbirth. She was a singularly favourable subject for study, and so the students brought her, somewhat quietly and by night, one would imagine, to York, where the body was 'concealed in a garret, and all the necessary dissections made'.

The *Sporting Magazine* for July 1808 makes this dramatic comment, 'To dissect the human body was his diligent pursuit, in as much that (as I have heard a relative of his declare) to procure subjects for his improvement Mr Stubbs had an hundred times run into such adventures at night as might subject anyone with less honourable motives to the greatest severity of the law'. In fact, it makes one realize that acquiring the specimens for study must have been a hazardous undertaking that was little short of body-snatching and grave-breaking. As it was, Stubbs was said to be held in 'vile renown' in York for his activities.

After all this sinister studying, the eighteen drawings for the book were finished, but Stubbs's labours for Dr Burton were not. The poor doctor found it impossible to find anyone to engrave the plates from the drawings—doubtless because the subject would, at that time, be considered exceedingly indelicate—almost verging on witchcraft. He tried hard to persuade Stubbs to undertake the etching of the plates himself, but Stubbs, who knew nothing at all about etching and engraving, was very reluctant to venture on the project.

It was a blessing that Burton pushed Stubbs so firmly into attempting the job of producing these plates, for without the experience he gained with this early work he might not have embarked upon the plates of *The Anatomy of the Horse*, and then it might never have achieved publication. Apart from this, the eighteen midwifery plates are the earliest known works of Stubbs, and for this reason are of great interest. They show a draughtsmanship which was to develop, from these expressive though technically almost amateurish etchings, to the authoritative way he draws the illustrations for *The Anatomy of the Horse*. Already, with the drawings of the babies in the womb, he shows an appreciation of form that produces a sculptural tranquillity and a sense of composition and design. They are also clear diagrams for a

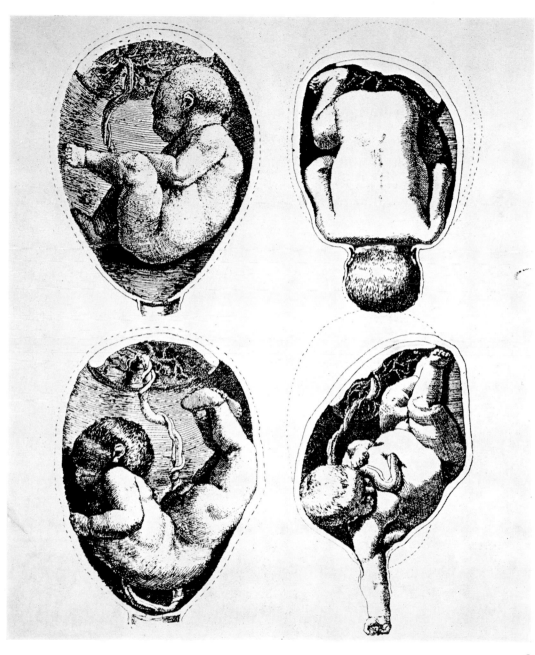

Plate from the Midwifery Book. 8½in × 6in.
Brown, Picton and Hornby Libraries, City of Liverpool.

work of some considerable importance, scientifically speaking. Dr Burton describes them in this way: 'Some inconsiderate People look upon Copper-plates, in this case, to be useless; but judicious Persons must be sensible, that in describing Objects not to be seen, the Reader will have a better Idea of them from a true Representation upon a Plate.'

To execute these 'true representations' upon plates caused Stubbs a good deal of trouble. He had never even seen an etcher or engraver at work, and though Winstanly had etched plates of the Derby Collection at Knowsley, this was quite a few years before Stubbs went to him as a pupil, and he was evidently not with him long enough to pick up any information. Burton insisted that from what he had seen of Stubbs's work, he 'could not fail in whatever he undertook'. So, Stubbs eventually decided to 'undertake the task and do his best'. This he did by starting at the very bottom and learning the craft. He went to Leeds to a 'house painter' who was an acquaintance of his—it is rather tempting to read into Humphry's manuscripts 'horse painter', though the subsequent transcripts are very clearly 'house painter'. This painter friend, who 'engraved now and then', gave him a rough idea of how to go about the job. 'He had no other instruction to give, than to cover a halfpenny with an etching varnish and smoke it, and afterwards with a common sewing needle stuck in a skewer he shewed him how etching was done.'

When Stubbs came to try this method he found that the varnish was much too hard and brittle. As his designs were fairly small and rather complicated, he needed to cross-hatch his lines in places, whereupon the varnish chipped away and spoilt the precision of his drawing. He experimented, and tried various ideas, until he found out that by warming the plate till the wax melted and ran off, he could produce a very thin film over the plate which would take the greater detail that he wished to etch. Even so, he found it necessary to finish off the plates with an engraving-tool. Here again was another craft and a skill which he had to learn and become efficient in. He managed to borrow some tools from a clockmaker and eventually the commission was completed. It gave him very little satisfaction, as he was well aware of his lack of skill and practice, and he felt disappointed with the results of his efforts. However, Dr Burton was delighted with the plates, which he said were 'exact and illustrative'. The book was published in 1751, though at his own wish Stubbs's name is kept out of it and does not appear in the text.

The publication of the book caused a certain amount of trouble between Dr Burton and the distinguished surgeon Dr William Smellie. In the preface Burton mentions a 'Person' who was going to publish 'My Improvements with some Work of his own; this put upon me the thought of publishing them myself'. In fact, Dr Smellie did publish his 'Treatise on the Theory and Practice of Midwifery' soon after the 'Essay towards a Complete New System' appeared, and it was received rather more warmly than Burton's book, all the critics reviewed it with approval. Burton then published a 'Letter to William Smellie, containing critical and practical Remarks upon his treatise'.

Two of Smellie's pupils were later on to be connected with Stubbs over artistic and anatomical matters. They were William Hunter, who eventually became the first Professor of Anatomy to the Royal Academy, and the Dutchman, Petrus Camper. Presumably they would have heard of Stubbs as early as this, through his work for John Burton.

During this time he was also working hard as a painter, for the plates for the book were executed in 'intervals of leasure'. Later on he never used daylight hours for work other than painting, so he must have engraved these plates during the evenings and at odd times that were inconvenient to his sitters.

The dates of this period are a little difficult to work out, but Humphry says that he was 'near twenty' when he left home and went to Wigan, this was probably late in 1744. After about eight months he went to Leeds for an unspecified period sometime in 1745 and in the same year he went on to York. When he was in 'the twenty second year of his age' he was starting to engrave the plates, and after they were finished he stayed on in York for 'two or three years'—say till 1751, when the midwifery book was published.

When he left York, he 'removed to Hull'. Perhaps his 'vile renown' in York became rather much for him, once the book was published, and was effecting his portrait connections. Anyway, he remained in Hull for two years, 'always practicing Portrait Painting and Dissection'.

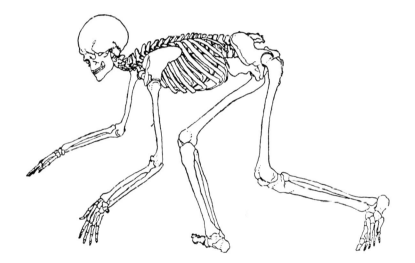

Line drawing of skeleton. *10½in × 17½in.*
Worcester Public Library, Worcester, Massachusetts.

Three · Rome

At the end of two years' work in Hull he returned home to Liverpool for a short time.

Then, in 1754, he set sail for Italy, quite an undertaking in those days of slow and difficult travel. The journey took over two months, for the sea voyage to Leghorn alone occupied nearly eight weeks. The whole journey to Rome would probably have cost Stubbs somewhere around £30, and furnished accommodation could be had for about £10 a year. It was said that an artist studying in Rome could live for £60, or even less, a year.

On reaching Rome, Stubbs found that among the English artists who were already there was the architect, Chambers, later Sir William, and first Treasurer of the Royal Academy, with his wife. Also 'Jenkins, Brettingham, Wilson, Hamilton and Verpoil etc.' Matthew Brettingham was in Italy collecting pictures and sculptures on behalf of Lord Leicester for his new house, Holkham Hall. Verpoil, or Vierpyl, the sculptor, was employed by various English noblemen to make copies of antique sculpture. Richard Wilson, the landscape painter, had been in Italy since 1750.

There was quite an English community of artists in Rome about that period. They collected round the Caffe Inglesi in the Piazza di Spagna and used it as a headquarters. Reynolds was there a few years earlier, and many other painters and sculptors came to Rome as part of a kind of art student's Grand Tour. It was very necessary for a painter to have been to Italy and to have seen the Vatican and the Palazzos of Borghese and Colonna, etc., and to have studied Greek and Roman art, otherwise he was at a disadvantage. Chambers said: 'Travelling to an Artist, is what the University is to a Man of Letters, the last stage of a Regular Education, which opens the mind to a more liberal and extensive way of thinking, diffuses an air of Importance over the whole Man; and stamps a value upon his opinions. . . .'

Stubbs did not care to take other people's experiences and use them second hand, so he made the effort and went to see for himself what art in Italy was all about.

His early convictions that, for him, the proper course of study was directly from nature does not appear to have been in the least shaken by his visit to Rome. He returned home unmoved in his opinions by the close contact with great works of art, and with men whose views on the value of such study were completely opposite to his own.

He had a natural aversion to the artificiality, and the pomp and circumstances of the 'Grand Manner', and preferred simplicity of subject and directness of approach, allied to deeply considered design and composition that was carefully and almost mathematically worked out. Others had a classical, historical, and extremely derivative training in how to paint fashionable subjects; Stubbs's anatomical and direct-from-nature training gave him a totally different background of study.

According to Humphry: 'It does not appear that whilst he

resided in Rome he ever copied one picture or ever designed one subject for a Historical Composition, nor did he make one drawing or a model from the Antique, either Bas-Relief or single figure:— and so much had he devoted himself to observe and to imitate particular objects in Nature, that when ever he accompanied the students in Rome to view the Palaces of the Vatican, Borghese, Colonna etc., and to consider the pictures in Rome he always found himself differing from them in opinion upon the pictures and if it was put to the vote, found himself alone on one side and all his companions on the opposite one.'

Though Stubbs had wished to 'qualify himself to paint familiar subjects in history', this was obviously not the way for him. Once can imagine him sweeping through the warm and rarified Classical atmosphere like a cold fresh English breeze and returning home to look at things exactly as he always had done, with great perception, and completely without preconception. He analysed and distilled his own very personal vision, not that of another artist.

If he never made studies of antiquities, or great paintings in Italy, he must have done some work while he was there, for a painting entitled 'Two Mendicants, painted while in Rome' is mentioned in the catalogue of the sale of his works after his death.

His real motive for going to Italy was to reassure himself that his ideas were right, and to prove to himself that there was no reason for him to feel in any way that his art education had been neglected. So many of his contemporaries had made the effort to go and study abroad, and so had the young men of good family, whose education was finished off with a Grand Tour. This influenced to a certain degree the taste of the times, by stimulating the collecting instinct. Horace Walpole wrote a letter home saying: 'I am far gone in medals, lamps, idols, prints etc. and all the small comodities, to the purchase of which I can attain, I would buy the Coliseum if I could.' As well as 'souvenir' hunting, many wealthy noblemen acquired paintings and sculpture that formed the basis of important collections of works of art. The Italian taste came home with them to affect the architecture of their homes. Men like Lord Burlington, whose influence was widespread among his circle, Italianized his existing house—Burlington House, Piccadilly—which became one of the first Palladian houses in London. The development of painters and sculptors in England in the eighteenth century owed more to the influence of the Grand Tour—both their own and their patrons—than to any other single factor. The Grand Manner and the development of Neo-classicism were due mainly to the close contacts with Italy. There was a tremendous interest in antiquities and Classical monuments, and amateur archaeologists poked around among Greek and Roman remains.

Mr Stubbs only went to 'convince himself that nature was and is always superior to art whether Greek or Roman, and having received this conviction he immediately resolved upon returning home'.

It is at this point that Humphry and both the other transcripts say: 'He first landed in London, where he continued about a week, from whence he removed to his native Liverpool.' There is absolutely no mention of his trip home, or of any experiences that he might have had on the way. Yet in the *Sporting Magazine* for May 1808 there occurs this quite detailed account of a trip to North Africa:

'Having remained the time necessary for his improvement, Stubbs embarked for England, and during his passage he became acquainted with a gentleman, a native of Africa, whose tastes and pursuits in life were similar to his own. This gentleman had been in Rome and was returning to his family: he was liberally educated, and spoke the English language with accuracy. His in-

13

formation made him a delightful companion to Stubbs, who often expressed how much it would add to his gratification if he could but behold the lion in its wild state, or any other wild beast. His friend, on one occasion, gave him an invitation to the paternal mansion he was about to visit. The offer was accepted with pleasure, and Stubbs landed with his friend at the fortress of Ceuta. They had not been ashore many days when a circumstance occurred most favourable to the wishes of our painter. The town where his friend resided was surrounded by a lofty wall and moat. Nearly level with the wall a capacious platform extended, on which the inhabitants occasionally refreshed themselves with the breeze after sunset. One evening, while Stubbs and his friend were viewing the delightful scenery and a thousand beautiful objects from this elevation, which the brilliancy of the moon rendered more interesting, a lion was observed at some distance, directing his way, with a slow pace, towards a white Barbary horse, which appeared grazing not more than two hundred yards distant from the moat. Mr Stubbs was reminded of the gratification he had so often wished for. The orb of the night was perfectly clear, and the horizon serene. The lion did not make towards the horse by a regular approach, but performed many curvatures, still drawing nearer towards the devoted animal, till the lion, by the shelter of a rocky situation, came suddenly upon his prey. The affrighted barb beheld his enemy, and, as if conscious of his fate, threw himself into an attitude highly interesting to the painter. The noble creature then appeared fascinated, and the lion finding him within his power, sprang in a moment, like a cat, on the back of the defenceless horse, threw him down and instantly tore out his bowels.'

It is curious that there is only this single account of Mr Stubbs's trip to Ceuta. On his return from his travels, he stayed at home, in Liverpool, for some two or three years. He was evidently doing good business and becoming sought after. 'Pictures in abundance were proposed to him' and he was kept busy painting portraits. An artist straight back from Italy had a definite value and reputation as a painter of portraits. He was also carrying on with his anatomical researches, and dissecting various animals. He was said to be 'considering his anatomical subjects'—perhaps with his friend, Miss Mary Spencer. She was born in Liverpool, and lived near the Stubbs family. She was the posthumous daughter of Captain Spencer of the Guinea trade, who was 'slain by an Insurrection in his ship, and by his own privileged slave in particular, who beat his master's brains out with an Iron Bolt, as he was stooping down to examine the fetters that had been filed through to effect a mutiny. After which he instantly jumped overboard and was immediately shot dead by the legion of the ship.'

Mary Spencer is described by Humphry as Mr Stubbs's 'Female relation and friend' with an added note to say that she was his aunt. In the transcript by Upcott the relationship has been changed to that of niece. However, it has been generally accepted that she was the mother of his son, George Townley Stubbs, who was born in 1756. It seems likely that once his mother died they made their home together for the rest of his life. She was certainly his companion for forty years and his sole assistant during his anatomical researches. She described herself as Mary Spencer, spinster, when his will was proved, though he omitted to put spinster in the actual will, when it was drawn up in 1794.

When he got back from Rome she became quite fascinated by his work; she 'had always, in that town, shewn particular pleasure in seeing from time to time the experiments he made there'. This was in Liverpool, and it was during this period that his mother died. After this event he remained at home for about a year and a half, finishing his 'abundant' commissions and settling up his mother's affairs.

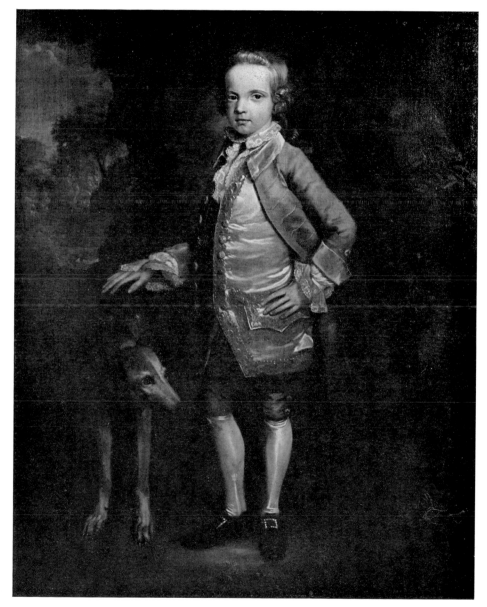

Sir John Nelthorpe as a Boy. *50in × 40in.*
By kind permission of Lt.-Colonel R. S. Nelthorpe.

15

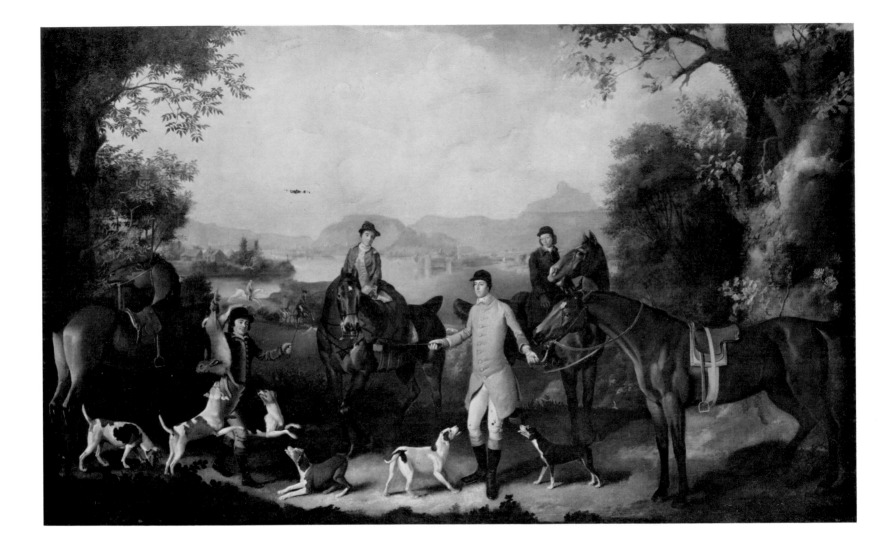

Coursing Party *60in × 90in. From the collection of Mr and Mrs Paul Mellon.*

16

While he was at home he painted a portrait of his own grey mare, which was admired by everyone and 'was thought to have succeeded greatly'. In fact, when a London picture dealer saw it he was sufficiently impressed to prophesy that if Mr Stubbs chose to come to London he could make himself a fortune by painting horses. However, at that particular time Stubbs had many portrait commissions still to undertake in the North. He was also anxious to carry out the immense project that had been in his mind since he left York. This would mean that he had to concern himself with collecting money together, with a view to supporting himself during a prolonged period of intense anatomical investigation. He must have spent a fairly large sum on going to Italy and he would have been unlikely to have made very much, if anything, during his travels. He may have been financed by some wealthy patron, but it seems much more likely that he relied mainly upon his own earnings and savings, and was perhaps helped out by his mother.

Once his mother's affairs had been put in order, Stubbs left Liverpool once again. This time he went to Lincolnshire, where he had various portrait commissions to execute for Lady Nelthorpe and other people in the neighbourhood. These had been arranged before he went to Italy, but he had not been able to carry them out for nearly two years. A portrait of Sir John Nelthorpe as a boy is one of the earliest known works. The Nelthorpes lived at Barton-on-Humber and it was to this district that he returned when he started his period of intensive study for the scheme that had been in his thoughts for such a long time.

Four · The Anatomy of the Horse

It seems as though Stubbs always had to have a project on hand. Some subject that was quite outside, though related to, the work that he was doing as a successful painter. A project to work at, to inquire into and to experiment with. He seemed compelled to have a scientific investigation as an occupation for the restless energy of his mind. As a child he was absorbed by the mystery of unknown natural forms, and as a youth he explored the world of living structure. His anatomical studies led him on to lecturing and teaching and to the scientific exactness of the midwifery drawings, followed by learning the processes of etching and engraving. He was not satisfied by following the methods taught him, but immediately experimented to improve all the technical processes. Now he was concerned with a really tremendous plan, that of producing a book on the anatomy of the horse.

This was to take him the better part of ten years to finish, and was the result of many more years of study and observation. It was 'upon the advice of his young Chirugical friends with whom he had been previously connected at York' that he decided to 'complete and publish *The Anatomy of the Horse*'. This last quotation from Humphry gives the impression that the project had been in Stubbs's mind for a number of years, and that he had done a good deal of preliminary work on the subject with the book in mind. In the preface to the book, he says that he consulted most of the treatises upon the subject, and when the book was advertised it said that it was the result of many years of actual dissection. Of the treatises upon the horse, the most important, anatomically speaking, was Carlo Ruini's *Dell' Anatomia et dell' Infirmita del Cavallo*. This was published as early as 1598 and little that was published subsequently improved upon it, either illustratively or scientifically. Petrus Camper, the distinguished anatomist, wrote of the illustrations: 'They convey a general idea of the anatomy of the parts; but they cannot serve the painter. What then is to be expected from the works of Sannier and Snape, and others which are merely bad copies from the imperfect engravings of Ruini!' There was not much inspiration to be gained from these later works. Stubbs's own creative observation produced a completely fresh approach to the subject. The horse appears to be a living animal instead of a dead and stylized figure.

To complete the final studies for this immense work Stubbs needed a period of peace and quiet, far away in the depth of the country, where he could dissect without offending anyone. He went to Lincolnshire, to the small village of Horkstow, about six miles from Barton, where he had stayed when he was working for the Nelthorpes. There he 'engaged a farmhouse That he might without inconvenience to others have dead horses, and subjects adapted to his purpose'.

The exact location of this farmhouse is not certain, but presumably it would have been some distance from the village and

isolated from neighbours. The 'inconvenience' would have been considerable had other farms been within receiving distance of the nauseating and penetrating smell of decaying horseflesh. Landseer said of the lion which the Zoo had provided for him to use as a model for his bronze lions in Trafalgar Square, and which had died whilst he was out of town: 'Anything as fearful as the gases from the royal remains it is difficult to conceive . . . We shut our eyes to nasty inconvenience and open them to the importance of the opportunity of handling the dangerous subject whilst in a state of safety.'

Stubbs must often have 'shut his eyes to nasty inconvenience' during the next year and a half. He tackled the whole project by himself, with no outside help, and with no other companion or assistant than Mary Spencer. It must have been rather hard on her, for she had not been brought up in the house of a tanner, and her nose was probably less accustomed to unpleasant odours.

The medical students and surgeons from York failed to come to Mr Stubbs's assistance with either money or practical help, as they had originally promised. So, single-handed, he began what to most men would be a life-work, and one requiring a good deal of careful organization. There were three main operations to be conducted. First, after the awkward and heavy job of rigging up the dead horse in the dissecting-room-studio, there was the dirty work of stripping and cleaning, and the injection of the animal's veins, preparatory to beginning the dissection proper. Second, having dissected and laid bare the part to be illustrated, there was the completely different task of making working drawings, which was clean, precise work, far away from the butcher's shop atmosphere of bleeding the horse to death, and then skinning and disembowelling it. Finally, there was the writing up of the descriptions for the book's text.

Humphry gives this detailed account of the way Stubbs attacked the project: 'As these studies and operations were singular and very important, the manner in which they were conducted may not be uninteresting to relate. The first subject which was prepared was a horse which was bled to death by the jugular vein,—after which the arteries and veins were injected. Then a bar of iron was suspended from the ceiling of the room, by a Teagle of Iron to which Iron Hooks were fixed.—Under this bar a plank was swung about eighteen inches wide, for the Horse's feet to rest upon, and the Horse was suspended to the Bar of Iron by the above mentioned Hooks which were fastened into the opposite side of the Horse to that which was intended to be designed; by passing the Hooks through the ribs and fastening them under the Backbone and by these means the Horse was fixed in the attitude which these prints represent and continued hanging in this posture six or seven weeks, or as long as they were fit for use.

'His drawings of a skeleton were previously made—and then the operations upon this fix'd subject were thus begun. He first began by dissecting and designing the muscles of the abdomen—proceeding through five different layers of muscles till he came to the peritoneum and the pleura through which appeared the lungs and the Intestines—after which the Bowels were taken out and Cast away—Then he proceeded to dissect the Head, by first stripping off the Skin and after having cleaned and prepared the muscles and &. for the drawing, he made careful designs of them and with the explanation which usually employed him a whole day. Then he took off another layer of Muscles, which he prepared, designed and described, in the same manner as in the Book—and so he proceeded till he came to the Skeleton—It must be noted that by means of the Injections the muscles, the Blood-vessels and the Nerves retained their form to the Past without undergoing any change of position—In this manner he advanced his work by stripping off the skin and cleaning and preparing as

much of the subject as he concluded would employ a whole day to prepare design and describe, as above related till the whole subject was completed.'

The drawings for *The Anatomy of the Horse*, or at any rate, some of the drawings made at Horkstow, can be seen and studied in the Royal Academy Library. If looked at very closely, it is possible to see beneath the drawing of the muscles a faint trace of the skeleton, drawn in pale ink. Also the outline or silhouette of the horse was generally laid in, in the same manner. Stubbs prepared a master drawing of the silhouette of the horse in the required pose, and the skeleton in the same position. These would have been traced on to a number of sheets of paper, the master drawing having been pricked all along the outline with tiny holes and placed over a blank sheet of paper, after which powdered charcoal or chalk would have been tapped, or pounced, through the holes on to the blank sheet, leaving a series of faintly dusted-in dots. These little dots were then carefully joined up to re-form the exact outline of the master drawing. It is fairly easy to see these joined dots on one or two of the drawings, as it gives a slightly jerky look to the line. He also squared up some of the drawings and reproduced them by this method. These tracings were executed in pale ink leaving a permanent, but unobtrusive drawing, as a basis on which to place the muscular layers as the dissections progressed deeper and deeper. Thus giving a continuity of size and pose over a number of different horses—Stubbs said that he 'dissected a great number of horses'.

One must bear in mind that many of these drawings were working studies through which he was gaining the knowledge and information needed to produce the final set of finished drawings from which the plates were to be engraved. Quite a number of these drawings are almost notes, rather than finished studies; they are rapidly and roughly scribbled in, in black chalk, and bear little visual resemblance to the plates. It is interesting to note that while the side-view studies are all in the same pose, though varying somewhat in size and proportion—there are two sets that correspond to two different master drawings—the front and back views have two poses each, with the horse in movement, in an almost trotting action. One pose which corresponds more or less exactly with the pose in the engravings, and a second set, in which the perspective is particularly steep and gives a curious impression of a very long hind leg in the back view, and of a badly taken photograph in the front view, with an exaggeratedly large head. This is more likely to have been caused by working in a restricted space without room to get away from such a very large subject, and not by inaccurate drawing or observation. Presumably these were the earlier drawings in the series, as they are also less highly finished and more roughly executed. These rapid notes tend to be considerably larger in scale than the careful studies.

Stubbs used quite a wide variety of media in the drawings. In the delicate and beautifully precise work which was to be used for the engravings, he uses pencil. These are meticulous in detail and wonderfully controlled. They have an expressiveness combined with an absolute authority which lifts them far above the normal study, and makes them a visual delight. Their clarity is amazing and the way he constructs a leg—bone, muscle, tendon, and vein are expressed so clearly and concisely, with subtle differentiation of texture, and all within so tiny an area. In some of the larger drawings he has used black chalk, and the smaller details are noted in sanguine.

The layout of the book, in eighteen 'plates' or 'tables', shows first the front, side, and back views of the skeleton, followed by five plates of the muscular layers progressing from the subcutaneous, deeper and deeper towards the skeleton. The fully

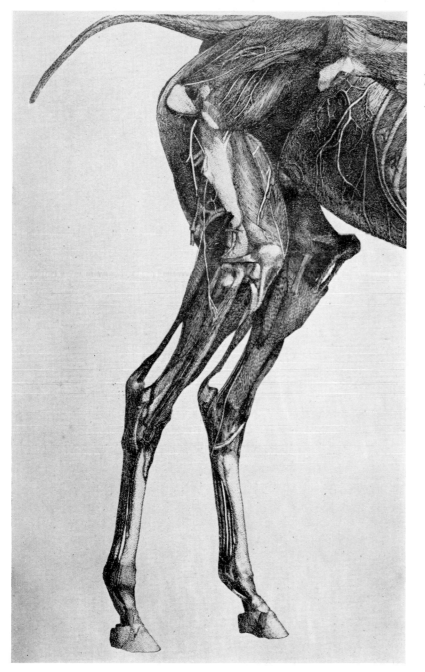

A detail of an engraving from 'The Anatomy of the Horse'. *Royal Academy of Arts, London.*

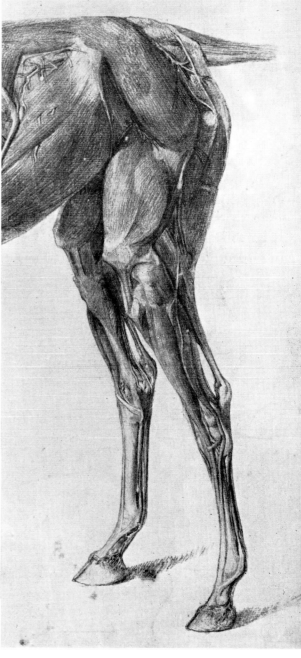

A detail of a drawing for 'The Anatomy of the Horse'. *Royal Academy of Arts, London.*

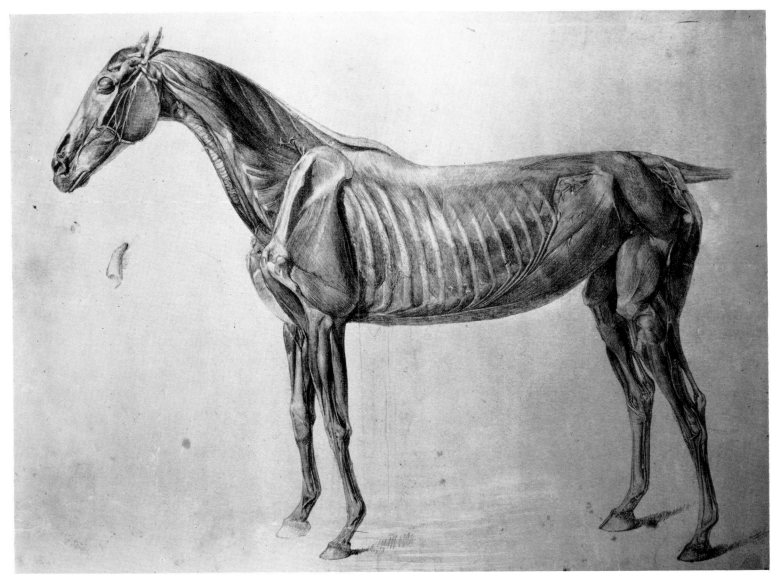

A drawing for 'The Anatomy of the Horse'. *19in × 24in. Royal Academy of Arts, London.*

modelled engravings are paired with the line engravings, or diagrams, of the same view and anatomical layer, lettered and numbered, to form a key to the text, and to clarify the position of the veins and nerves. This preserves the unity of the engravings, which are unspoilt by any type of key spotted over their surface. Camper points out the similarity in arrangement to Albinus's famous *Tabulae Sceleti et Musculorum Corporis Humani* illustrated by Jan Wandelaar. Stubbs would have undoubtedly studied this book, published some ten years before, in 1747.

To return to the drawings, there are studies for the diagrams as well as for the engravings. These are mostly drawn in a golden yellow ink and with the horse's outline in sanguine chalk. The arteries or nerves are put in in pencil and the letters and figures in brown ink. However, he uses a number of variations of this arrangement. One of the drawings of the skeletons is boldly drawn in dense black ink, and there is a set of three very fine measured drawings in sepia ink. Each bone is related by measurement to the whole, and by related angles and fixed points, the position and proportion is worked out. At the top of the side-view drawing, in Stubbs's own writing, it is possible to make out the words' 'Proportions taken from an old mare about 13 hands high'.

Camper, in his book, says: 'You will naturally suppose that the skeleton of the horse which is the most beautiful and useful of animals, must have been delineated with peculiar care and exactness. But alas, exclusive of those painted by the great master in this department, Stubbs, and engraved after his paintings, I know not of any that deserve commendation. . . .'

He also said, of *The Anatomy of the Horse*: '. . . that of Stubbs is masterly and accurate; all the parts are properly placed, are in just proportions, and are well delineated. In his finished pieces the muscles are represented with an accuracy that cannot be exceeded. In a word, his skeleton of the horse, and his arrangement of the muscles, exhibit such a masterpiece, that the author deserves the highest honours that were ever bestowed upon an artist.'

It seems probable from the following extracts by 'Janinus' in 'Conversations on the Arts' in *Ackerman's Repository* that Stubbs had articulated a skeleton so that it could only be moved into poses that a live horse could take, and that it could only make the same actions as a real horse. 'I refer to a skeleton which I have, invented by Mr Stubbs, the horse painter. It is so prepared that in whatever attitude it is put, it continues in that position. By this contrivance a painter can always have before him the osteology exactly in the position of the figure which he is painting.' And also: 'I will place this skeleton upright. It has in it a great number of copper and annealed wires. It is never prepared in this way by the common mounters of skeletons. This not only retains the position it is placed in, but it cannot be put in an unnatural position.'

The drawings were completed at the end of about eighteen months of hard labour—and it must have been very hard and dirty work for Stubbs to cope with, and with Mary Spencer as his only help and assistant. Luckily for him, he was young, tough, and extremely strong—not only physically but mentally and morally, with an immense will-power and determination. It became a kind of legend that he could carry a dead horse up the stairs to his dissecting room without help. The strain of rigging up the dead weight of a carcass to draw from would have taxed most men's strength, and he did this to a 'great number of horses'—not just one. He was subject to considerable dangers from infection from the putrefying remains. Without antiseptics, many anatomists died. Jesse Foot recalled five lecturers who died of a 'putrid myasma'. Stubbs was said to have worked on one

horse for eleven weeks. The state and the smell of it must have been indescribably horrible, yet the drawings have a calm, unemotional quality, completely unaffected by any of the drama of the situation.

Stubbs's command of the technical side of dissection was surprising. A great deal of highly specialized knowledge was required to prepare the horse for dissecting; the arteries and veins had to be injected with wax and other substances to keep their shape and position, so that they could be recorded. He had to be able to dissect extremely quickly, for without any form of preservatives, decomposition would set in very rapidly, particularly in small, stuffy and poorly ventilated surroundings such as a farmhouse. No other anatomy of the horse was anything like as advanced scientifically or as accurate. Even now, two hundred years later, it remains a monumental work that would be hard to fault.

Mr Stubbs left Horkstow sometime in the summer of 1759, and probably returned to Liverpool for a short while, for the register of St Peter's Church records that Mary, daughter of George Stubbs, limner, was buried there on 18th September. He proceeded to London in the autumn, with the drawings complete and ready for the engravers to make a start on the plates. However, this was not as easy to arrange as he had hoped. He approached 'Mr Grinion and Mr Pond' and made inquiries to many other engravers of professional standing, but when his drawings were shown to them, they all declined to undertake the commission, even Mr Grinion, who had engraved some of the plates for Albinus's Anatomy. The reason given being that though many of the drawings were of entire horses, others were of parts only, such as ears, noses, and limbs. The engravers had not worked on such a project before and didn't understand it at all. They laughed at the studies and were unwilling to have any-

thing to do with the book in case they should be ridiculed, and, anyway, the subject was not one which appealed, having a slightly disreputable flavour. It is interesting to speculate on what happened to the drawings of 'ears, nose, and limbs', as there are none in the collection in the Royal Academy Library. In fact, Stubbs presumably did a great number of drawings and studies at Horkstow, of which perhaps only a fraction remain. Some may yet turn up, but at the present time there are forty-two at the Royal Academy and one at the British Museum, plus a couple of others in private collections. It was as late as 1963 that the number of known drawings for *The Anatomy of the Horse* at the Royal Academy changed from eighteen to forty-two. The eighteen were well known and loved by many R.A. students and lovers of horses, as well as by scholars of Stubbs. They had been housed in the R.A. Library in a solander case for many years.

They were left to Mary Spencer, with many other works, in 1806, when Stubbs died. She kept them till her death in 1817, when they were bought by Colnaghi. At the time when Joseph Meyer was collecting material for his essay on Stubbs he wrote to the animal painter, Abraham Cooper, R.A., and received the following reply: '. . . Perhaps you are aware that my friend Edwin Landseer R.A. possesses Stubbs's original drawings for *The Anatomy of the Horse*. Old Colnaghi bought them at a sale some years back when a sale of Stubbs's things took place and Landseer painted him—Colnaghi—a picture for them.' Landseer thought a lot of them, and though he had offers to sell the drawings, he never parted with them. They were left by him in 1873 to his brother Charles, who was Keeper of the Royal Academy Schools for over twenty years. When Charles Landseer died, six years later, he bequeathed to the Royal Academy a large sum of money —over £10,000—to found scholarships and prizes for art students, and the Stubbs Drawings. The bequest of the drawings is

not mentioned in the Royal Academy's Annual Report for 1879, though the money is recorded. However, in the Report of the Inspectors of Property of the following year, it is stated: 'That the anatomical drawings of the Horse by George Stubbs A.R.A. be removed from their present position on the staircase leading to the Diploma Galleries, and placed with his other works in the Library for the more convenient reference of the students.' These 'other works' must refer to the two books by Stubbs, *The Comparative Anatomy* and *The Anatomy of the Horse*, which were already in the Library.

For many years the eighteen drawings were thought to be the entire collection, but in 1963 the Royal Academy put on an exhibition of 'Treasures of the Royal Academy'. It was while searching for interesting relics that a rather battered portfolio came to light, and while going through some distinctly uninteresting architectural drawings a grubby paper parcel emerged from the bottom. Inside were twenty-four more drawings. It seems likely that at the time when they were bequeathed the most suitable were mounted and framed, and hung on the Diploma Gallery staircase. These were the more highly finished and delicate of the forty-two. Also they were the ones most directly related to the plates. The few of the same type that were in the parcel of unmounted studies were all quite large and would hardly have hung conveniently with the others. The eighteen would also have been considered the most useful and helpful for the R.A. students to study from. There is no mention in the Academy's records as to the number of drawings originally in the Landseer Bequest.

Of the eighteen engravings and eighteen diagrammatic line engravings in the book, twenty of them have drawings in the collection that directly relate to the plates. Of these, fifteen are from the old set of eighteen, and five belong to the newly dis-

covered twenty-four. All the five relate to the diagrams and the others are drawings from which most of the plates were actually engraved.

Because no engraver would take on the job of translating the drawings into engravings—and not just into artistic renderings, but super accurate illustrations to a scientific work—Stubbs was obliged to undertake the work himself. It is obvious from the finished plates that he set himself an exceedingly high standard of execution. There is a tremendous advance on the midwifery plates, both technically and aesthetically. In the ten years since then he had developed and matured, and the period of tremendous study at Horkstow was a very great influence on his powers of observation and analysis of form. His draughtsmanship was by this time masterly and sensitive. The preparation and engraving of the thirty-six plates, and the finishing of the text, took Stubbs six years, for he never used daylight hours for anything but painting, so the plates were worked on during the evenings and in the early mornings.

Mr Stubbs considered that the best way to get the book published and sold was by subscription, so it was advertised in the papers, and a form or leaflet was printed, also giving the same information:

PROPOSALS for Publishing by Subscription, THE ANATOMY OF THE HORSE INCLUDING a particular Description of the Bones, Cartilages, Muscles, Facias, Ligaments, Nerves, Arteries, Veins and Glands. Represented in Eighteen Tables, all done from Nature. By GEORGE STUBBS, Painter.

CONDITIONS.
The Tables engraved on Plates 19 inches by 15. The Explanation of the Tables will be printed on a Royal Paper answerable to the

Plates, each of which will be printed upon an half Sheet of Double Elephant. The Price of the Book to Subscribers will be 4L. 4s. one Half to be paid at the Time of Subscribing, the other Half when the Book is delivered. The Price to Nonsubscribers will be 5L. 5s. The Names of the Subscribers will be printed at the Beginning of the Work.

N.B. The Plates being all finished and the whole Work in the Press, it will be published as soon as 150 Subscribers have in their Names; which will, together with their subscriptions, be received by the following Booksellers, viz. Mr Dodsley, in Pall mall; Mr Nourse, in the Strand; Mr Owen, at Temple Bar; Mr Newberry, in St Paul's Churchyard; and by all other Booksellers in Great Britain and Ireland. Subscriptions are likewise received by Mr Stubbs at his House in Somerset Street, opposite North Audley Street, Oxford Road.

This Work being the Result of many Years actual Dissections, in which the utmost accuracy has been observed, the Author hopes, that the more expert Anatomists will find it a useful Book as a Guide in comparative Anatomy; and all Gentlemen who keep Horses, will by it, be enabled not only to judge of the Structure of the Horse more scientifically, but also to point out the Seat of Diseases, or Blemishes, in that noble Animal, so as frequently to facilitate their Removal, by giving proper Instructions to the more illiterate Practitioners of the Veterinarian art into whose Hands they may accidentally fall.

RECeived the Day of1765 Of
2L. 2s. being Half the Subscription Money for one BOOK of the Anatomy of the Horse. *Geo. Stubbs.*

The date of publication was to be Saturday, 1st March 1766, and the book was printed by J. Purser for the Author. In it Stubbs refers to himself as 'George Stubbs, Painter', which he also did in the advertisements. This was extremely useful publicity for him as a painter, but it did tend to make people think of him as primarily a painter of horses. The commissions that followed the fame that the book brought him, were mainly for horses, portraits of horses, compositions of horses, and scenes where horses feature largely. These must have given him considerable satisfaction at the time, when his name was not so widely known, but later on this limiting of his subject-matter became a very sore point, as society placed the animal-painter at the very bottom of the scale and far below the 'face-painter' and history-painter. Certainly by the 1780s he was anxious to make a name for himself in this type of work.

Stubbs says in the introduction to the *Anatomy*:
'When I first resolved to apply myself to the present work, I was flattered with the idea that it might prove particularly useful to those of my own profession; and to those whose care and skill the horse is usually entrusted, whenever medicine or surgery becomes necessary to him; I thought it might be a desirable addition to what is usually collected for the study of Comparative Anatomy, and by no means unacceptable to those gentlemen who delight in horses and who either breed or keep any considerable number of them.

'The Painter, Sculptor, and Designer know what assistance is to be gained from hitherto published on this subject; and as they must be supposed best able to judge, how fitly the present work is accommodated to their purpose, and address to them is super-fluous.

'As for Farriers and Horse Doctors, the Veterinarian School lately established in France shews of what importance their pro-fession is held in that country; amongst us they have frequent opportunities in dissecting, and many of them have considerable skill in anatomy: but it were to be wished that this as well as other

parts of medical science, were as well attended to by them, as by those gentlemen who treat the diseases and wounds of the human body. If what I have done may in any sort facilitate or promote so necessary a study amongst them, I shall think my labour well bestowed.

'I will add, that I make no doubt, but Gentlemen who breed horses will find advantage, as well as amusement, by acquiring an accurate knowledge of the structure of this beautiful and useful animal. But what I should principally observe to the Reader concerning this my performance, is, that all the figures in it are drawn from nature, for which purpose I dissected a great number of horses; and that, at the same time, I consulted most of the treatises of reputation on the general subject of anatomy. It is likewise necessary to acquaint him, that the proportions which I have mentioned in several places of the book, are estimated from the length of the head, as is usually done by those who have treated on the proportion of the human figures; this length is taken from the top of the head to the ends of the cutting teeth, and is divided into four equal parts, each of which is again divided into twelve minutes.'

The book was an immediate success. It was a work of great interest to the scientifically minded and a pioneer work in its own field. The advance on its predecessors was so enormous that it aroused genuine appreciation from the greatest scientists and anatomists in Europe as well as in England. The 'Gentlemen who keep horses' were such a very inclusive category in the eighteenth century, when the horse was train, plane, and car to all, and both privately and commercially the prime means of transport on the roads. For this reason the book had a very wide appeal.

Ruini's work had remained the basic authority on equine anatomy for the better part of two hundred years, but the Anatomy of the Horse was to take over from it—and has yet to be surpassed, aesthetically, at any rate.

The engravings have a life-like, yet sculptural quality, without following the direct footsteps of Vesalius and Albinus, who show the figure in dramatic attitudes, as actors on a stage. Even to the point of trailing their dissected muscles like discarded clothes that have become too warm, as in Vesalius. The anatomized figures were set in exotic backgrounds of ruins and tropical forests containing strange beasts, such as rhinoceroses. Stubbs's simplicity of design is striking and powerful in contrast to these grandiose compositions. The design of the horse on the page is beautifully arranged and considered in relation to the available space. It has a monumental quality, and a solidity of form which is aesthetically satisfying, and has an authoritative accuracy. It also represents an enlargement of knowledge that was outstanding.

This letter from Camper makes it quite clear just how outstanding this anatomical research was

'Sir—If ever I was surprised to see a performance, I was it surely, when I saw yours on the 'Anatomy of the Horse'! The myology, neurology and angiology of men have not been carried to such perfection in two great ages, as these horses by you. How is it possible a single man can execute such a plan with so much accuracy and industry? You have certainly had before you the scheme of the great Albinus, but even his plates have not that delicacy an fulness, nor the expression of yours. Give me leave to ask you, was you the engraver? for you do not mention the engravers name. I once had a plan to offer to the public, a subscription for the like; but I am sure I could not have obtained the elegancy and exactness of yours. I dissected many horses; but I especially examined the head, and all the different sections of the inside, the bowels and so on. I made figures as large as life. I dare venture to say they are beautiful, mostly done by different means

upon life itself. My intention was to reduce them to one-eighth, and to have them engraved, but after having seen and admired yours, I dropped all hopes of succeeding. This favour I hope you'll grant me, to tell me whether or not you still go on to finish this beautiful undertaking, and whether or not we may flatter ourselves to see the internal parts of this useful creature, and something about the disorders, and internal diseases of the horse.

You will be curious to be acquainted with a Dutchman who admires with so much ecstasy your Tables. I am public professor of Medicine, Anat. and Surgery at Groningen; and I have published some figures of the human arm, pelvis, etc. I am actually publishing the Brain and the Organs of Hearing, Smelling, etc. in different animals. I dissect, but I do not love horses, though I keep them for proper use and for my family. I am sure my acquaintance can be of little use to you, but yours to me of great consequence. I desire to have two copies of your performance, one for me, and one for a gentleman who admires as well as I do your book. I do not know whether your bookseller has any correspondence with us, if so he may send them to any in Holland, and they will be sent to me, and which was perhaps more easy. Direct them to Mr Fagel junr. Greffier de leurs H(autes) Puissances les Etats généreaux, à la Haye; and our ambassador will send them to the Hague. I'll get you payed by my banker in London, Mr Andrew Grote & Co. Nothing shall be easier than to establish a correspondence with little or no expense on both sides between us.

I am, with the greatest veneration, Sir,
Your most obediant and most humble servant,
Petrus Camper, F.R.S.
Member of the R. Acad. of Surgery of Paris, of Edinburgh, and
of the Societies of Haarlem and Rotterdam.
At Groningen, 28th July, 1771.

This letter, from such an extremely eminent man in the field of anatomical research, must have given Stubbs a great deal of satisfaction. A year later Camper wrote to him again:

'The Duke of Wolfenbottle, the Baron du Sour, and I are the only owners of your elegant performance in these provinces, though it is much wondered at by others. I am amazed to meet in the same person so great an anatomist, so accurate a painter and so excellent an engraver. It is a pity you do not like to pursue the viscera of this useful animal . . . 27th July 1772.'

These letters came some time after the publication date; earlier the *Medical Review* of 1767 said of *The Anatomy of the Horse:*

'This work not only reflects great honour on the author, but on the country in which it was produced. France may reap great credit from the vetrinarian school lately established in that country; but what praise is not due to a private person, who, at his own expense, and with the incredible labour and application of years, began, continued, and completed the admirable work before us? But it is impossible to give our readers an adequate idea of Mr Stubbs' performance without placing the book itself before their eyes. All we can therefore add concerning it is, that the author himself dissected a great number of horses for the sake of attaining that certainty and accuracy for which his engravings will ever (if we are not greatly mistaken) be highly valued by the curious in comparative anatomy. His original drawings were all his own, and the plates were likewise engraved by his own hand. In short, we are at a loss whether most to admire the artist as a dissector or as a painter of animals. Of his excellence in the last-mentioned capacity, few of our readers who have any pretensions to connoisseurship can be supposed ignorant; especially as some of his admirable pieces have appeared at the public exhibitions. His picture of the "Lion and Horse" and "Lion and Stag" in particular, were deservedly applauded by the

best judges; nor were his Brood Mares' less excellent, though in a very different style of painting yet we think we have seen some of his animal portraits, both of wild and tame subjects, that are, if possible, superior to those above mentioned.'

The effect of this large folio of engravings on painters cannot be underestimated. It changed the outlook of British sporting art as regards horses, Sawrey Gilpin, Ben Marshall, and James Ward all owed a great debt to Stubbs. Sir Thomas Lawrence owned two copies of the book, and Gainsborough certainly had a copy, as they appear in the sales of their effects. Painters and sculptors have blessed the distilled knowledge that is so easily obtained by flipping through the pages or by making slow and serious notes and studies. Sir Alfred Munnings, who was a great admirer of Stubbs, always maintained that the finding of a copy of *The Anatomy of the Horse* was a landmark in his career. It was while he was still a student in Norwich that a second-hand bookseller managed to get hold of an original folio edition for him. It cost him 50*s*. and he described it as 'The most unique thing of its kind ever compiled. This heroic effort, an epic of the eighteenth century, is as great and unselfish a work as anything could be.'

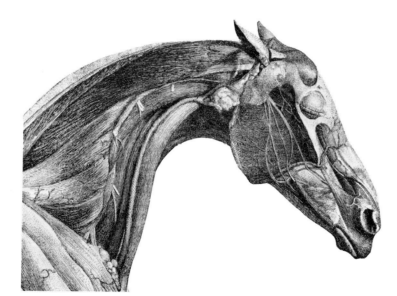

29

Five · London - Goodwood - Eaton Hall

Though *The Anatomy of the Horse* took about eight years of sustained effort, from the period at Horkstow to the publication date, Stubbs, once he had completed the drawings for the plates, left Lincolnshire and returned to Liverpool some time in the summer of 1759. His little daughter, Mary, died in Liverpool and was buried at St Peter's Church on September 18th. She was presumably Mary Spencer's child, as was his son, George Townley Stubbs, who was born in 1756. From Liverpool, he moved to London, where he remained till his death over forty years later. One of the main reasons for his move to London was to find an engraver for the book, but it was also to establish himself in town and to widen his circle of patrons. A little later on it was the vast influence of the book which gave him fame and publicity, and tended to limit his commissions to portraits of horses and equestrian subjects. But at this time relatively early in his career one of the major factors in getting him work with such noble patrons as the Duke of Richmond, Lord Grosvenor, and the Marquis of Rockingham was probably his connection with Domenico Angelo.

Angelo, who was born in Leghorn in 1716, was much sought after by noblemen who wished to improve their fencing and horsemanship. He had studied riding in Paris and became a notable horseman, as well as acquiring a great reputation as a fencing master. He migrated to England in the 1750s and opened an establishment in Soho, which rapidly became fashionable. In 1763 he published a book, *L'Ecole d'Armes*. His Riding-School was quite a meeting-place for painters who wanted to draw horses, as well as for gentlemen who wanted to improve their seats and the schooling of their horses. Benjamin West made studies at the school, among others. It was soon after Stubbs arrived in London that he began to visit the *manège*, but whether it was originally to polish up the fencing that he had learnt in York or to give him a more elegant seat on a horse is not certain, but what is certain is that he would be sure to take the opportunity to study from nature. He soon became friendly with Angelo, and drew and painted his horses—he also painted Mrs Angelo. Domenico's son Henry, who was also a fencing master and who eventually took on the school, becoming its head, published his very voluminous *Reminiscences* in 1830. In it he said that it was through his father's recommendation that Stubbs received most of his early commissions. Or rather, his first commissions after arriving in London, for he was now over thirty and had been painting for a living for nearly fifteen years. These commissions came from many of the noblemen and gentlemen of rank who patronised the *manège*, and knew Angelo.

Humphry, who does not mention Angelo, says that Stubbs's first important commission after he arrived in London was given to him by Sir Joshua Reynolds. The great man wanted a painting of a Warhorse, but Stubbs ended up by keeping the canvas, and it appears again in the sale catalogue of his effects in 1807, when

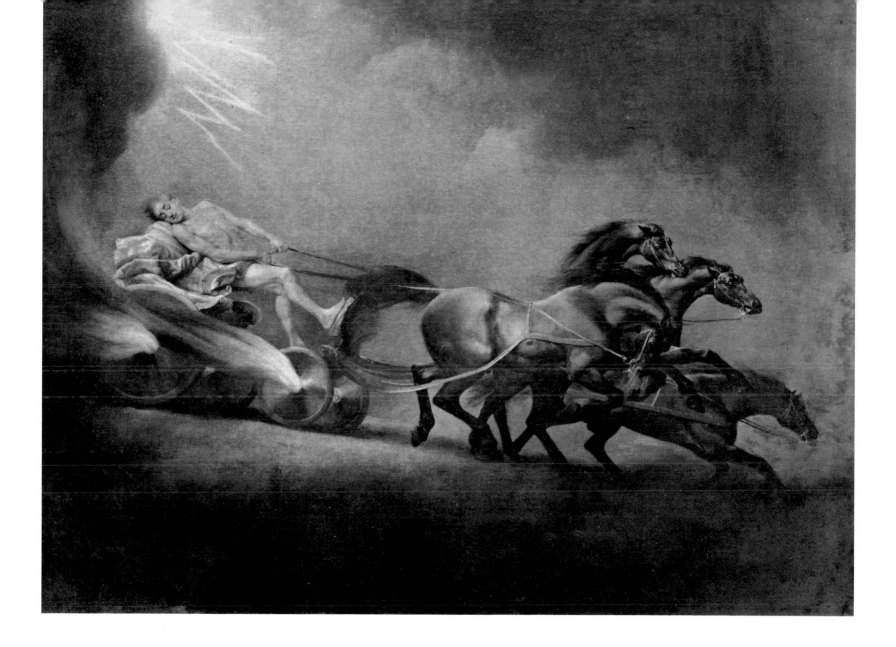

The Fall of Phaeton. *48in × 38½in. The National Trust (Saltram House Collection, Plympton)*.

it is described as 'Portrait of a Manèged Horse'. Perhaps it was painted at Angelo's, as in the same sale catalogue No. 14 on the first day was '9 studies of Horses in the managed action' and where would be a better place to see horses being schooled. Stubbs later painted a picture as 'a speculation', the subject being 'The Fall of Phaeton'.[1] This painting impressed Sir Joshua so much that he asked Stubbs if he might exchange the Warhorse for it. The Phaeton was exhibited at the Society of Artists in 1762, and Sir Joshua may have seen it there, as he was also exhibiting work in the same exhibition. There was more than one version of the subject. This one, with a team of roan horses galloping from the sun, was said to be drawn from coach horses belonging to Lord Grosvenor, and a later version, which was exhibited in 1764, was painted for Colonel Thornton, from his own team of greys, and is still at Saltram. In an article in *Fraser's Magazine*, February 1852, the journalist Cyrus Redding writes: '. . . We met Lord Boringdon (afterwards Earl of Morley) who invited Turner, Demaria and myself to Saltram, to dine and sleep, the following day . . . Zuccarelli's best paintings adorn the hospitable mansion, but I could not extract from Turner any opinion regarding them. In the billiard room was the Stubbs fine picture of "Phaeton and the horses of the sun", with which I remember the artist was much pleased, as, indeed, everybody must be; but elicited no further remark than the monosyllable "fine".' The King of Sweden's court sculptor, Serial, saw the painting on his way back from Rome and said that the drawing of the horses was equal to the finest antique sculptures, particularly in their life and expression. There is also a plaque, modelled for Wedgwood many years later, and a version painted in enamel, that was exhibited at the British Institution in 1806.

In the painting, Phaeton leans back on the reins, with his foot braced against the front of the fiery sun-chariot, trying to control the four horses of the sun, who plunge forwards down a slope of rather solid cloud. The arrangement of the horses is interesting and beautifully drawn and designed, yet the whole is curiously disappointing. There is a lack of dramatic impact and imaginative inventiveness. However, it was much admired by the artists of his time and enhanced Stubbs's reputation, particularly as it had impressed the great Sir Joshua sufficiently to acquire it for himself.

About 1760 he was given a good deal of work by the Duke of Richmond. This entailed going down to Goodwood to paint, and he stayed there and worked for nine months or so. Not only was he painting hard, doing large and major works, but he was also carrying on with the preparation of the plates for *The Anatomy of the Horse*. He also worked 'late into the night' on his book, for there was the text to be considered and written. He seemed to thrive on too much work. The series of three paintings that he was executing at Goodwood were large, complex, and ambitious. One of these of a shooting party, shows Lord Albemarle and Lord Holland—in a blue coat—out shooting with their dogs. They were cousins and brother-in-law to the third Duke of Richmond. Two of the servants in the picture are wearing the yellow and scarlet livery of the Dukes of Richmond. In the left-hand corner a negro servant holds an Arab with four white stockings. There is a pleasant blending of the landscape with the figures, and the composition already shows the careful working out of the design that distinguishes so much of Stubbs's work.

Even more attractive is the painting of the third Duke, with the Duchess and Lady Louisa Lennox watching his horses exercising.[2] This is one of Stubbs's finest works. The composition is beautifully designed, with a simple landscape, showing Chichester in the misty distance. The Duke and Duchess are centrally placed, watching a string of three race-horses in training. Their

[1] Illus. p. 31.

[2] Illus. p. 34–5.

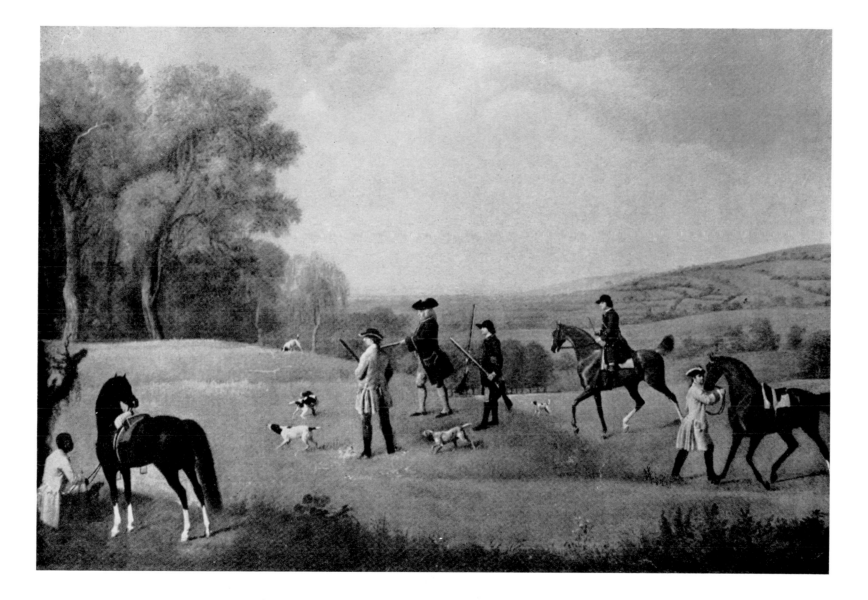

Shooting. *54in × 80in. By kind permission of The Trustees of the Goodwood Collection.*

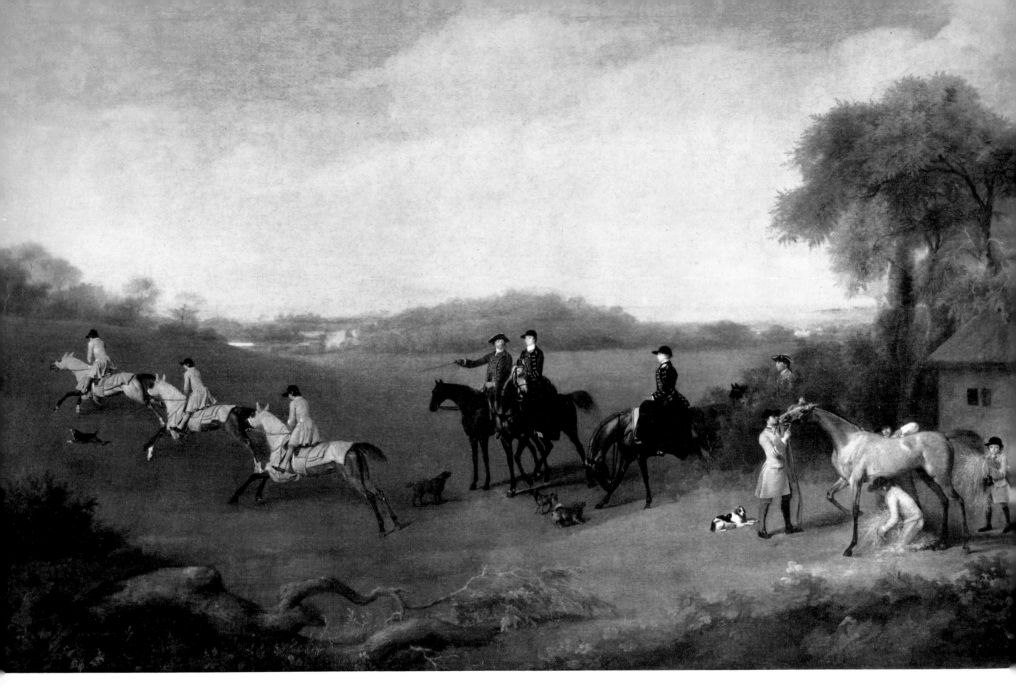

34

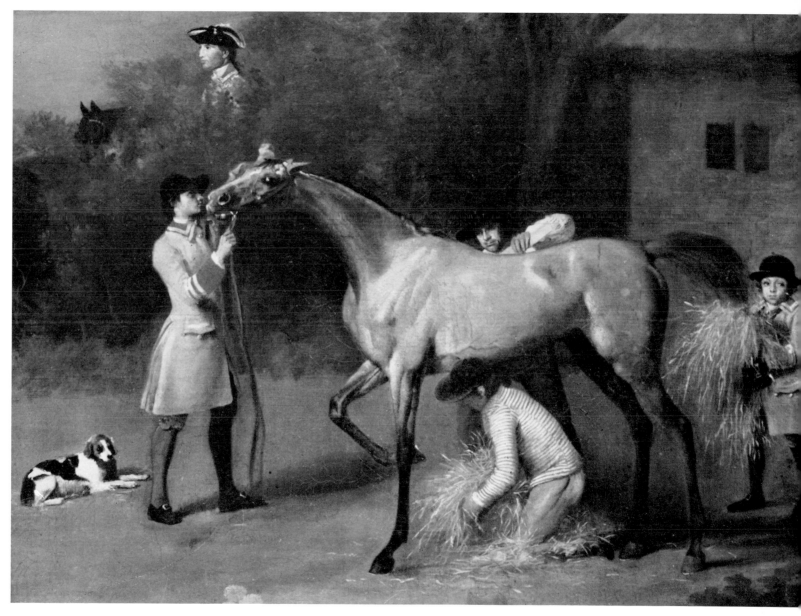

Exercising.
50¼in × 80¾in.
By kind permission of
The Trustees of
the Goodwood Collection.

Detail from
Exercising (opposite).

35

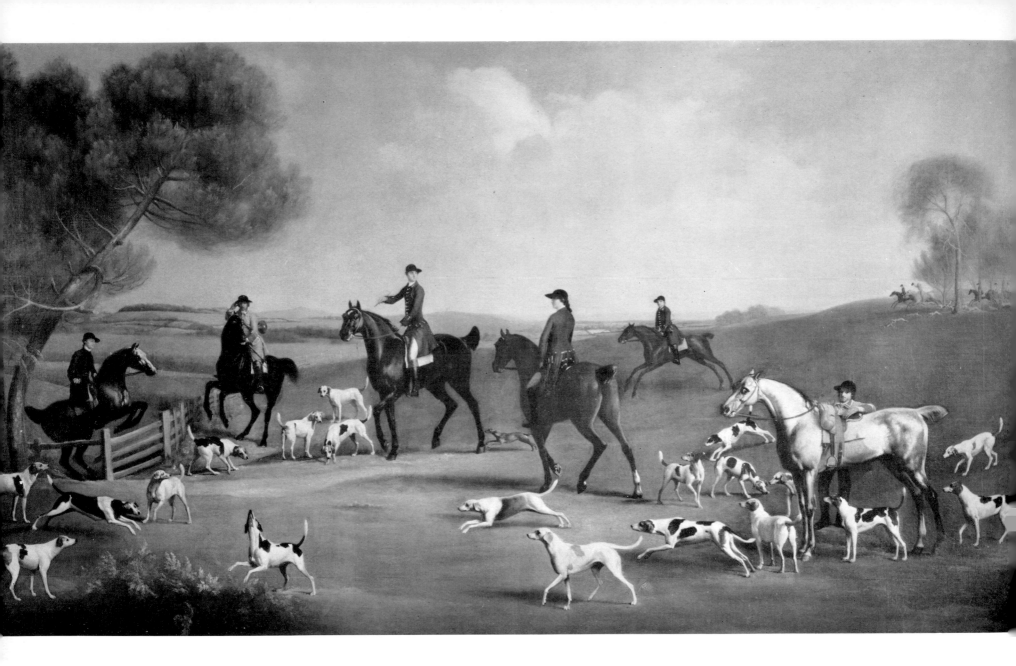

Hunting. *55in × 97in. The Trustees of the Goodwood Collection.*

36

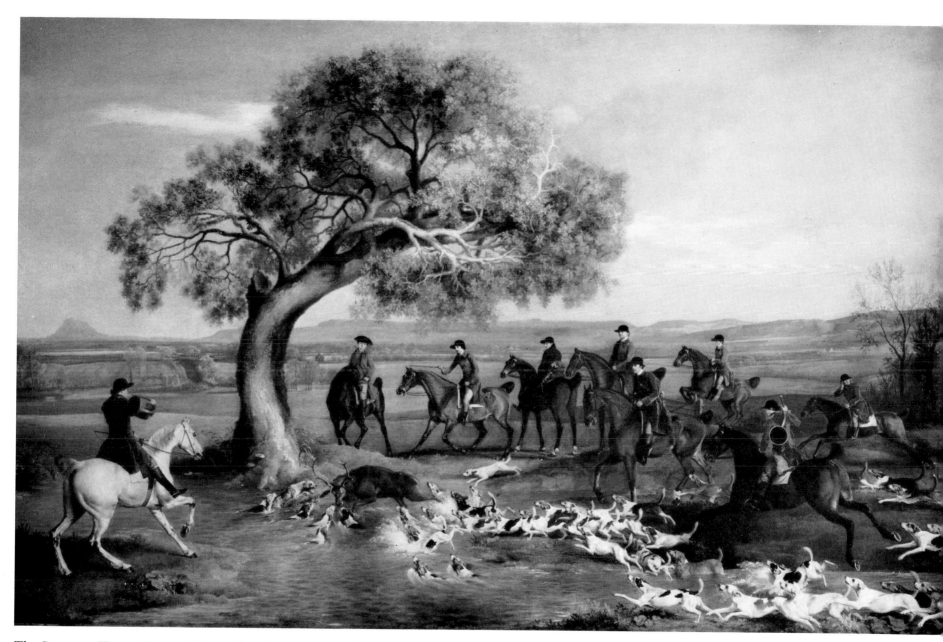

The Grosvenor Hunt at Eaton. *59in* × *95in. The Trustees of the Grosvenor Estate.*

yellow and scarlet rugs and the lads' livery make them the focal point of the picture and the diagonal line of repeating figures diminishing and receding uphill, give a sense of pace and perspective to the rather formalized movements of the horses. On the opposite side of the painting is a splendid group of a long-legged iron grey, who, having been exercised, is being wisped, attended by four grooms. It is freely and beautifully painted with Stubbs's facility for expressing the exact pose of a tired and fidgety horse. The head, with its extended nostrils and laid-back ears, grouped with the groom's head and hands, is a lovely piece of observation and design. The legs are specially long from the knees and hocks to the fetlocks, with very long cannon bones. This is noticeable in many of Stubbs's earlier paintings, when the proportions are a little uncertain. Compare this with the picture of Gimcrack, painted about five or six years later. It is not surprising that the throats and necks are so swan-like in portraits of race-horses of the period, when one looks at the amount of hoods and rugs that they were exercised in. The sweating must have caused a fining away of all excess flesh. Behind this group occurs an amusing portrait of a groom, practically hidden behind the hedge, with only his head and the ears of his horse showing. He is vital to the design, helping to balance the very strong diagonal of the race-horses, which is echoed by a secondary parallel diagonal of the Duke's group and the grey.

The third painting in the series is the Meet of the Charlton Hunt.[1] At the beginning of the eighteenth century, Charlton was a village near Goodwood, and was famous as hunting country. The Duke of Monmouth and Lord Grey of Uppark hunted here, later the pack was taken over by the Duke of Bolton and finally the second Duke of Richmond took over the kennels and by an arrangement in 1727 with Lord Tankerville it was agreed that a pack of not less than forty couples should be maintained by them jointly. The third Duke succeeded to the title in 1750. He had less time to devote to the Hunt than his father, and its fame became somewhat dimmed. When the new kennels were built at Goodwood the name was changed to the Goodwood Hunt. The 'Charlton Meet' is, like the other two paintings, a large canvas. They are all rather more than 4 feet by 7 feet, and quite an undertaking for Mr Stubbs. The Meet shows the Duke with Lord George Lennox and General Jones out hunting. Among the portraits in the painting was that of Lord Albemarle, whom Stubbs painted while he was eating his breakfast on the day before he embarked on his 'ever memorable and successful expedition to the Havannah'.

There are not many hunting pictures by Stubbs, which is rather curious, in the heyday of foxhunting, when so many of the sporting painters were being commissioned to paint this subject. Those that he did paint occurred early in his career, for a period of less than ten years, from 1759. It may have been that his intensely accurately observed portraits of horses were so far and away superior to the horses of any other painters of the period, and were so very much the horseman's horses, that all his commissions tended towards portraiture, once his skill became widely known. This hunting picture shows one of the few horses Stubbs painted actually jumping. There is a study of a jumping horse in the Mellon Collection, but it might equally well be a drawing of a Levade. There is another, smaller picture of a hunting scene with a jumping horse in the Goodwood Collection, and in each case the position of the horse is much the same, rather static, taking off almost under the fence, with the hocks very bent, and right under the body.

Another painting of this early period, that was probably done at Goodwood, was the portrait of the Countess of Coningsby. She is wearing the blue costume of the Charlton Hunt, with gold

[1] Illus. p. 36.

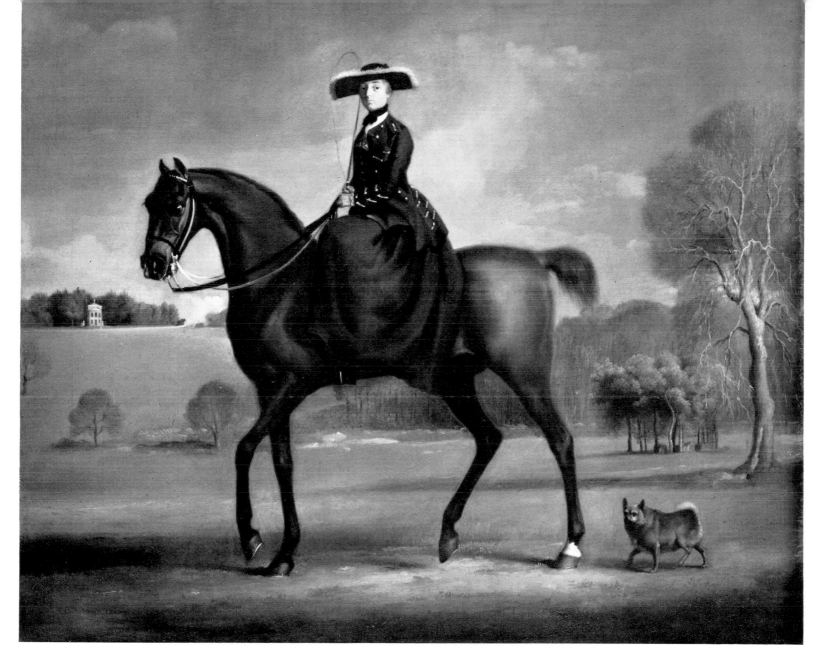

The Countess of Coningsby wearing the Charlton Hunt costume. *25in* × *29¼in. From the Collection of Mr and Mrs Paul Mellon.*

frogging, and a black hat fringed with ermine. She is riding a large and leggy chestnut, who has a very knowing eye, as has the Countess, their expressions are similar. In fact, there is something rather humorous about this painting. The very upright and stately lady is followed by a stout and pompous little dog; their self-importance is equal. He is quite delightful, and has been lovingly painted.

The picture is inscribed on the back: 'The Charlton Hunt was the private pack of the Duke of Richmond and the park is almost certainly that of Goodwood. Where Stubbs is recorded circa 1759 1760. The Countess died in June 1761, having succeeded her father, the first Earl of Coningsby, under the terms of a remarkable special remainder. However her titles became extinct on her death, as her only child died an infant, having been dropped by his nurse, who was frightened at the sight of an ape.'

Once Mr Stubbs had finished his work for the Duke of Richmond, he left Goodwood, where he had been installed for nearly nine months, and went up to Cheshire. He had previously undertaken to paint a number of pictures for the Earl of Grosvenor, so he went to stay at Eaton Hall to carry out the various commissions. His most important painting there was the big 'Grosvenor Hunt'.[1] This composition shows the stag brought down in the stream, at the foot of a great oak, the pack converging on their prey, making a diagonal pattern of light shapes against a darker background. The movements of each hound is observed and noted, yet without destroying the unified rhythm of the whole pack, the slanting line of pale figures draws the eye to the focal point. The Hunt has caught up with the pack and stands in a semicircle on the river bank, making a curving line of spectators, opposing the strong curves of the wind-blown tree. The whole design is held by the single huntsman, mounted on a grey, and blowing his horn, in the foreground on the near side bank. The scene is set in a wide landscape, with Beeston Rock on the sky-line, away in the distance. This view can be seen from the drawing-room windows at Eaton Hall. In the painting there are portraits of Lord Grosvenor, on his favourite hunter, Honest John, and of his brother, Thomas Grosvenor, with Sir Roger Mostyn and Mr Bell Lloyd, and the appropriate Hunt servants. According to the notes added to the Humphry MSS. the painting, when finished, hung for a time in Stubbs's show-room or studio. An old hunter, who was having his portrait painted, and who was in the habit of dozing off, used to 'whenever he was roused from his dozing, and looked towards this Hunting piece, began to Neigh and seemed very pleasantly agitated'.

The painting measures 8 feet by 5 feet, quite a large canvas and with a magnificent design, giving such an impression of space and size that Sir Alfred Munnings described it as 'fifteen feet long and almost as high'.

Among other paintings Stubbs did for Lord Grosvenor was one of his 'Mares and Foals' and a portrait of his horse Bandy, so called because of his crooked leg. This painting was exhibited at the Society of Artists Exhibition in 1763.

[1] Illus. p. 37.

Six · Society of Artists

Stubbs had shown work in the exhibitions of the Society of Artists from 1761—practically from their foundation.

Art exhibitions were a completely new venture for painters and sculptors at that time in the middle of the eighteenth century. The idea of taking a large room for the sole purpose of hanging pictures and showing the result to the public had come about in a curious way some years previously. The Foundling Hospital had built new premises in Bloomsbury, and, finding the great dining-hall looked rather bleak and bare, Captain Coram, the founder, got his friend, the painter Hogarth, and other artist acquaintances to contribute some of their works to decorate the great hall. These were so much admired by the public, who used to be admitted to inspect the orphanage, that it became a popular Sunday outing to go and see the pictures and be charitable to the little orphans. Looking at pictures and sculpture was an occupation not often indulged in by ordinary people, as the only way to see such things was either by going to an auction or sale room or by somehow getting into one of the great houses which had a collection of works of art. This was often only achieved by bribing the servants when the family were away.

It was obvious to the artists concerned that here was a novel way of enhancing their reputation and showing their work to the public. At a meeting in 1759 it was resolved to hold an 'Exhibition' of contemporary work in the following April. This was held in a large room in the Strand, belonging to the recently formed (Royal) Society of Arts, for the encouragement of arts, manufactures, and commerce. The exhibition was a great success, and over 6,000 catalogues were sold at 6d. each during the fortnight the exhibition was open. In 1761, when Stubbs first exhibited, the exhibition had moved to Spring Gardens, Charing Cross, and had increased in size from 130 exhibits to 229 and was now known as 'The Society of Artists of Great Britain'. The original collection of artists had split in to two groups and the slightly smaller group became the 'Free Society'.

Stubbs was represented by one painting, 'A Stallion called Romulus', and in 1762 he showed 'Phaeton', 'A brood of mares', 'A Portrait of a horse, call'd Tristram Shandy', and 'Its Companion, Molly Long Legs'. By 1765, the Society of Artists became, by Royal Charter, 'The Incorporated Society of Artists of Great Britain'. It now had a list of over two hundred members, the President being George Lambert, Francis Hayman was Vice-President, Richard Dalton was Treasurer, and Francis Milner Newton was the Secretary. There were also twenty Directors.

On 12th November 1764 Mr Stubbs was a steward at one of the Society's Dinners. His fellow steward was Mr Ed. Rooker. Eighty-eight members and exhibitors sat down to the table. It cost them 3s. for the actual dinner, plus a wine ticket, for which they were charged 2s. each. They dined off 'Codshead, Stewed Carp and Whiting, Turkey Rost, Toung, Fowles, Wild Ducks & Ham, and Blomanges and Minced Peys. They spent 11/2 on sugar

and lemons, 2/1 on Tobacco and £1.0.1 on 54 Potts of Strong Beer'. The final entry on the bill—'10 glasses were broak = 5/-.' Perhaps it was a jolly evening.

On 2nd February 1765, Stubbs was elected a Fellow of the Society of Artists. His name appears above those of Reynolds, Benjamin West, and Gainsborough, who were also elected at the same meeting; in fact, in the first rough Minutes, he is at the very top of the list of newly elected Fellows. Five days later, on 7th February, a vacancy occurred for a Director, through the death of Mr Lambert. 'The following gentlemen being proposed Viz. Messrs Stubbs, West, Catton, Richards, Zoffany A Ballot being taken, Mr Stubbs was declared elected. . . . Ordered that Mr Stubbs be acquainted that he is elected one of the Directors of this Society.'

Mr Stubbs attended three Directors Meetings in 1765, on 19th February, 18th June and 24th December, and also in the following two years he attended three meetings a year. He exhibited three or four paintings at each of the exhibitions, mainly horses and wild animals.

By 1768 trouble was brewing among the Fellows, because the same Directors remained in office without either retirement or re-election. The Fellows wanted a certain proportion made ineligible for election for a year. There was also considerable disapproval over the general management of the Society and the Exhibitions. Finally there was a fuss about tickets of admission for a special exhibition held, for two days only, in October, in honour of the King of Denmark. This relatively small matter seems to have helped to bring about the resignation of a number of the more distinguished Directors. However, at the same time as this was happening plans were being formed to set up in opposition.

William Chambers, the architect, who had been the Incor-porated Society's Treasurer for about eight months since Richard Dalton's resignation, was working on an idea of founding a 'Royal Academy'. He was in a good position to bring the plan before the King, as he had been tutor in architecture to George III and was Architect of the Works, so he was able to get an audience without too much difficulty. He was helped by Benjamin West, who was at that time working for the King, and so was also able to talk fairly privately and informally to him. They explained the troubled situation in the Society of Artists, and put forward their idea of 'A committee of dissenting artists, to draw up a plan for an Academy'. The King approved of their idea and, on 28th November 1768, a Memorial signed by twenty-two artists, most of whom had exhibited with the Incorporated Society, was laid before him. This stated that the principal objects were the establishment of a 'well-regulated School or Academy of Design, for the use of students in the Arts, and an Annual Exhibition, open to all artists of distinguished merit. . . .' They also hoped 'to distribute somewhat in useful charities'. The Memorial also asked for the King's patronage and protection.

Chambers had only resigned as Treasurer of the Incorporated Society on 18th November just ten days before the King gave his sanction to the rival institution, and so it seems as though the idea could hardly have developed in so short a time. With the royal approval of the Instrument of Foundation on 10th December, the Royal Academy, under Royal patronage, was now an attractive alternative to the Incorporated Society. As it was laid down that members of the new Royal Academy might not be members of any other society, there were a large number of resignations from the Incorporated Society. On 18th November Wilton, West, Moser, Sandby, Wilson, and Newton had all resigned as Directors, in company with Chambers. This was a big blow to the Society, as it removed their most influential men,

almost completely. The meeting immediately proceeded to elect six painters in their place, among them was Reynolds, who declined the honour in a letter dated 25th November, and Gainsborough, who did not send his refusal till 5th December, five days before he became a founder member of the Royal Academy. At the same meeting Mr Stubbs, whose Directorship had apparently lapsed some time the previous year, for he last attended a Director's Meeting on 28th August 1767, was re-elected a Director. At the following meeting, on 29th November, ten days after his re-election, he was elected Treasurer, in place of Mr Chambers.

Humphry says that Stubbs was Treasurer for eight years, but this is not correct. He was actually Treasurer from November 1768 to September 1772, nearly four years. He was a Fellow and Director for about nine years, from 1765 to 1774, which is probably what Humphry meant, that he was intimately connected with the Society's administration for a period of eight years.

On 17th January, 'A letter of Attorney from the Society empowering George Stubbs Esq. to accept transfers and receive dividends on any part of their £3,080 Annuities, and also to transfer the sum of £80 part of their said Annuities, being read, was sealed with the Common Seal of the Society.' The business of the Treasurer of the Society of Artists was clearly stated in the minutes of March 1766: 'The Treasurer shall attend at the Exhibition Room every evening during the time of the Exhibition (or someone of the Directors by his appointment in writing) to check the Accounts, receive the Money collected that day and give the Secretary a proper discharge for the same and at the end of the Exhibition or sooner if required, the Treas. shall attend the Directors to account for such Monies as may be in his Hands and dispose of the same as the Directors shall order. He shall keep a cash account of all receipts and payments fairly stated.' Mr Stubbs's 'cash account of all receipts and payments' is neatly written up in a little book in the Society's archives in the Royal Academy Library. The first entry being 'To balance of last years Cash Account reced. from Wm. Chambers, late Treas. $6/5\frac{1}{4}d$'. He also received £46 4s. half-year's interest on the Society's £3,080. Each day of the Exhibition is entered up with the number of tickets sold and the money taken, for example the highest number was on the fourth day of the exhibition of 1769, when 970 tickets were taken and £48 10s. was taken in cash. This exhibition opened on 1st May; it had been preceded by the first exhibition of the Royal Academy, which opened on 25th April. Whereas the new Academy showed 136 exhibits, the Society of Artists had 365 on view, among which were such curiosities as 'An Old Man's head done with a hot Iron'—poker-work, perhaps?—a 'Vase of Flowers in Shell-work' and a number of needlework pictures, as well as a portrait of a lady, 'composed of human hair'. This lack of selection on the part of the Society of Artists was helpful to the Royal Academy, who excluded such oddities.

Mr Stubbs had six paintings in the exhibition that year, 'A tyger', 'A lyon devouring a stag', 'A horse and mare', 'Two gentlemen shooting', 'A gentleman and a lady', and 'A cat'. The last item may perhaps have been Mr Stubbs's pet white Persian cat, the one mentioned in his sale list, as being a particular favourite of his.

It is obvious that he did a tremendous amount of work for the Society during the next few years. He attended the Directors' Meetings very frequently in a most businesslike way. He seems to have been involved with the business and administration of the Society, because on 7th March he was chosen with Paine, Cosway, and Richard Wright—his friend from the early days in Liver-

pool—to 'attend the arrangements of the pictures for the Exhibition'. In other words, they were the hanging committee for that year. It was this exhibition that Their Majesties attended on 11th May, and were received by the President, Mr Kirby, the Vice-President, the Secretary, and the Treasurer, Mr Stubbs. The exhibition was closed that day as the King 'had desired only the officers'. So Mr Kirby wrote to Mr Paine (the Secretary): 'Please give notice to those gentlemen that they may be ready to receive from their gracious and condescending King and Queen the highest degree of pleasure and encouragement.'

According to Walpole, the painting, catalogue number 78 in the exhibition, 'View of Ockham Mill in Surrey' by John Joshua Kirby, the 'figures by Mr Stubbs', was said to have been painted by the King himself. Did the King 'encourage' Mr Stubbs or vice versa?

Because the Royal Academy had based their whole Institution on their Schools, the Society of Artists decided to open their own Academy, or School in that year, too. They rented a former auction room in Maiden Lane, at £55 per annum. The Academy was to be open five evenings a week, at six o'clock, and was for the use of the Fellows and their pupils. Six members of the Society were elected to set the Models in the new Academy. Mr Stubbs appears first on the list, which also had the names of Ozias Humphry, Mortimer, J. Wright, Zoffany, and Pine. The artist who set the model, had to 'preside in the Academy during the sitting of his model and take care that due decorum be preserved'. As a recompense for his trouble, he was allowed the honour of the '1st choice of seat'—possibly the reason why Mr Stubbs took on the job, and the origin of the 'Academy figures' in his sale. The six members who undertook to look after the school also had to decide, from his drawings, whether a student applying for admittance to study at the school had sufficient

ability to profit from being allowed to work there. One of the first applications to be allowed to draw in the school was received from no lesser person than George Romney. Lectures were arranged, Dr Cursiter gave a series on the chemistry of paints, and John Hunter was approached to give anatomical lectures. Monsieur André also gave lectures on anatomy—which had to wait 'till the next public execution, so that a suitable subject for dissection could be obtained'. Stubbs must have been extremely interested in these lectures which he could almost have given himself. The duty of setting the models was an undertaking that apparently lasted for a year, because in the following October Mr Stubbs was not one of those elected.

However, on 18th June he was one of a committee of six Directors, including Robert Strange, who were elected to 'prepare the publication resolved on by the Society'. This was the pamphlet called 'The Conduct of the Royal Academicians' which was published in 1771. Stubbs's connection with this publication could hardly have endeared him to the Royal Academy. The author was finally described as Sir Robert Strange. He was a painter and engraver, who exhibited at the Society of Artists quite frequently. In a letter to the Marquis of Bute he tells of a coloured drawing of his that the Society did not think suitable to accept, 'They all called out, "put it to the ballot"—Mr Moser and Mr Stubbs excepted. I had not the pleasure of knowing the last of the gentlemen but I could easily see from his benevolent behaviour, and the tête-a-tête coversation that he had with several of the Directors, that he was my friend.'

This benevolence and kindliness of Mr Stubbs's character is very evident in the oval self-portrait, painted in enamel on a Wedgwood plaque in 1781, which is now in the National Portrait Gallery. He looks out of the frame almost shyly, his hair neatly brushed into a grey curl on either side; he doesn't go in for a wig,

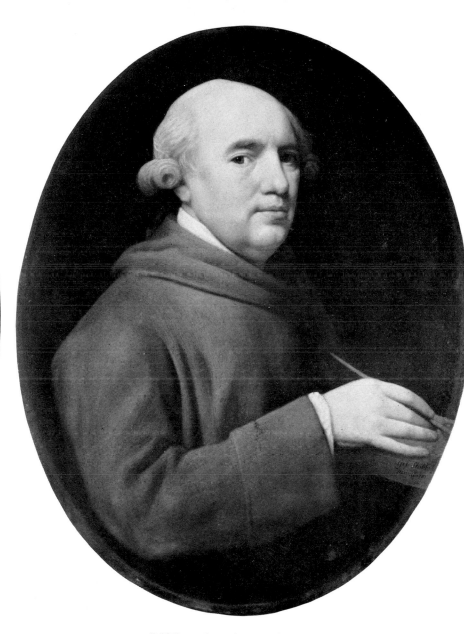

Self-Portrait on a White Hunter. *36in × 27½in.*
The Lady Lever Art Gallery, Port Sunlight.

Self Portrait. *27in × 20in.*
National Portrait Gallery, London.

45

and he is getting a very high forehead, in fact he is rather bald. He wears a brown painting smock, and his skin is pink and white and very luminous. His right hand, holding the paint-brush, is most delicate with slim fingers. Inscribed on the back is 'Geo. Stubbs painted by himself for his friend Richd. Thorold of Inner Temple. 1781'. It is signed on the front of the painting on the palette.

In the minutes of 28th September 1770 it was recorded 'Mr Stubbs reported that he had advanced to Mr Ralph, late ass. secretary of the Society, more money than was due to him, in order to support him in his illness'—also a benevolent gesture.

During Mr Stubbs's period of office as Treasurer, one matter must have given him a good deal of trouble, and extra work and worry. It had, for some years, been the intention of the Society of Artists to build themselves a gallery for their exhibitions and studios for their schools. In the exhibition catalogue of 1771 there was an announcement saying that this was to be the last exhibition held at Spring Gardens, as the Society had purchased 'a Plat of Land in a situation more convenient and central to the Inhabitants of this Great Metropolis, on which to erect an Academy, Exhibitions Room, etc.' The purchase of this land took all the Society's capital; they had about £3,000 invested, which when sold brought in barely enough to pay the £2,500 that the building site had cost them. This meant that the actual building had to be paid for on borrowed money. The building committee raised a loan of £5,000, and James Paine, the architect, who was also President of the Society of Artists, undertook the designing of the new Academy. The site had been intended for a theatre for Garrick, who was part owner of the 'plat', and it was situated where the Lyceum Theatre was eventually built. Paine, as well as designing the galleries, also supervised their construction and stood security for the loan. All the bills from the various tradespeople involved in the erection came in separately—plasterers and bricklayers and carpenters and many other craftsmen, who worked on the project. The receipts are still in existence in the Society's archives, including one from the carpenter responsible for the window frames, with the curiously familiar name 'Joshua Reynolds'.

The work progressed very well and the gallery was ready in time for the exhibition of 1772. It was considered a handsome building and a great improvement on the old auction room in Spring Gardens. It was much larger and had been designed as an exhibition room with proper lighting. The opening ceremony on 11th May was quite an occasion, with no expense spared. There was a concert given by an orchestra, with singers and—according to a bill—twelve violinists who received a guinea each. Stubbs showed eight paintings in the exhibition, and was the most notable painter exhibiting, Reynolds and Gainsborough having gone over to the R.A.

On 19th October, only a few months after the opening of the new gallery, Mr Stubbs was elected President of the Society, 'upon the discontent with Mr Paine had occasioned', and this, in a roundabout way, was one of the factors that contributed to the grave financial difficulties that beset the Society from then on. James Paine, the previous President, was a fairly wealthy man and had guaranteed the loan that the building committee had borrowed. Now that he was no longer President he withdrew his support, and this caused such serious monetary troubles that the Society, less than a year after the triumphant opening of their lovely new gallery, were obliged to let the premises to Mr Christie, the auctioneer, for £200 a year, and to mortgage the building as well. They were allowed to use it for their exhibitions, and through the profits of these they hoped eventually to pay off their debts.

It was a worrying period for the Society, as it must have been quite obvious that the Royal Academy was going from strength to strength and not only had royal patronage but also had support from nearly all the painters and sculptors of merit, and to make matters worse they had nearly all been previously connected with the Society of Artists, so their change of allegiance was hardly a good advertisement. Stubbs did all he could to help the exhibition of 1773 by exhibiting eleven paintings, including a portrait of 'the Kongouro from New Holland',[1] which was something of a curiosity in those days.

Mr Stubbs was president for exactly one year, and then on St Luke's Day 1773 he was succeeded by another painter of horses, Sawrey Gilpin, of whom it was said by Anthony Pasquin, 'Mr Gilpin is inferior to Mr Stubbs in anatomical knowledge, but superior to him in grace and genius'. However, he also said this of Stubbs: 'Perhaps it is not urging too much to aver that Mr Stubbs has done his nation honour, inasmuch as he has become, by his genius and his researches, the example of Europe, in his particular department.'

Mr Stubbs was again elected a Director, an office which he held for a year, but though he sent one picture to the exhibition of 1774, his interest in the Society had waned, and in the following year he, like so many other distinguished painters, began to exhibit at the Royal Academy. He had been closely involved with the Society for thirteen years and he had exhibited sixty-four paintings in their exhibitions. He had given up a great deal of his time to helping them, particularly in the last few years, when he was Treasurer and President. No wonder it was said that the 'Interruptions which these offices gave to his professional studies and domestic repose were always considered by him as a great evil, and produced in him a desire to withdraw from all academical associations'.

[1] Illus. p. 87.

Seven · The Somerset Street House

About 1763, Stubbs took a house in London and settled there permanently. This was 'No. 24 Somerset Street, opposite to North Audley Street, near the Oxford Road', as Oxford Street was called in the eighteenth century, when it was the main road out of town, on the way to Oxford. Somerset Street, which ran behind and parallel to Oxford Street, is no more; it was pulled down after the First World War to make way for extensions to a big London store—Selfridges. The approximate site of No. 24 is commemorated by two large bronze plaques on the walls of what is now the book department. The plaques were put up in the 1950s and are by the sculptor Frederick Mancini. The subject is a low relief of Hambletonian, after the life-sized painting of the horse by Stubbs.

London in the eighteenth century was spreading rapidly, particularly to the north and west. Many of the great landowners were developing their land as building sites, laying out streets round their own large houses, which not long before had been out of town and in open country. These estate developments usually carried the family names, such as, Grosvenor Square, Cavendish Street, and Portman Square, just round the corner from Somerset Street. Robert Adam was the architect for some of the houses there, which were built in the 1770s. Round about these palatial mansions, which were set round elegant gardens and squares, were streets of smaller houses in rows. Little Georgian houses, to house the middle classes—Horace Walpole described them as 'Middling houses, how snug they are'.

Mr Stubbs's house was evidently one of this type. It was a small comfortable house, with a studio built out in the garden at the back and reached through a door in the entrance hall. Beyond the studio was the coach house and stabling for four horses. Inside the house there was a front and a back parlour, or dining-room and sitting-room, with the kitchens and wine and coal cellers underneath, and above were the bedrooms. Sir Walter Gilbey says: 'The house was furnished in the substantial fashion the owner's character might us to expect'. There were ponderous four-poster beds, mahogany book-cases, chests and tables, Brussels and Wilton carpets, Wedgwood table service, and pictures on the walls. He owned a number of paintings, including canvases by such great men as Titian, Tintoretto, Georgione, and Van Dyck. One would imagine Mr Stubbs's tastes to veer towards strong, solid, and well-made furniture of plain and neat design, rather than the elaborate and ostentatious. He had his frames made very plainly, specially for exhibition purposes, so plain, in fact, that when he sent two of his works up to an exhibition in Liverpool he wrote to the organizer, Mr Daulby, and said that he feared that he would disapprove of their plainness.

The studio, or what he called his Exhibition Room, was large

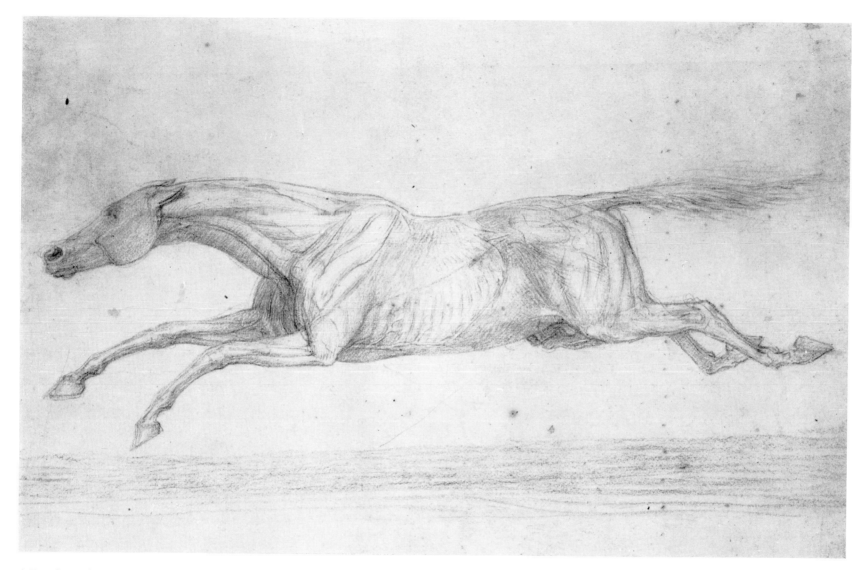

A Racehorse in Action. $6\frac{3}{4}in. \times 10\frac{1}{2}in.$
From the collection of Mr and Mrs Paul Mellon.

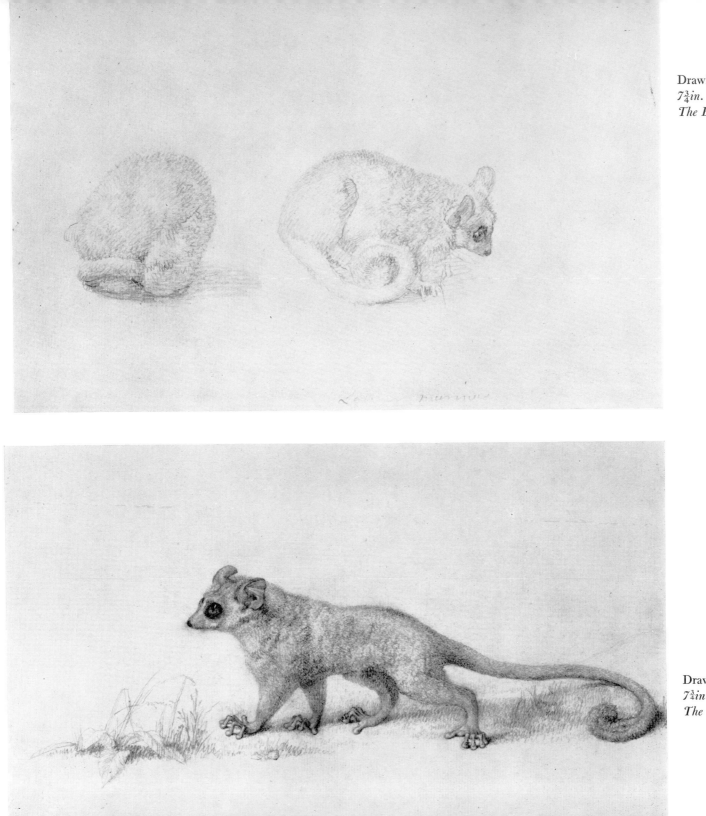

Drawing of two Lemurs.
$7\frac{3}{4}in. \times 10in.$
The British Museum, London.

Drawing of a Lemur.
$7\frac{3}{4}in \times 12\frac{1}{2}in.$
The British Museum, London.

and well lighted with a lantern skylight. The size of the studio was nearly 28 feet by 21 feet, big enough to have a horse inside as a model, and with plenty of room to complete the great life-sized paintings of Scrubb and Hambletonian, and the big hunting piece for Lord Grosvenor. He would have needed all the room he could get, for in addition to a large clear area of space for actual painting, he needed space for his experimental work, for his anatomical studies and subjects, and for his engraving equipment.

Stubbs was a neat, methodical man, any untidy, artistic temperament was severely disciplined by his strong will and obstinate determination to accomplish whatever task he had decided upon. His studio was the centre of so many different activities that it must have been crowded with work of various kinds. Portfolios of studies and sketches, and sketch-books literally by the dozen, and hundreds of drawings, as can be seen by the list of his effects that were sold after his death. Drawings of lions and tigers, monkeys, buffaloes, as well as great heaps of useful studies of less exotic subjects. It is a terrible loss that so few of these drawings have survived, or, if they have survived, that they have not yet come to light. So far, it appears that the anatomy studies have come off the best, probably because of their unique information. They may have been preserved for the value of their research rather than for their artistic merit, though this fact does not in any way detract from their undoubted aesthetic contribution to British Art. Their existance enhances Mr Stubbs's reputation as a great draughtsman.

Nearly 600 drawings were sold in 1807—ranging from Lot 22, which consisted of 200 landscapes, views and sketches, to studies of cats and dogs. The drawings for *The Comparative Anatomy* have reappeared, as have the twenty-four drawings at the Royal Academy. It seems possible that somewhere in an album of collected drawings, or in an old portfolio that has been put away and forgotten, there may be some unknown drawings which will one day be found. It would be a revelation to see his landscape drawings and the sketches of backgrounds used in his paintings, and his studies of trees, and of the plants that appear in the foregrounds of so many of his compositions. One can speculate on the drawing that must have been done for the lovely foxglove in the portrait of the hound, Ringwood, and for many of the wild flowers that are touched in so crisply and with such authoritative knowledge in his paintings. Anyone as devoted to nature as Stubbs was reveals in his drawings his whole approach to his work. So many of his compositions must have been built up from penetratingly accurate observations noted down, and to see these working studies would give a wonderful insight into his methods. There is nothing photographic, nothing illustrative and no 'copying from nature' in his work. Everything is drawn from knowledge acquired by investigation, by careful and deliberate weighing up of what he saw, and what he knew, about the forms in front of him. He never reproduces mere surface forms, but, like a sculptor, he re-creates the solid whole, with the basic, underlying forms affecting the superficial shapes. The tensions and stresses of ligament and muscle over bone are as structurally balanced and as beautifully articulated as a modern mobile. The interrelationship of the various parts in space are allied to architecture and sculpture in their approach.

Of the drawings that are known, apart from the two sets of anatomical studies—for the *Horse*, and for *The Comparative Anatomy*—only a dozen or so remain, distributed among museums and collectors. In the 1930s a small number of drawings came on the art market and were split up among private collections. The British Museum have two sheets of studies or drawings of Lemurs. These used to belong to Sir Joseph Banks and are in a volume of drawings of natural history that he collected. They are delight-

fully and most sympathetically drawn, in characteristic attitudes, but there is no trace of sentimentality in their portrayal. Stubbs was intrigued by the contrast of the furry bodies and the strange skinny feet, with their almost human fingers. The British Museum also have an odd drawing for *The Anatomy of the Horse*. There is a study of a horse in the Mellon Collection. It could be a drawing for one of the equestrian portraits, where the horse is doing a Levade, as in the great Whistlejacket painting, or a study for one of his horses jumping in a hunting scene, though it is a very static kind of jump. There are five interesting but very slight sketches in the Meyer papers at the Picton Library. Curiously enough, in the huge British Art Exhibition at the Royal Academy in 1934, Stubbs, who was quite well represented by his paintings, had one drawing exhibited. This was a study of a horse from the Nottingham Art Gallery, and is quite unlike Stubbs's work. It seems odd that the organizers never realized or remembered that there was a collection of really magnificent drawings actually in Burlington House. Also it seems strange that the Vasari Society should have bothered to reproduce this rather doubtful and very uncharacteristic drawing in their collection of beautifully produced prints.

Stubbs used quite a variety of media when drawing. As has been previously stated, he used pen and ink, pencil and chalk in his studies. He favoured pencil for his delicately finished studies, but for the more rapidly noted sketches he liked black and white chalk on a toned paper, usually grey or blue. He made his measured drawings in ink, some of them exceedingly finely and minutely executed. Occasionally he made drawings which had a strong line in dense indian ink and sometimes, for the finer ones, he used sepia ink. He used a strange almost golden ink for his diagrams and he also used sanguine chalk for certain drawings, and for some of the additions to his anatomical studies.

His line drawings and engravings are always crisp, precise, and most expressive. They have a simplicity of statement that never generalizes, nor do they become formal and stylized. The line, though hair fine, is never wiry, and is always rhythmic and living.

A wide variety of media was also used in portraits of Stubbs himself. The self-portrait, already referred to in the previous chapter, was painted in enamel on a Wedgwood plaque in 1782; the study for it is in ink and chalk and is in the Mellon Collection. Also on a plaque is the oval painting he did of himself on a white hunter.[1] In it he sits comfortably, well back, with his legs stuck forward with the heels down, and his hand in his pocket, not particularly elegant or smart, but very relaxed and happy. His horse is intelligent and alert looking, perhaps a little over at the knee on the off foreleg, but with a pretty little head. He used the same arrangement of horse and rider much earlier in the portrait of Sir William Evelyn, painted in 1770. This self-portrait was always thought to be a painting of Josiah Wedgwood, but because of its obvious likeness to other portraits of Stubbs has now been accepted as 'Lot 97' in the sale of his effects, 'Portrait of Mr Stubbs on a white hunter—a most excellent likeness of the great painter'. This painting, among others, was bought in by Isabella Saltonstall. She had been painted by Stubbs, in a family group, when she was a little girl. The Saltonstall Family was painted in 1769. He painted her again, on a Wedgwood panel in 1782, 'In the character of Una, from Spenser's *Faerie Queene*'. She reappears towards the end of Stubbs's life, as a friend and benefactor, and as co-executrix with Mary Spencer, in his will.

Of the other portraits of Stubbs, there is one attributed to Caddick, possibly of him as a young man; he is dark haired and dark eyed, with a large and rather sharp nose, not so full at the tip as Stubbs gave himself, but with a rounded jaw line and a suspicion of a double chin. Ozias Humphry painted him twice, a

[1] Illus. p. 45.

Portrait of George Stubbs by George Dance. *10in × 8in.*
Royal Academy of Arts, London.

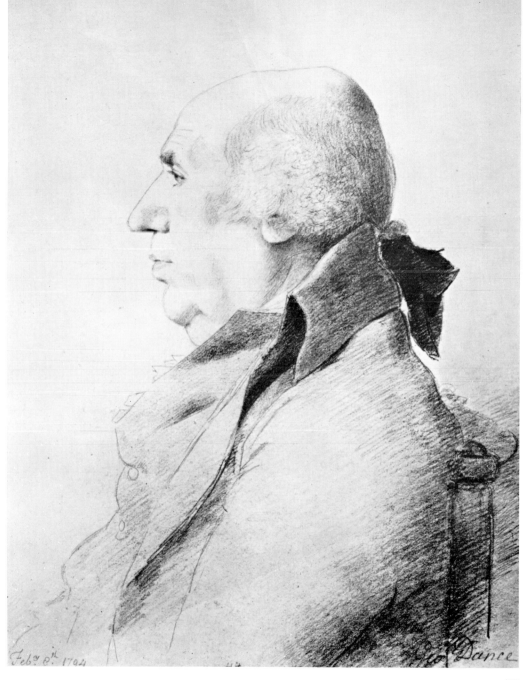

53

pastel portrait, now in the Walker Art Gallery, Liverpool, probably done in the 1790s. He looks serious and direct, his grey hair is nearly white and has receded so far back that it leaves the top of the cranium bare. His side-pieces are shorter and fuzzy, instead of being curled into a neat roll on either side of his head, as they were ten years before. Meyer had the portrait reproduced as a marble relief by the sculptor Giovanni Fontana.

Stubbs was seventy when George Dance added him[1] to his collection of drawings of the Royal Academicians which he did in the 1790s, and which were later engraved by William Daniell. The exact date of the drawing is 8th February 1794, and in it Stubbs is shown in profile. His hair is drawn back and tied with a black ribbon bow, he has only a fringe of hair left round his head, the whole top is bald. His nose projects dominantly over his face, with a curiously straight line beneath the nose, giving a rather pinched look to the nostrils, but most of Dance's profile portraits have this characteristic. His eyebrows have remained dark, though his hair is grey. His chin is deeply modelled, under a full and protruding bottom lip, and above an equally full double chin. His brow is not particularly high and slopes back into a large cranium. He is short necked and sits as though he was tired, slumped into his coat. From the indicated line of his waistcoat, he has grown somewhat portly with his advancing years, and he hardly looks as

though he took quite as much exercise as he was said to take. He has a kindly look, but it is not as evident as in his self-portrait.

Of the other portraits of him, Elias Martin was said to have painted him and exhibited it at the Royal Academy of 1790, calling it merely 'An Artist and a Horse', because he had been told that his painting would be rejected by the Selection Committee if they knew that it was of Stubbs, as he was in so much disfavour with the Royal Academy. This is rather difficult to believe, as he exhibited two paintings at the R.A. that year: the 'Lincolnshire Ox',[2] and a 'Portrait of an Arabian Horse', and in the following year he had four works exhibited. Martin himself was chiefly notable for the fact that in 1832, some sixty years after his election as an A.R.A., the Royal Academy 'erased his name from the list of Associates' because 'no proof of his actual existence' had reached the Royal Academy for many years, and this had caused 'some inconvenience'. It was later discovered that he had been dead for about thirty years!

Orde did a portrait of Stubbs working, which was engraved by Brotherton. It shows him painting at an easel, sitting rather close to his work, which is one of his paintings of Phaeton. There is also one by B. Reading after Falconet, engraved in 1792, and a second portrait by his friend, Humphry, a half-length water-colour in the National Portrait Gallery.

[1] Illus. p. 53.

[2] Illus. p. 93.

Eight · The Mares and Foals Series

Of the major themes that interested Stubbs during his life, the variations on the groups of mares and foals was one of the most delightful. He painted a number of these compositions, mainly in the 1760s. The design in each case was a horizontal one, with arrangements of mares and their foals, in shallow, lateral groups, like a classical frieze, against a park-like landscape. Probably the best known of all of them, is the lovely, backgroundless one belonging to Earl Fitzwilliam at Wentworth Woodhouse, in Yorkshire.

After Stubbs came to London, at the end of the 1750s, he worked for the Marquis of Rockingham at Wentworth. The Marquis succeeded to the title in 1750, and to the task of rebuilding Wentworth Woodhouse into one of the finest houses in the country. He commissioned a number of paintings from Mr Stubbs, including the 'Frieze of Brood Mares and Foals'.[1]

The grouping of this frieze represents the ultimate in Stubbs's brilliant designs. Study the clever arrangement of the legs, so often a designer's problem, when four legs to each animal are far too many to arrange satisfactorily, and only achieve the effect of a haphazard forest. Cover the upper part of the frieze with a piece of paper so that the legs become an abstract pattern and it is immediately obvious how beautifully designed they are. Consider the spaces and the shapes between, and the groupings of the legs, with the opposition of vertical forelegs and the diagonal lines of relaxed hind legs, with the occasional sharp angle of

hocks. Drop the paper lower to cover all but the pasterns and hoofs, and even the arrangement of hoofs on the ground is interesting. Move the paper up to cover the legs, and the rhythms and subtle curves of the backs, with the deeper curves of matronly bellies, and upward swirl of the heads and necks, make another triumph of design. The whole group of seven animals makes a superb pattern, the complete frieze is built up from two groups and two separate horses, the centre-piece being the graceful, grazing filly, flanked by four brood-mares and two foals. Some of these are exactly repeated in other paintings, but assembled differently, in others the design of the group has been used, but with portraits of other horses. The mare and foal on the left of the Rockingham painting appears in the Tate Gallery's painting[2] and in the same position to the left of the canvas, the rest of this group being made up of the second mare and foal placed next to them, the separate mares in the centre being omitted and the mare on the far right being replaced by an old grey mare in a slightly different pose, though she is linked by her nose and shoulder to the group next to her in precisely the same way as in the other painting. The Rockingham frieze, which was paid for on 15th August 1762, was almost certainly painted from life, as each horse is obviously a portrait and, one would think, a good likeness. The irritable mare on the right must surely have posed for, at any rate, the head of the great 'lion and horse' painting that Mr Stubbs also did for Lord Rockingham. If she were teased, her furious

[1] Illus. p. 58. [2] Illus. p. 61.

55

expression would serve very well for extreme terror. It is a difficult emotion to produce often, without sending the model into such a state of panic as to make it practically useless for purposes of study. Quite apart from it being a somewhat dangerous practice for both horse and handler.

The question as to why the frieze is without a background is difficult to answer with any certainty. Stubbs usually painted his horses first and added the background some time afterwards, painting the landscape in behind the figures in the foreground, fitting it in painstakingly between legs and round the backs and heads. He seldom seems to have even touched up his horses after this. The lighter paint of the sky is dragged thinly up to, and sometimes slightly over the edge of the silhouette of the animals. It is the reverse of the usual practice of painting either both edges together, or the object on to and over the background. His groups are nearly always composed of a line of figures, fairly near the bottom edge of the canvas. There is seldom any recession or depth in the grouping, leading back into the middle distance; they stand more or less on one plane and so the profiles are particularly important to the general design.

There are two possibilites: one, that Stubbs always intended it to have no background, or two, that Lord Rockingham did not wish it to be touched. The life-sized portrait of Whistlejacket was, as it were, stopped before it received either rider or background, and he may have wanted other paintings to match it. Stubbs also painted a set of three stallions and a figure, the right hand one is Whistlejacket himself, being patted by his groom, Simon Cobb. The canvas is the same size as the 'Mares and Foals', 75 inches by 40 inches, and is also without a background. They were painted at the same time, as they are both mentioned in the receipt that Stubbs gave the Marquis dated 'August Ye 15th 1762. Recd of the Most Honble ye Marquis of Rockingham, the sum of one

hundred and ninety [*sic*] four pounds five shillings in full for a picture of five brood Mares and two foles [*sic*] one picture of three Stallions and one figure and one picture of a figure on horseback and a picture of five Dogs and another of one Dog with one Single Horse. R. Geo. Stubbs.'

Another picture that might have been painted as a pair to it is the portrait of Samson. It is the same size and much the same arrangement, except that it is the portrait of only one horse instead of three different ones. The Humphry memoirs refer to 'Samson in three different views on the same canvas, viz. a front, back and side view, all without background. Samson was a very large black Stallion.' It would appear from this that at some point it was considered finished without its landscape background. One can imagine a room decorated by the huge Whistlejacket painting on one wall, with perhaps the two compositions of the three horses on either side, and the brood mares opposite, all painted on completely plain, slightly toned primings. However, Samson did not survive as one of the backgroundless pictures, a landscape was subsequently painted in behind, not by Stubbs, but probably by George Barret, who was also working for Lord Rockingham at that period.

Samson was bred by James Preston in 1745; his sire was Blaze, a son of Flying Childers, and his dam was by Hip. Samson was said to be 'the largest boned horse ever bred as a racer'. He was 15·2 hands, and the following measurements were taken by the Marquis of Rockingham: the dimension of his foreleg, from the hair of his hoof to the fetlock joint was 4 inches. From the fetlock joint to the bend of the knee, 11 inches. From the bend of the knee to the elbow, 19 inches. Round the narrowest part of his leg, below the knee, $8\frac{1}{2}$ inches. Round the narrowest part of his hindleg, 9 inches. He won a £50 purse at Malton and a £60 purse at Hambleton 1750 and in the same year he won the King's Plate

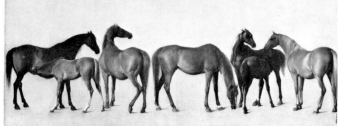

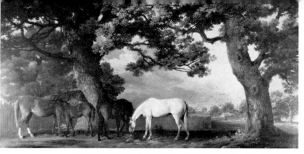

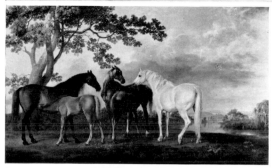

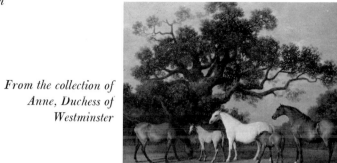

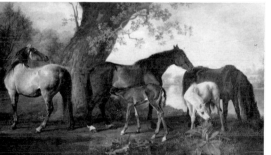

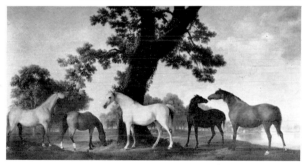

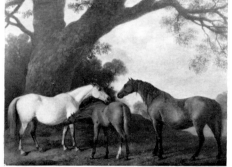

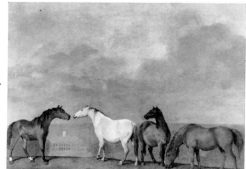

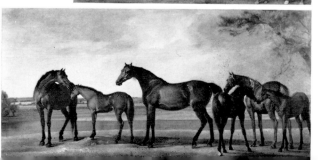

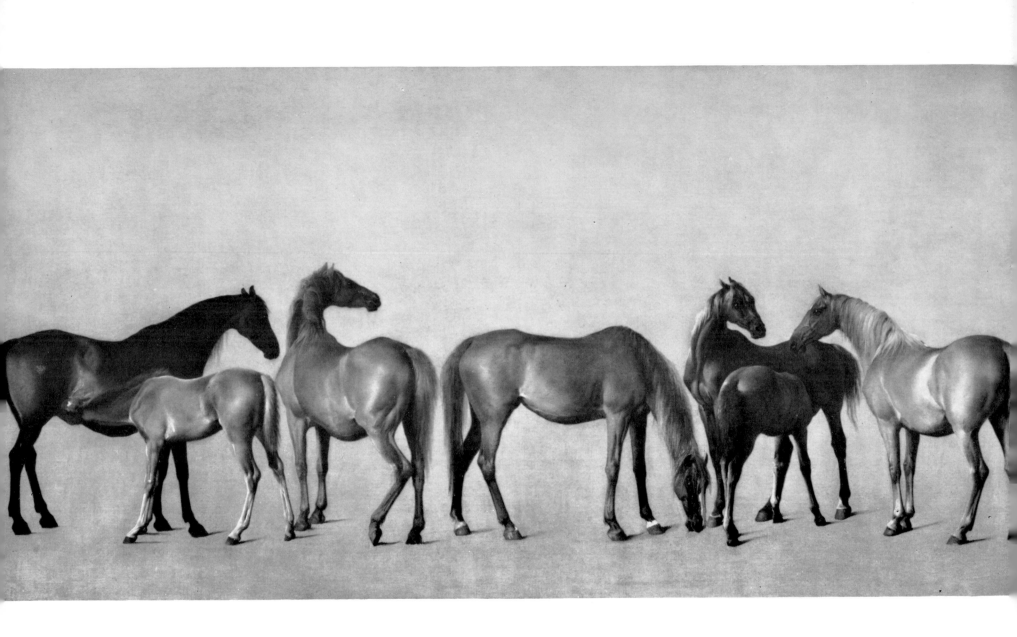

Mares and Foals. *40in × 75in. By kind permission of The Earl Fitzwilliam.*

58

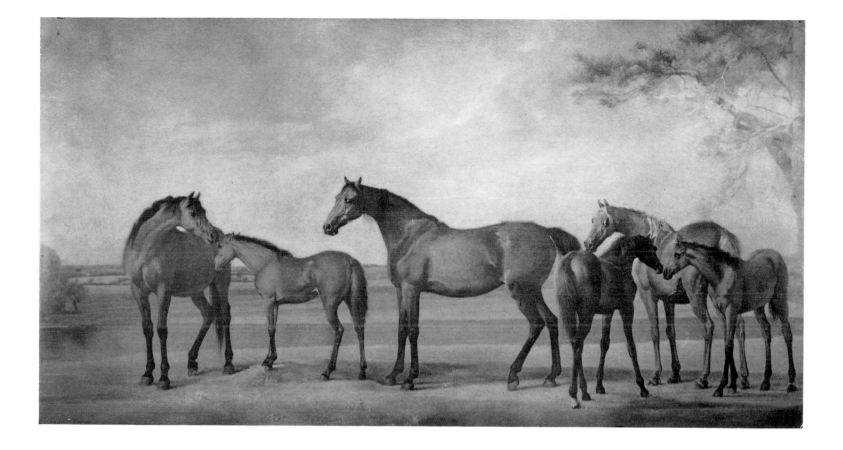

Mares and Foals disturbed by an approaching storm. *39in* × *74in*.
By kind permission of the Viscountess Ward of Witley.

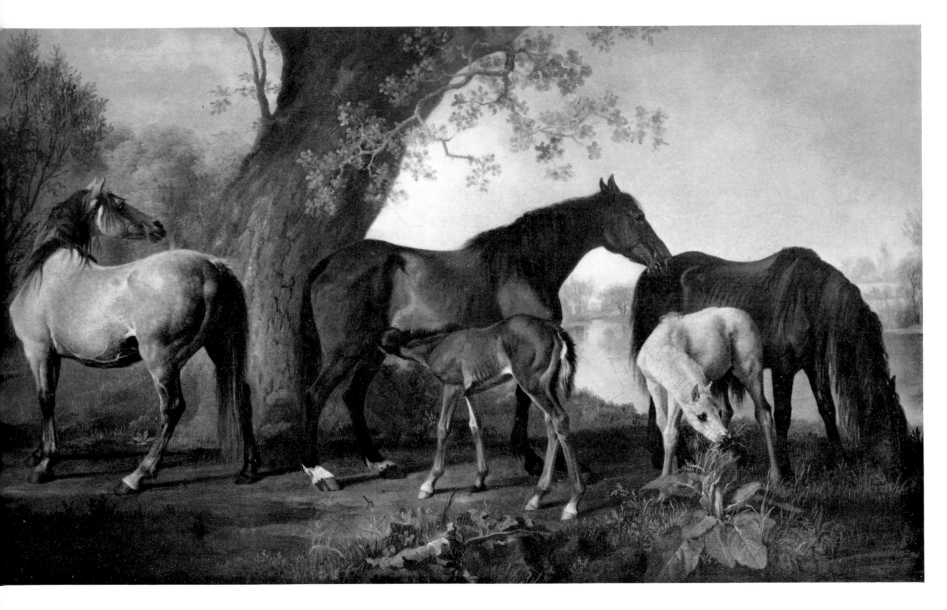

Mares and Foals by a Stream. *23½in × 39½in. By kind permission of His Grace The Duke of Grafton.*

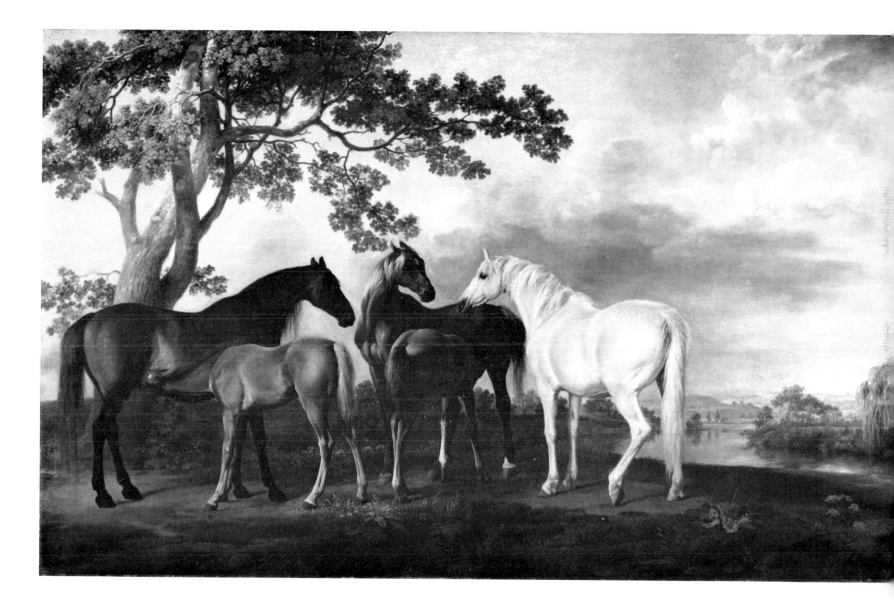

Mares and Foals in a Landscape. *39in* × *62½in. The Tate Gallery, London.*

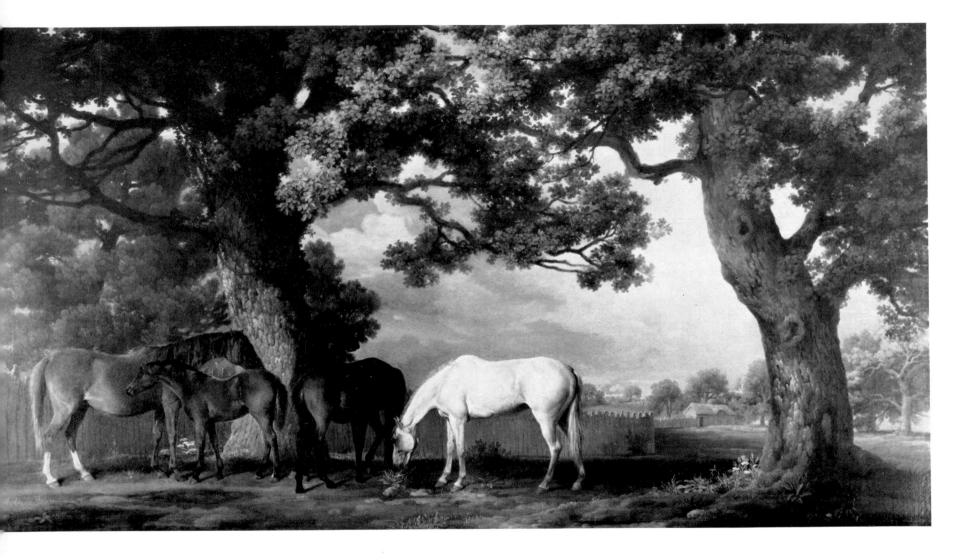

Mares and Foals. *39in × 74in. By kind permission of Anne, Duchess of Westminster.*

62

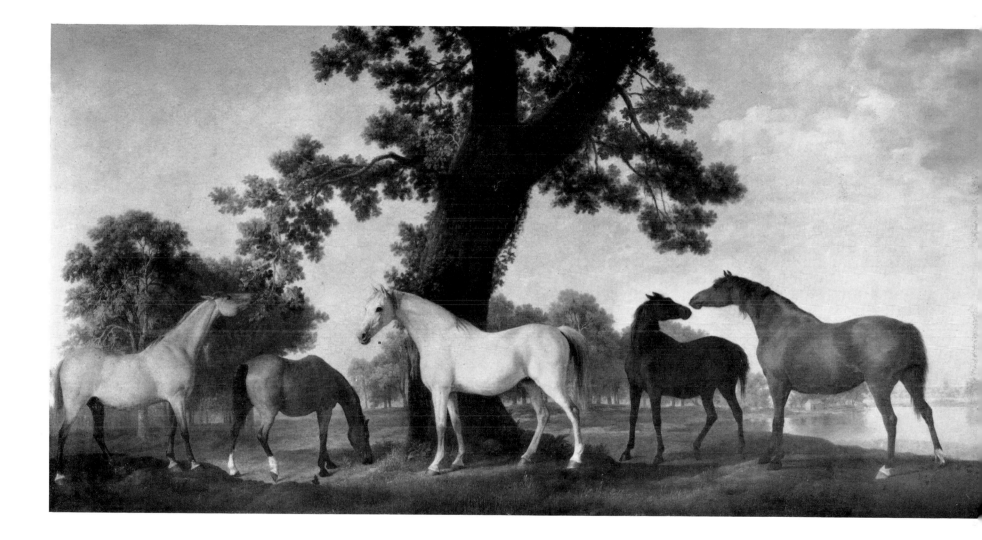

Five Mares. *39in × 74in. The National Trust. (Rothschild Collection, Ascott.)*

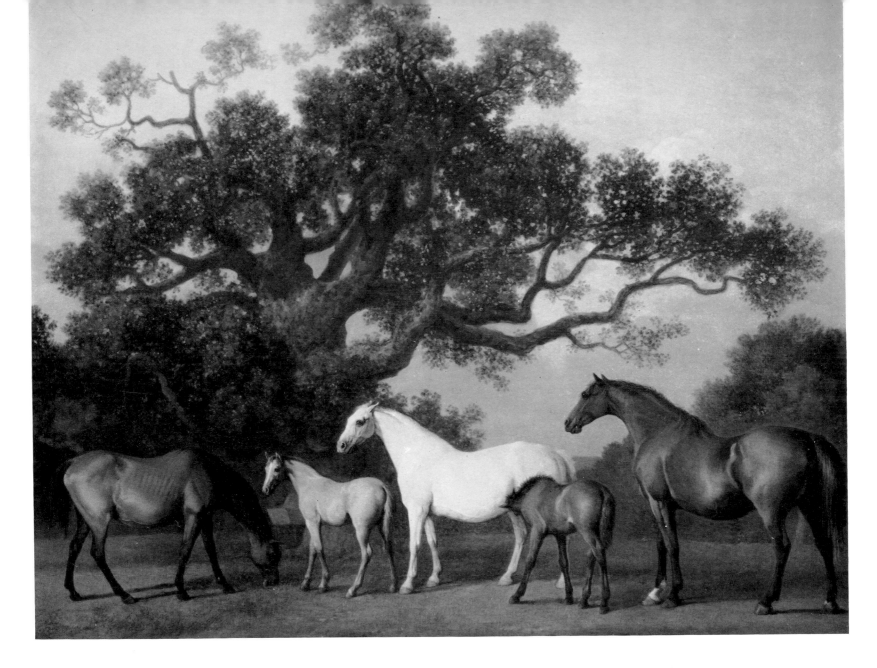

Mares and Foals under an oak tree in the middle of a wood. $32\frac{1}{2}in \times 40in$. *By kind permission of Anne, Duchess of Westminster.*

of a 100 guineas at Litchfield, beating Gustavus. He was undefeated till 2nd April 1752, when he was beaten by Sir W. Middleton's Thwackum. He stood as a public stallion at Malton and later as a private one at the Rockingham Stud. He died at the age of thirty-two.

The painting of Whistlejacket,[1] Lord Rockingham's palamino stallion, was to have made a pair with the painting of a similar subject by Morier. The horse was to be painted life-sized by Stubbs, the rider was to be a portrait of the King, by 'the best portrait painter', and the landscape was to be by 'the best artist in that branch of art—hoping by this union of talents to possess a picture of the highest excellence'. When Stubbs had practically finished painting Whistlejacket, who was a difficult horse, and at times vicious, and almost unmanageable, an odd thing happened. He was only allowed out when led by his own groom, Cobb, who used to bring him to the yard where Stubbs was working, and leave him with a stable boy. It was during the last sitting, or session, with the horse posing, that Mr Stubbs, who had really finished the painting, took it off the easel and placed it against the stable wall to get a different view of it, and to pull it together in places by glazes and by scumbling. The young lad who was holding Whistlejacket, had been leading him up and down a long range of stable buildings, as they came back, the painting was facing them. Instead of only seeing the back of the canvas, Whistlejacket could now see his portrait for the first time. The minute he caught sight of it he stared at it wildly, and then screamed out, rearing up and lashing out at it with his forelegs. The lad tried to check him, and caught the bridle close to the bit, but the horse threw up his head, and lifted the boy clean off his feet. He called out to Mr Stubbs for help, and Mr Stubbs promptly rushed up and 'pummelled Whistlejacket with his palette and mahl stick' endeavouring by this to scare and distract him and to take

his mind off the stallion in the picture. He succeeded in turning the horse away from the canvas, and as soon as he could no longer see the painting he soon calmed down, and became quiet enough to be led back to his stable. The Marquis, when he heard this story and saw the magnificent portrait that Stubbs had painted of his stallion, was so impressed that he refused to allow the painting to be touched, and so it remains today, a life-sized picture of Whistlejacket, doing a levade, painted on to a plain ground or priming. This monumental work is housed in a special room, 40 feet square, once a dining-room, now called the Whistlejacket Room. The exact date of the painting is not certain, possibly the receipt dated 30th December 1762, from Mr Stubbs: 'Eighty guineas for one picture of a Lion and another of a Horse Large as Life' may refer to it, but that would make it three months later than the other two backgroundless paintings. Also, the receipt is much more likely to refer to the pair of paintings of life-sized animals—'The Lion attacking a Stag' and 'The Lion attacking a Horse' (see chapter on Lion and Horse). It seems more likely that Mr Stubbs painted Whistlejacket first, followed by the other two, painted to the same formula, to match in with it.

To return to the theme of the 'Mares and Foals', that so much occupied Stubbs during the 1760s. He exhibited six at the Society of Artists between 1762 and 1768, and one at the Royal Academy in 1776. Of these, the first of them was described as a 'Brood of Mares', three were called 'Mares and Foals', and two 'Brood mares'. The favourite size seems to have been 40 inches by 75 inches; there are at least seven variations on the theme, of this particular size and shape. The design within this long horizontal shape intrigued him for about ten years, after which he seems to have worked it out of his system and moved on to other problems of space filling. There are a number of other groups on a slightly smaller scale, in a less elongated shape.

[1] Illus. p. 66.

The Whistlejacket Room at Wentworth Woodhouse.
By kind permission of The Earl Fitzwilliam. (Photograph by courtesy of Country Life.)

A painting which fits into the theme of 'Mares and Foals' by the design rather than the subject—there are no foals—is the 'Group of John Musters's horses at Colwick Hall'.[1] This is particularly interesting as it is unfinished. The horses are laid in in broad flat tones and very simply treated. The background is roughly scrubbed in, the house is just indicated and the landscape is completely unfinished.

His landscape backgrounds tend to have a fairly low eye level, with a narrow belt of middle distance and a stretch of water, giving light to the composition and carrying the pale tones back into the misty distance. The result is that the pattern of the horses are easily seen, from the hocks upwards, expressively silhouetted against the horizon and the sky. The tonal weight of the darker foreground is taken up into the top of the composition by means of a great tree, or trees, to form a dark mass on one side of the design, often making a diagonal across the picture, balancing the open spaces of sky and distance. This is rather reminiscent of the landscapes of Claude. Stubbs used this device of composition so frequently that sometimes in his less successful designs there is a slight feeling of a stage-setting, with a misty backcloth and a cut-out border of trees masking the wings and proscenium. He is always a most thorough and conscientious craftsman and his work is never scamped or unworthy; it is based on very careful study of every part. Occasionally, the components do not come together to make an integrated whole, and the unity of the the picture is somewhat lost.

Stubb's greatest gift is the ability to produce a nostalgic tranquillity, a stillness that is not frozen, but, like a dancer, posing in absolute balance, gives a feeling of permanence to a fleeting moment.

The play of forms and shapes of the standing figures of the Rockingham—or rather the Fitzwilliam 'Mares and Foals' as it is now, is infinite in its variety. They are linked into a pattern, and the design is unified into a single constructed whole, as in a piece of sculpture, when the solid exists as a mass in space, and the displacement of the space is as important as the solid that displaces it. Compared with the 'Mares and Foals' in the Duke of Grafton's collection, they are slightly idealized, and are given a smooth, polished beauty. The Grafton 'Mares and Foals' are far more rugged, and are rather non-flattering portraits. The old mare in the centre has extremely long sloping pasterns, quite unlike her counterpart in the Fitzwilliam frieze. The painting is inscribed 'Antinous's dam and Cassandra'. The setting is by the stream in the park at Euston Hall, and there is some of Stubbs's favourite vegetation, docks and wild rhubarb, which make an interest in the foreground. He uses the opposition of light against dark, dark against light, more in this design than in the other mares and foals. The two dark mares are silhouetted against the luminous water and sky, while the grey is a light shape in front of the trees and shrubs in the background. The painting of Antinous, grown up,[2] shows him as a long-legged horse, with hind legs that don't seem quite right in action—there is something odd about the drawing of the off hind leg. His jockey sits well back with his switch under his arm, his hands held rather high. Probably a very characteristic pose, and a good portrait. This picture is perhaps the painting that was exhibited at the Society of Artists in 1764 called 'Antinous, a horse belonging to the Duke of Grafton'.

The Tate's 'Mares and Foals' is rather less long in proportion. The double group of three mares and two foals is taken from the Fitzwilliam picture and is set rather to the left of the canvas, beneath a tree and by a river. The mare and foal on the extreme left is exactly the same as in the Fitzwilliam painting, the two centre figures, the backview mare and the grazing filly, have been omitted, and the right-hand group has been placed next to the

[1] Illus. p. 69. [2] Illus. p. 68.

Antinous. *38½in × 40½in. By kind permission of His Grace the Duke of Grafton.*

68

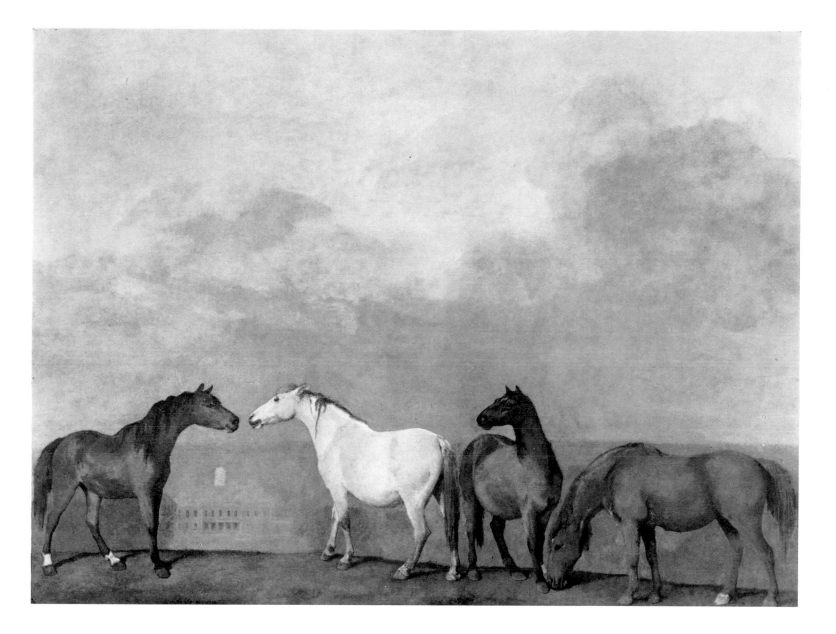

A group of John Musters's Horses at Colwick Hall. *38in × 50in. By kind permission of Mrs Aileen Plunket.*

left-hand group, with the alteration of the colour and pose of the outside mare.

The two other lovely 'Mares and Foals' paintings are the Rothschild one at Ascott[1]—this has a line of five mares, with a particularly beautiful flea-bitten grey, reaching up to an overhanging branch. The almost chestnut flecks in the grey coat are wonderfully expressed in paint. The other is the group of three mares and two foals,[2] set under magnificent park trees, in a long landscape, painted for Lord Grosvenor in the early 1760s. This painting is so very essentially English, so cool and tranquil, with riding horses sheltering beneath old mature trees, wild flowers at their roots, and with a background of grassland and farm buildings.

It is hardly surprising that the horse-loving English gentlemen wanted Stubbs to paint their hunters and racehorses. The rise of the well-to-do middle class, the increase in large country houses, landscape gardening, the Grand Tour, the more scientific approach to agriculture and the selective breeding of animals, the development of foxhunting and racing as a gentleman's sport, leading to the specialized breeding of hunters and racehorses, had all come about comparatively recently, and had had a marked effect on the taste and on the requirements of the time. Stubbs's expert knowledge of horses—so different from the rather fantastic and unreal ideas of some of his predecessors, must have come as a welcome relief to those who wanted a true and faithful record of their achievements. This was what the English country gentlemen really wanted to acquire, as a decoration for their houses. The painting had to be a recognizable and exact portrait of their animals, showing off with proper appreciation all their best points. In fact, it was their standard for all art, whether for a painting of their wife, their house and lands, or possessions. Once they had their possessions recorded, they kept them hanging on their walls, as so many Stubbs's have been for two hundred years. A surprising number of his paintings still remain in the families that originally commissioned them. The paintings were accurate descriptions, simply expressed and easily understood by those who were not art connoisseurs, yet they satisfied the most knowledgeable and cultivated man of taste. No wonder men like the Marquis of Rockingham employed him to paint, not just one painting, but nine.

In the same 'horizontal frieze' group, is the painting of five hounds, mentioned in the receipt of August 1762. Stubbs was just as happy with dogs and their shapes as with his beloved horses. He manages to achieve a very happy arrangement of level backs and curved tails, echoed by the alert heads of the five hounds. Each one is full of individual character and personality.[3]

As well as these hounds and the brood mares and the three stallions, which were mentioned in the receipt for £194 5s is the portrait of the Marquis's jockey, John Singleton, on Scrub. Singleton was one of the first really notable jockeys; he was born in Yorkshire in 1715, and began riding, and then racing, as a child. He soon became known as a horseman of judgement and skill. After winning a race one day, he received a sheep as a prize from one of the local farmers. Some years later he had a small flock, all bred from the original prize ewe. He had become, over the years, very much aware of the tremendous advantage of Arab blood in racehorses. He strongly advised his master to put his mares to such a stallion. Unfortunately there was no spare money for such a venture, and finally Singleton sold his own sheep to pay the fees of the stallion, Smiling Tom, from the Hampton Court Stud. The filly produced from the venture, Lucy, ridden by Singleton, won the Subscription Plate at Hambleton in 1736. Scrub was her grandson. They bred several winners, and did reasonably well. Eventually, Lord Rockingham bought one of their more promis-

[1] Illus. p. 63. [2] Illus. p. 62. [3] Illus. p. 98.

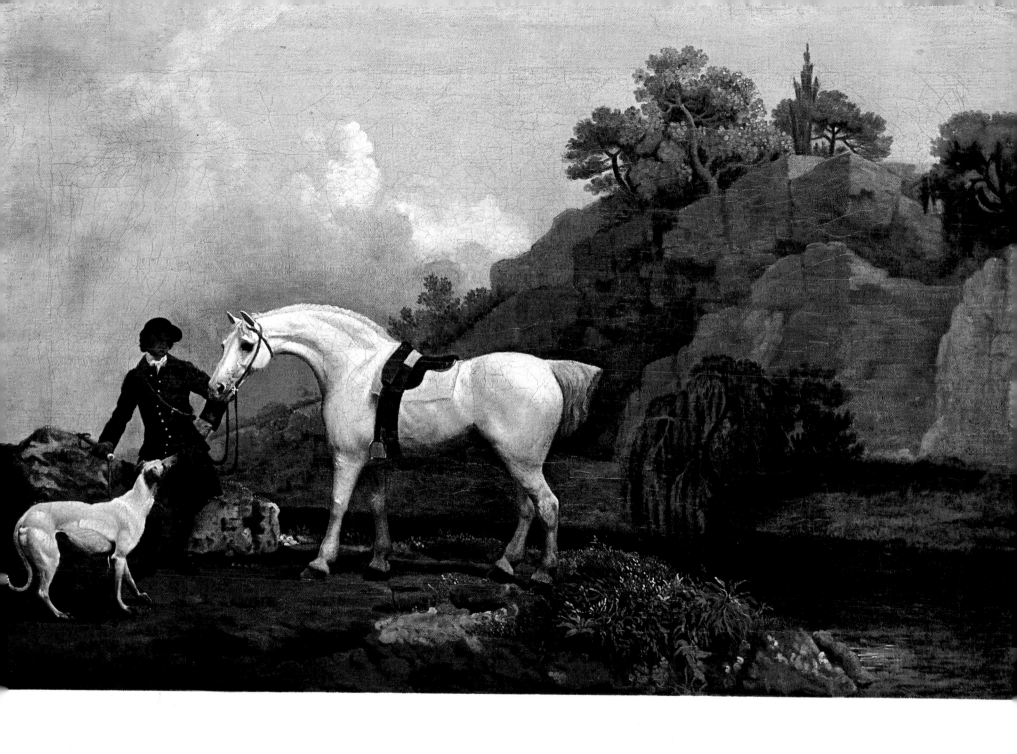

Grey Hack with a Greyhound and Groom. $17\frac{1}{2}in \times 26\frac{1}{2}in$.
The Tate Gallery, London.

ing winners and also engaged Singleton at a salary of £40 a year, to be his trainer and jockey. When he heard that the Marquis wanted him painted on Scrub, he remarked that 'His Lordship had mounted him on many good horses and on many bad ones, but now he had mounted him on a Scrub for ever'. Scrub was a small horse, standing only 14 hands 1 inch, and was foaled at the Rockingham Stud in 1751. John Orton in his *Turf Annals* says 'Scrub was esteemed a very excellent horse, and was never beat in private, and only beat three times in public. When an old horse, he was given by Lord Rockingham to his rider, Singleton, in whose possession he died at Givendale, Yorkshire.'

Scrub won a number of matches between 1755 and 1761, including the 'Give and Take' Sweepstakes in 1757, and the Great Subscription Plate at York in 1761. When Stubbs painted Whistlejacket as a mount for the King, and the Marquis decided to keep it solely as a portrait of the stallion, he was immediately asked to paint another life-sized portrait of a horse to serve as the King's Charger. This time the Marquis picked a dark bay stallion with a black mane and tail, Scrub, to pose for the portrait. Mr Stubbs completed the painting, but for some reason or other he fell out with Lord Rockingham over it, and eventually removed the portrait altogether. This huge portrait of Scrub was sold to a Mr Ryland, and according to a note—probably added to the Humphry memoirs by Mary Spencer—the picture was sent out to India, but for some unknown reason it never landed. It returned to England, very much damaged by the journey. Mr Stubbs took it back in part payment and relined the canvas and repaired it. It was later disposed of to Miss Saltonstall, at his sale. It was finally bought by Lord Rosebery.

Of the other paintings done for Lord Rockingham, there is a fine 'Racehorse and Groom in a Rocky Landscape'. The landscape is very similar to the background of the Tate painting[1] of the 'White horse, with his groom and a greyhound'. In the account book of Lord Rockingham there is mentioned a payment to Mr Stubbs of £70 15s on 31st August 1764, and again in August 1766, when he was paid 40 guineas for a picture of an Arabian'. This was probably the painting of Bay Malton. From this it seems that the disagreement over the life-sized Scrub in no way affected Mr Stubbs's commissions from the Marquis.

It seems almost incredible when one thinks of the amount of work that he did during the period immediately after he finished working at Horkstow. In the six or seven years that he was at work producing his 'splendidum opus', working hard to perfect the plates and writing the text, he managed to paint an amazing number of paintings, some of them fairly small, but on the whole, most of them were quite big canvases, 40 inches by 50 inches and 40 inches by 70 inches. There were at least four life-sized paintings, two portraits of horses, and the pair of 'Lion and Stag', and 'Lion and Horse'. Then there were the hunting pieces for the Duke of Richmond and Lord Grosvenor, which were all large, complicated and intricate compositions, full of portraits from life. With this enormous output, his standard never falters. He was triumphantly establishing himself as the outstanding painter of animals of the century. It was as if the production of the Anatomy had crystallized his vision and skill. His long years of dedicated study had given him a craftsmanship akin to the painters of the Renaissance. His perception of form was so acute that he was always completely in command of the object in front of him. He never becomes merely illustrative, and his skill never leads him into photographic copying from nature. Nor does his deep knowledge of equine musclature ever lead him into overmodelling and overstatement, his mares are wonderfully and simply expressed, powerful, yet delicately and sympathetically controlled. He had reached a peak in his career in the 1760s, and he managed to maintain and add to it, right on till he painted Hambletonian when he was in his mid-seventies.

[1] Opp. p. 70.

71

Nine · The Lion and Horse Series

In this extraordinarily productive period of the 1760s, after Stubbs had returned from Horkstow and had set up in London, he began on the second of his three themes. It was to last longer than his frieze of 'Mares and Foals' theme. It was his most interesting and original set of variations on an idea, and by far his most ambitious one. The basis for this theme is a lion and a horse in opposition to each other. He painted the episode in four different stages. There are two versions of the horse being stalked by the lion; the first, when the lion is still quite a long way away, and is only a little figure in the distance, and the horse is merely startled and apprehensive. The second version is of the horse in obvious danger, showing terror, the lion having come into the foreground of the picture, a comparatively small but menacing figure. The third phase shows the lion, having attacked the horse and leapt on to its back, sinking his teeth into its withers. The final version shows the horse having sunk down to the ground.

Stubbs painted these lion and horse compositions in all sizes from tiny enamels on copper, almost miniatures, to the great and majestic life-sized canvas painted for Lord Rockingham, and now in the Mellon Collection. He interpreted them in all his various methods, oils, enamels, mezzotints, and modelling. He continued to come back to this theme for more than thirty years.

The origin of the idea has always been said to come from the visit Stubbs is supposed to have made to Morocco, on his way back from Italy, in 1754. (See page 13.) The incident, in fact the whole visit to the fortified town of Ceuta, is curiously enough not mentioned by Humphry nor by either of the other transcripts. The information occurs in an article that was published in the *Sporting Magazine* in May 1808. It is signed with the initials 'T.N.' and the author claimed to be acquainted with Mary Spencer. The Humphry notes on the Italian visit are concerned with the fact that Stubbs was unimpressed by the value—to him—of studying from the antique and of copying great pictures. One has to remember that the Humphry memoir was written when Stubbs was getting to be an old man, and conveys a feeling that he was very proud of his independence of thought and style, and of his determination to study from nature and not from art. The final paragraph in Humphry's account of the trip to Italy, 'Stubbs's motive for going thither was to convince himself that Nature was and is always superior to Art whether Greek or Roman; and having received this conviction he resolved upon returning home.' This is in the nature of an exit line for the Italian trip, and possibly the fact of stopping off in Morocco did not seem to Stubbs or to Mary Spencer to be important at that point in his life history or relevant to his studies. Though, as there are the detailed passages dealing with how he managed to paint an angry lion at Lord Shelbourne's villa at Hounslow (see page 81), and how he obtained the expression of terror in a horse, by having a yard-brush swept towards its feet, one would have thought that the Ceuta visit would have been mentioned somewhere if it had happened.

The fact that Stubbs wanted to see lions in the wild would have been entirely in character and in keeping with his passion for nature, and for seeing things for himself.

The incident of the lion actually on top of the horse is the first of the series that he worked on. He did not produce the other two episodes till some years later. Probably the earliest was the life-sized picture in the Mellon Collection.[1] This was finished about December 1762, when he was paid 80 guineas for the pair by Lord Rockingham. It could have been exhibited at the Society of Artists in 1763, of which, Horace Walpole says 'The Horse rising up, greatly frightened.' This hardly gives the impression of a horse with a lion actually on its back, though as it was hung with 'Its Companion' this is most likely to be the other huge painting done for Rockingham, the 'Lion and Stag'. The following year 'a Lion seizing a Horse' was exhibited and said by Walpole to be 'Bad'. In 1770, 'A Lion devouring a Horse, painted in enamel' was said to be a 'singularly large piece of enamel & fine', also 'very pretty', and the year after, he says 'A lion and horse, in enamel exhibited last year, very fine, £105 with frame', which was a very good price for a small work. Stubbs never exhibited a 'Lion and Horse' picture at the Royal Academy, though it was this theme that greatly enhanced his reputation, even after his death. The Irish painter, James Barry, wrote home in the 1760's: 'There is one Stubbs here, who paints horses and other animals with a surprising reality. He is very accurate, and the anatomy of a horse, which he has etched from dissections he made, will soon be published, and may be worth your seeing.' He was much impressed by Stubbs's work, and in another letter he wrote; 'We have had our two exhibitions since I wrote to you; the pictures that struck me most . . . and a fine picture of broodmares by Stubbs: his lion and tyger fighting near a dead stag, a tyger lying in his den large as life, appearing as it were disturbed and listening, which were

in the last years exhibition, are pictures that must rouse and agitate the most inattentive: he is now painting a lion panting and out of breath lying with his paws over a stag he has run down: it is inimitable.' Barry's admiration of Stubbs may have been the reason for the inclusion of a lion and horse incident in the background of his large mural of Orpheus instructing a Savage People, at the Royal Society of Arts. He became one of Stubbs's friends, and according to Farington, he was in the habit of taking tea with him. It was one of Barry's kinks that 'he would leave sixpence on the Tea-board when he took tea with Stubbs so that he was not beholden to him for anything but his company'. Angelo said that 'he would not dine at the table of a private friend without leaving two shillings upon the cloth, the price, whatever the entertainment, set upon it by his own arbitrary valuation'. It certainly had nothing to do with Stubbs's hospitality.

It is interesting to see Stubbs's appreciation of horses appear almost unconsciously as he paints the mortal conflict with the lion, who, when shown with the horse, is not the dominating and majestic animal that it is when it is shown by itself, or with a stag. Compare the companion pieces, the life-size 'Stag and Lion', both in the Mellon Collection. There is nothing pathetic about the attitude of the horses in any of Stubbs's paintings; in fact, it is the horse in these episodes that is the dominant figure. It is shown as a sculptural unit—almost architectural in its design—with the out-thrust foreleg acting as a buttress against the lion's weight on the withers, and the exaggeratedly long and full tail forming a solid support between the hind legs. Curiously enough, the paintings were far more sculptural than the modelled low-relief that he did for Wedgwood.[2] It is fascinating to compare the various versions of the episodes, if one takes the group of the lion on the horse and considers the similarities and the differences. For example, the life-size canvas has a tremendous diagonal move-

[1] Illus. p. 78. [2] Illus. p. 112.

ment in the composition, from the upflung tail of the lion right through the foreleg of the horse, and echoed by its tail and hind leg. The movement is stopped and balanced by the upraised leg, and steadied by the horizontal line of the mane and the lion's back, which is echoed again by the parallels in the landscape background. The composition is beautifully planned and carried out, particularly as the canvas is on such a grand scale. On a smaller scale is the painting in the National Gallery of Victoria, Melbourne. The lion devouring the horse makes a small unit in an open and spacious landscape, the group is slightly more dramatic in action, there is greater strain on the horse's neck, and the legs are set at an even more oblique angle. The actual canvas size is 26 inches by 38 inches, while the earlier one 96 inches by 131 inches. The horse is white, not palamino or light chestnut, and is very similar in pose to the painting of the same subject at Yale University.[1] This is a little bigger, 40 inches by 50 inches and has a much darker and more sinister and theatrical setting. The dramatic impact is enhanced by the background, and the whole comes closer to the popular ideal of the sublime, as laid down by Burke. 'The passion called up by the great and the sublime in nature, when those causes operate most powerfully, is astonishment; and astonishment is that state of the soul, in which all its motions are suspended, with some degree of horror. In this case the mind is so entirely filled with its object that it cannot entertain any other, nor by consequence, reason on that object which employs it.

'Hence arises the great power of the sublime, that, far from being produced from it anticipates our reasoning and hurries us on by an irresistible force. Astonishment, as I have said, is the effect of the sublime in its highest degree: the inferior effects are admiration, reverence and respect.'

The Melbourne picture was painted about five years after the

Rockingham, and the Yale painting was done about 1770. The group differs in the two later paintings: the lion's tail is curved round to echo the line of the horse's quarters. This episode is also repeated in the two little octagonal paintings, an enamel on copper, that belonged to the Royal College of Surgeons,[2] and an oil in the Mellon Collection. The background in these is quite dark and uncomplicated, and gives a simple but dramatic effect. The horse is heavier and rather more stylized, and the group is hemmed in and confined by the plants and rocks in the foreground. All the landscapes are rocky, but no special attempt has been made to give a desert or Middle-Eastern feeling. The trees are not particularly African in character, and while the landscapes are naturalistic, they do not have an 'on-the-spot' visual and topographical quality. If one discounts the visit to Ceuta as unlikely, and a fabrication by 'T.N.' of the *Sporting Magazine*, then one has to consider where Stubbs got his original idea from. If it wasn't straight from nature in the wild, by direct observation, then it was either pure imagination—and Stubbs had a scientific and not an imaginative type of mind—or it came directly or indirectly from some painting or sculpture that he had seen. There was nothing at that time in English Art that could have influenced him in this direction. The obvious paintings that come to mind, the baroque hunting scenes such as Rubens's Lion Hunts, have little in common with Stubbs's majestic groups. These are so sculptural in conception and design that one could well suppose that he was influenced by some classical group seen in Italy. Of course, the whole idea may have come originally from Lord Rockingham, who commissioned the very first of the series.

The difference between Stubbs's interpretation and others is that Stubbs's horses are not pathetic victims, their dramatic energy prevents this, and they appear more as the hero in a tight spot, and a worthy opponent of the lion, even though terrified

[1] Illus. p. 80. [2] Illus. p. 79.

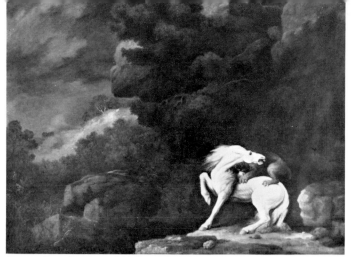

From the collection of Yale University Art Gallery

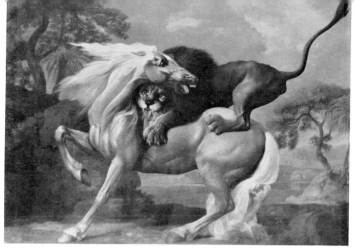

From the collection of Mr and Mrs Paul Mellon

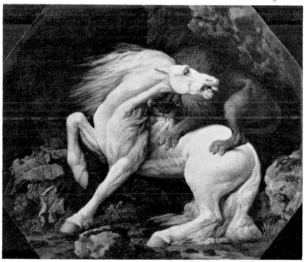

From the collection of the Tate Gallery

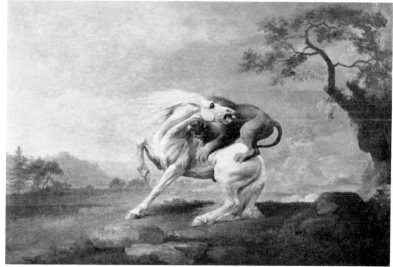

From the collection of the National Gallery of Victoria

From the collection of the Walker Art Gallery

From the collection of Mr and Mrs Paul Mellon

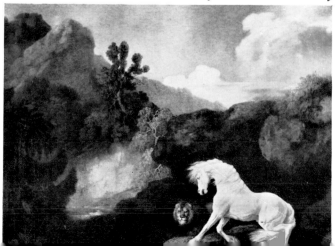

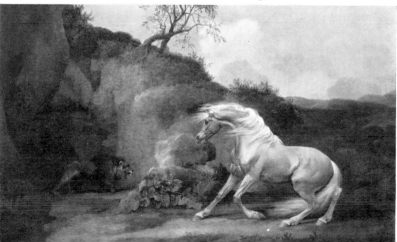

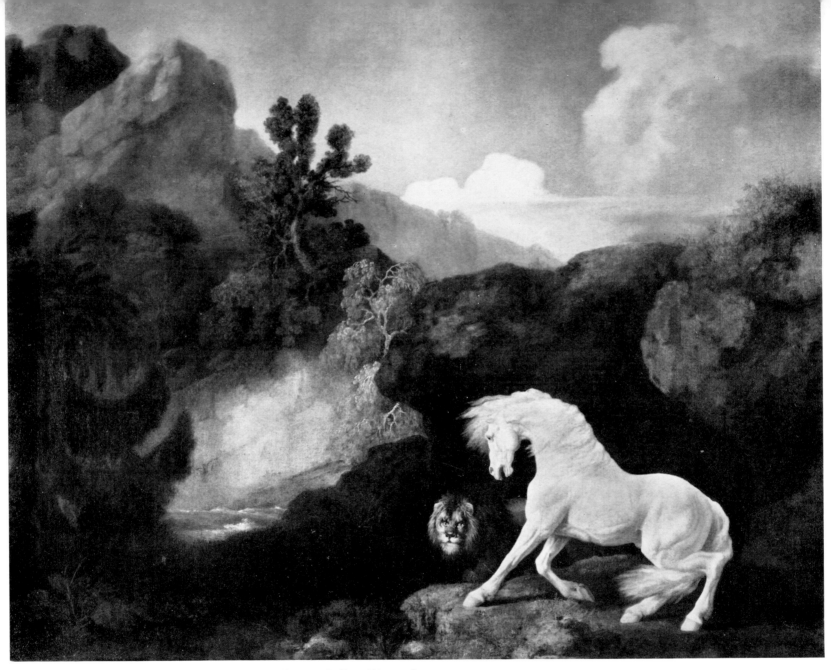

Horse Frightened by a Lion. *40in × 50in. The Walker Art Gallery, Liverpool.*

76

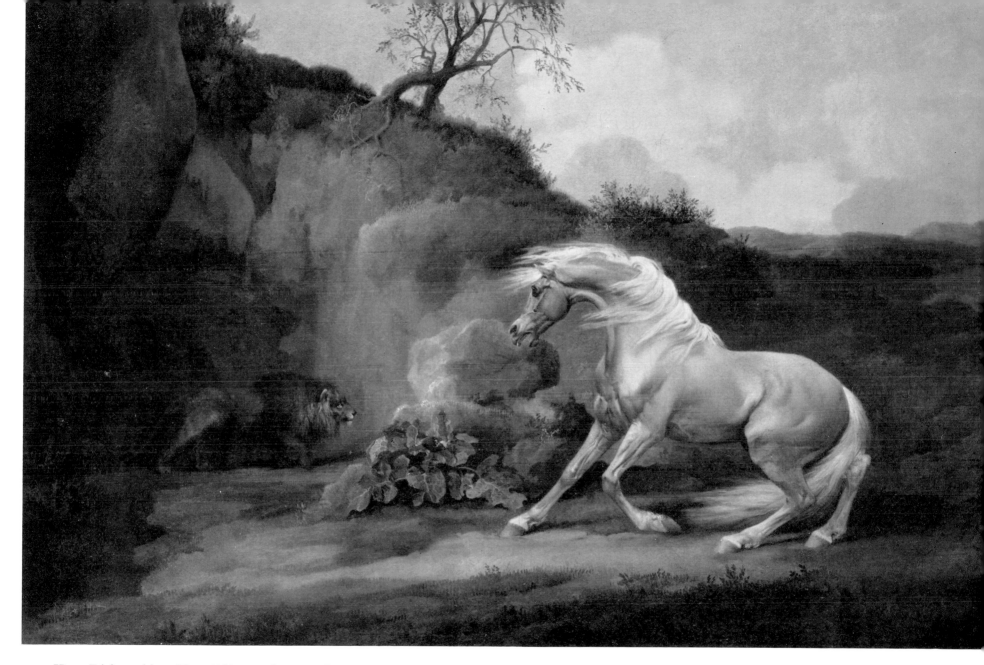

Horse Frightened by a Lion. *27½in × 41in. From the collection of Mr and Mrs Paul Mellon.*

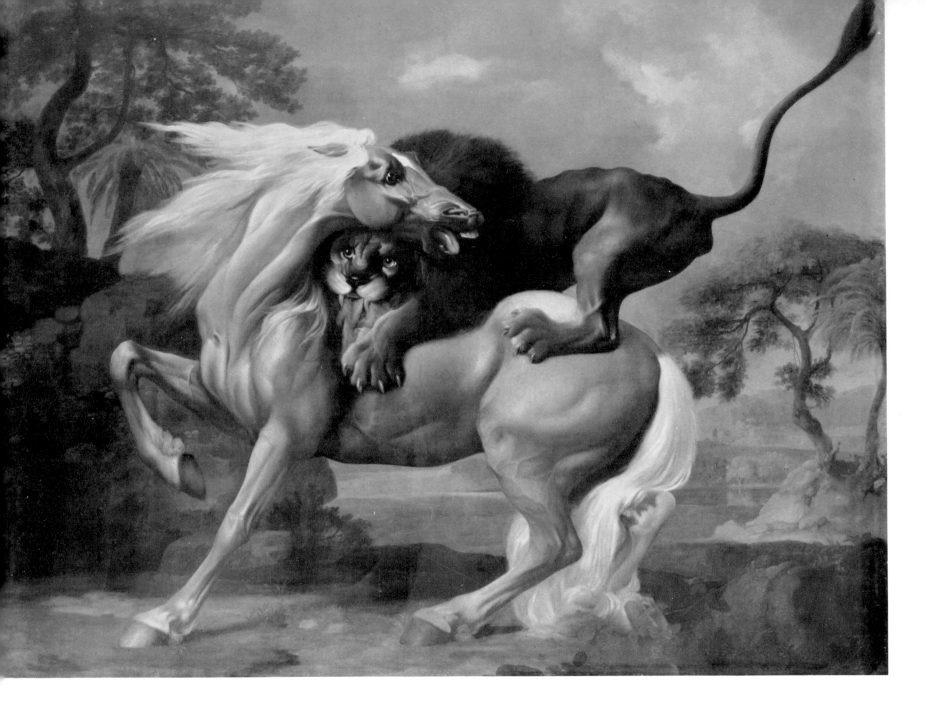

78

Left
Lion attacking a horse.
96in ×131in.
From the collection of
Mr and Mrs Paul Mellon.

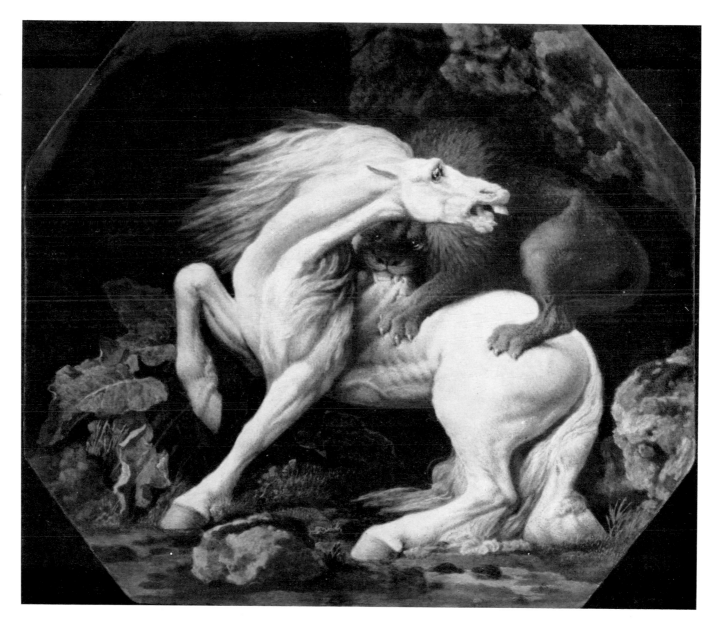

Lion devouring a horse.
10⅛in × 11⅝in.
The Tate Gallery,
London.

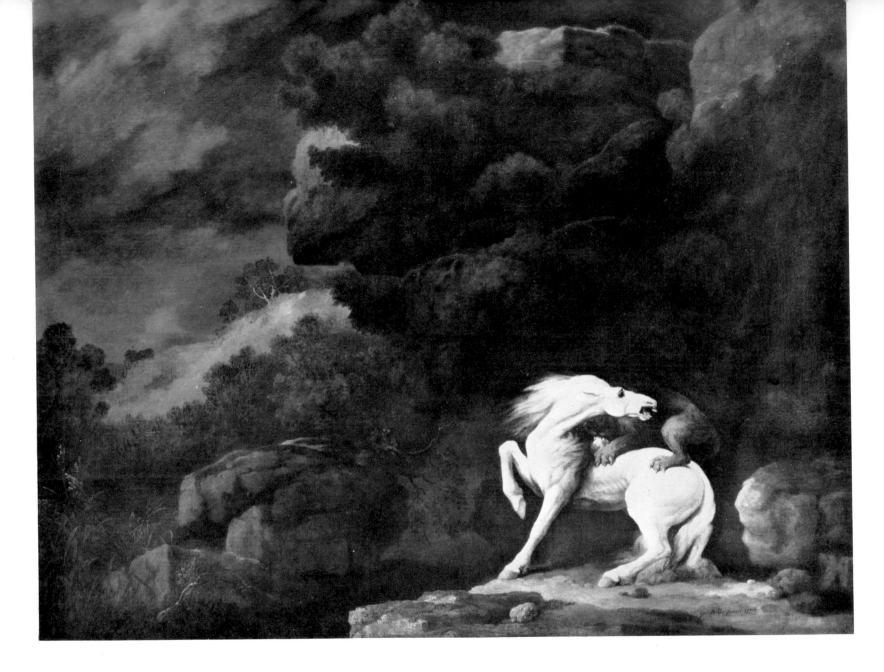

Lion Attacking a Horse. *40⅛in* × *50¼in. Yale University Art Gallery (Gift of Yale University Art Gallery Associates) U.S.A.*

80

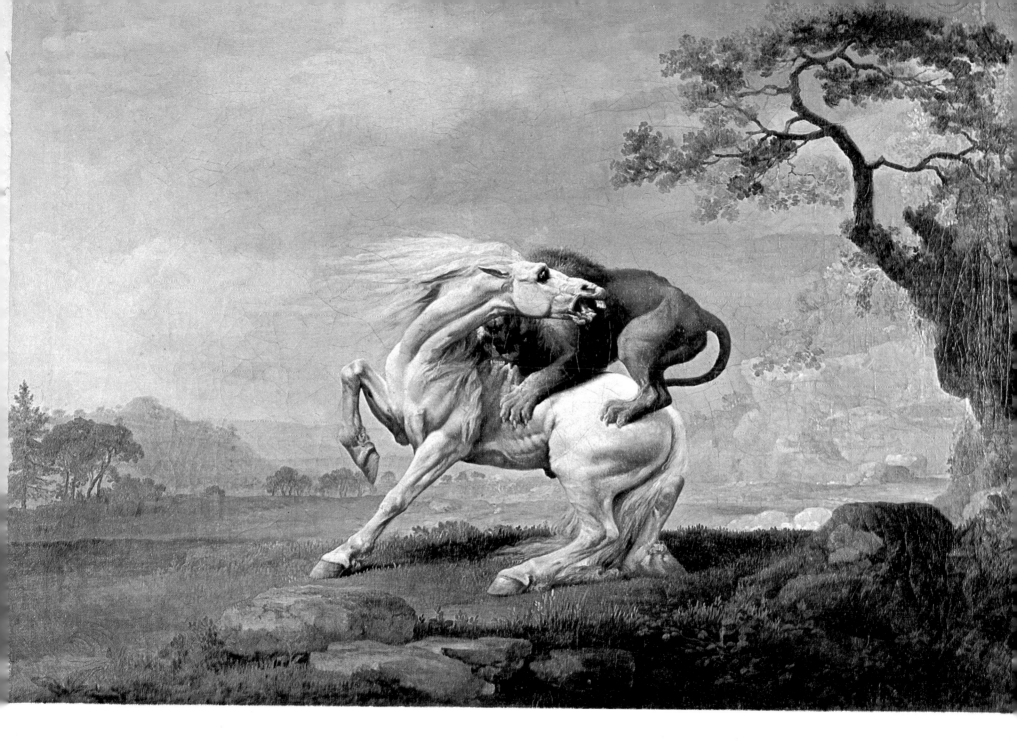

Lion and Horse. *26in* × *38in.*
National Gallery of Victoria, Australia.

by their situation. Stubbs's theme of animals in terror is so original in its idea that it marks a breakthrough towards the Romanticism which was to come. The French painter, Géricault, who painted dramatic and romantic equestrian themes, copied one of Stubbs's 'Lion and Horse' paintings, which is now in the Louvre.

Of the other two episodes in the series, Stubbs had already painted four or five variations on the theme of the 'Lion on top of the Horse' in the 1760s, before he added the scenes of the lion stalking the horse to the series, in the 1770s. For the sake of clarity, the paintings where the lion is in the distance might be called 'Horse stalked by the Lion'[1] and the paintings where the lion has closed in on the horse called 'Horse frightened by a Lion'.[2] Of the stalking pictures which were painted in the 1770s and later, the one in the Mellon Collection is very like the modelled low-relief done for Wedgwood in 1779, though the composition is in reverse. The lion in the painting is farther away in the distance, whereas in the relief it is more or less on the same plane as the horse, who looks a very much more formidable animal than the lion. The relief is not as sculpturally satisfying as the paintings, nor are the shapes as monumental or as decisive in form. The technical difficulty of creating the illusion of depth of form and perspective, and his lack of practised skill in modelling and using clay or wax, are no doubt the reasons.

There are two paintings of the 'Horse frightened by the Lion', one on canvas and an enamel on copper, now in the U.S.A. This is quite small, and octagonal in shape, like the Royal College of Surgeons' enamel of the lion on top of the horse. The oil is a 40 inch by 50 inch, and the group is set in a romantic rocky landscape. The horses in both are heavier-boned animals than the palaminos in the earlier paintings.

According to Humphry the 'White Horse frightened at the Lion'[3] was painted from one of the King's horses at the Royal Mews, probably one of the coach-horses. Mr Payne, the architect, was able to get Mr Stubbs's permission to use them as models. Most of the paintings of frightened white horses belong to the period 1768–71, when Mr Stubbs was seeing a good deal of James Payne, through their mutual interests in the Society of Artists, of which Payne was President before Stubbs took over in 1772.

The startled action of the frightened horse backing away in terror from the unknown danger approaching was produced by pushing a sweeping brush along the ground straight at his feet. This scared the horse each time it was done, and so Stubbs was able to see the movement repeated sufficiently often to be able to make studies of the exact action.

Some years earlier, in 1761–2, he painted the pair of enormous canvases of the 'Lion and Horse' and the 'Lion and Stag' for Lord Rockingham in London, and for these he turned his attentions to studying the lion in detail, both in construction and conformation and in movement. The studies for these were made at Hounslow Heath at the villa belonging to Lord Shelbourne, who kept a lion in a cage in his garden. Mr Stubbs, who managed to get permission to work there from the gardener, spent a good deal of time studying the animal in all kinds of poses and made many drawings of it, mostly in black and white chalk or black pencil. These were all rapid and sketchy notes, very slight, hardly more than a few lines. Once he had decided on the action needed for the painting, he prepared his design and had everything ready to catch the lion at the odd moments when it happened to be in the right pose. However, as the lion seldom made exactly the right movement for the picture, Stubbs had plenty of time to make drawings and further studies of it, in all kinds of poses, eating, sleeping, walking about, and lying down. These must have been invaluable for reference later on, when he started on the 'stalking' versions of the theme. Many studies of lions and tigers are men-

[1] Illus. p. 77. [2] Illus. p. 76. [3] Illus. p. 79.

81

tioned in the sales catalogue of 1807. There were fourteen sketches of lions and tigers in one book of drawings and thirty-four tigers in another, as well as twenty-two sketches of lions and stags. Humphry describes various incidents that happened while Stubbs was standing watching the lion at Hounslow. He must all the time have been hoping to see the animal spring at, or on to, something. Even at feeding time a lion in captivity doesn't necessarily spring on to its meat, and, in the earliest versions of the theme, the lion has sprung on to the horse's back. So Mr Stubbs must have been delighted when occasionally the lion could be induced to stalk a man coming up the garden path towards the cage, and stand frozen in an attitude like a pointer, one leg up, waiting. When the man came quite near the cage, if the lion sprang at the bars it gave him vital information on how the claws are spread and stretched out to grip and tear the prey and the correct bunching of the muscles on landing. There is also an account of the timidity of the lion when faced with something that he did not understand. For example, a gardener carrying a table for Mr Stubbs to work on, from the summer-house to the lion's cage, on his head, caused the lion to run to the back of his cage and hide. Hence, perhaps, the slightly shy and retiring air of some of the stalking lions.

When Stubbs was well on with his painting he was in the habit of visiting the Royal Menageries in the Tower of London, where lions were kept in the eighteenth century. Started in the Middle Ages, when wild animals were given as curious presents to the kings, and were housed in the Tower, the animals became one of the sights of London. The Menagerie continued until William IV divided the animals between the new 'Zoological Gardens' in Regent's Park and Dublin. It was convenient to go there to refresh his memory with a look at the live animal.

With all this careful description of how the reality of the 'Lion and Horse' series was achieved, it is all the more curious that the North African trip is ignored by Humphry. Yet if it was pure fabrication, why did Mary Spencer allow it to go uncontradicted.

The final phase of the series, where the horse has sunk to the ground, is the closest in composition to the sculptural groups that Mr Basil Taylor has mentioned in his article in the *Burlington Magazine*. There is the eighteenth-century copy of a classical group that is now in the Walker Art Gallery. It was formerly in the collection of Henry Blundell of Ince-Blundell Hall, who also had a painting by Stubbs of the same subject. Stubbs could also have seen the carving of the antique group in the courtyard of the Palazzo dei Conservatori in Rome. As well as these, there is the very similar group by the sculptor, Peter Scheemakers, done in 1743, for the garden of Rousham in Oxfordshire. It is interesting that Scheemakers was working for Rockingham in 1762, at the same time as Stubbs, and it seems to me that there is a possible connection there. Perhaps the subject was suggested by the Marquis, who had seen or heard of the Scheemakers carving at Rousham.

Probably the most likely answer is that all the different episodes and incidents are correct. That the sculptures in Rome did fire his imagination, that he did take the opportunity of seeing for himself nature in the wild at Ceuta, and that once home the ideas triggered off by his travels had to wait for an appropriate moment before being put down on canvas. That moment came when the Marquis wanted a pair of large hunting paintings, rather similar in grouping to the Scheemakers, and that after a period of about five years his memory of the original idea would need to be helped by studying both the animals concerned, most precisely, particularly the more unfamiliar lion.

Ten · Wild Animals

Stubbs's curiosity about the form and structure of animals was as wide as it was scholarly. No animal was too far removed from his beloved horses to be ignored. Not only did he paint the domesticated animals, dogs and cats, and cattle and deer, but at a time when wild beasts were more of a curiosity than they are now he delighted in exploring the odd and the exotic. His interest in anatomical investigation gave his approach to the new and unfamiliar shapes a discipline and an exactness that was unaffected by the superstition and fantasy that surrounded the practically unknown. Many of the wild animals that he painted had hardly been seen in Europe before. For example, the famous rhinoceros that toured Europe in 1748 caused considerable interest wherever it was shown. It even appears in the background of some of the plates in Albinus's *Anatomy*, but is still a fantastic, rather than an exact portrait of the animal. Earlier, the strange engraving by Dürer had been considered a sufficiently accurate portrait of the beast, and much subsequent work is based upon this representation.

During the period that Mr Stubbs was Treasurer of the Society of Artists, when they were trying hard to keep going, the School, or Academy, ran a series of lectures on anatomy and chemistry. It is recorded in the minutes that they wrote to William Hunter, inviting him to give a course of lectures on Anatomy. This must have put him in a slightly awkward position, as he had just accepted a permanent post as Professor of Anatomy to the new Royal Academy. His situation must have got round to the Council of Directors, for they agreed not to wait upon Dr William Hunter's reply, but go ahead and ask his brother, John Hunter, to give the lectures instead.

The Hunters were two of the most important anatomists and medical teachers of the century, and their work was not limited to the field of human anatomical research. They were great collectors of all species of animals. John Hunter, who was an outstanding surgeon, had a large private menagerie attached to his house outside London, in the village of Earl's Court, where he kept a collection of very varied wild animals. These included leopards, bees and blackbirds, and as well as this zoo he had a huge collection in his scientific museum at Lincoln's Inn Fields. He amassed over 10,000 anatomical, pathological, and biological specimens. From the 1770s onwards he gave private lectures, and throughout his life he conducted many highly original experiments in the field of comparative biology, anatomy, physiology, and pathology. He greatly advanced the knowledge of the animal world, and was said to have dissected more than 500 different species of animal.

William Hunter, who was the elder brother, was a surgeon and anatomist, too, but he was pre-eminent in obstetrics. He had, when young, worked with Smellie, who was the rival of Dr Burton, for whom Stubbs made the plates of the midwifery book. William had a house in Great Windmill Street, which he rebuilt

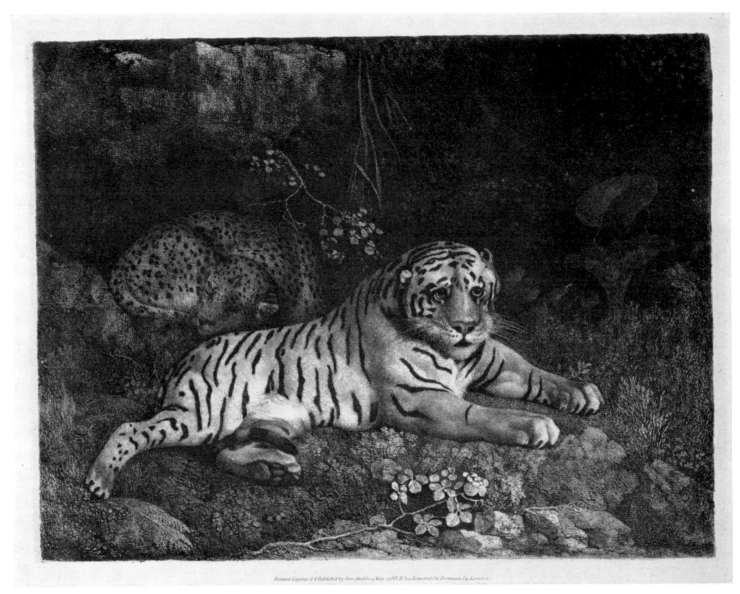

Painted Engraved & Publish'd by Geo. Stubbs 1 May 1788 N° 24 Somerset St Portman Sq London.

Tiger (Engraving). *9in* × *12in. The British Museum, London.*

84

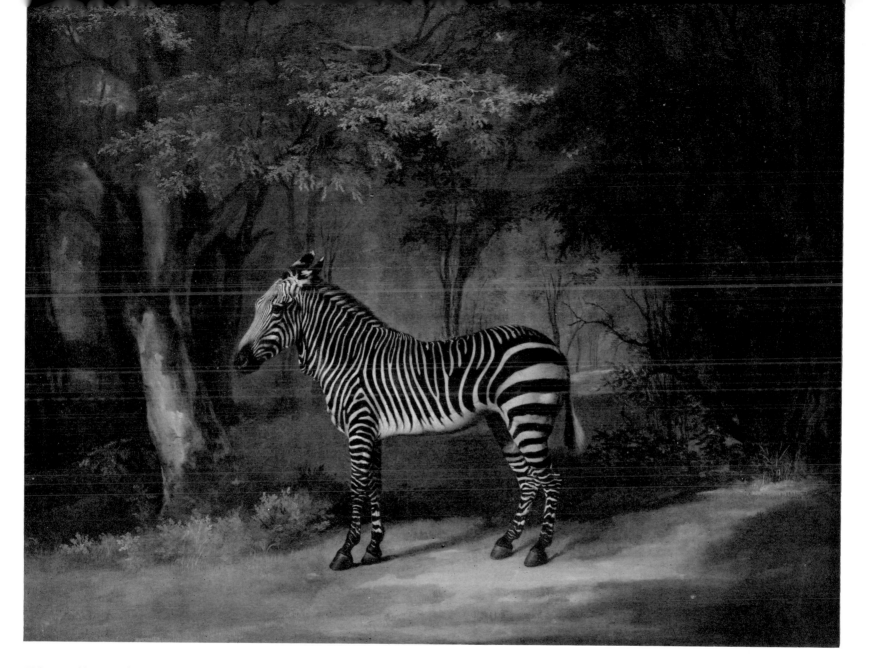

Zebra. *40½in × 50¼in. From the collection of Mr and Mrs Paul Mellon.*

on a grand scale to contain an amphitheatre for lectures, dissecting-rooms, and a very fine museum. His collections extended from anatomical and pathological specimens connected with his work, with his experiments, and with his teaching and lecturing, to his later interests of coins and medals, and minerals, shells, and corals. As well as these, he collected manuscripts and pictures and books. His library was enormous and was an outstanding collection of works. The Hunters were deeply concerned in the study of evolution, and in comparative anatomy.

Stubbs was commissioned by both the Hunters to paint studies of wild animals in the early 1770s. Perhaps it was through their connections with the Society of Artists that they came together, or did Stubbs already know them through his own anatomical researches. It is quite likely that he would have gone to some of the public lectures given by William in his lecture theatre in Great Windmill Street. He may even have been able to obtain a ticket for the course of lectures given at the Royal Academy, for he must have had many friends and acquaintances who were members, even in the very early days of its formation.

The biological museum of John Hunter was really the prototype of all Natural History Museums, and it was available to the public from the end of the 1770s. Stubbs would have been particularly interested in John's theories of animal physiology and evolution, and comparative anatomy. Presumably he would have had access to the menagerie, especially during the period of the early 1770s, when he was involved with commissions for both of them.

For William he painted a moose, which may have belonged to the Earl of Orford and is mentioned in a letter from Walpole to Hunter, a nylghau—an animal that Hunter wrote a paper on for the Royal Society, 'An account of the Nyl-Ghau, an Indian Animal not hitherto described'; he said of the picture it 'was done under my eye by Mr Stubbs, that excellent painter of animals'. Stubbs also painted a picture for him that does not appear to have survived, the portrait of the spotted cavy, and a painting of the pigmy antelope. These were subsequently left to Glasgow University, as part of the Hunterian Collection.

For John Hunter he painted a yak, which was 'Brought alive to England by Warren Hastings on his return from India. The animal was wild and intractable.' It has a solid, sinister bulk, set against blue and grey mountains. The painting of the Indian rhinoceros, of which he made a number of studies—'Nine studies of the Rhinoceros, in different attitudes' were sold on the second day of the Stubbs sale—was also a commission from John Hunter. The animal was exhibited in 1772 at Pidcock's Menagerie, in Spring Gardens.

It was to Mr Pidcock's that Mr Stubbs went late one night, according to the story: 'At the time Mr Stubbs lived in Upper Seymour Street intelligence was brought him at ten o'clock in the evening, that a dead tiger lay at Mr Pidcocks in the Strand, and that it was to be obtained at a small expense if he thought it proper to apply for it; his coat was hurried on, and he flew towards the well-known place and presently entered the den where the dead animal lay extended; this was a precious moment; three guineas were given the attendant, and the body was instantly conveyed to the painter's habitation, where in the place set apart for his muscular pursuits, Mr S. spent the rest of the night carbonading the once tremendous tyrant of the jungle.' This episode is echoed by the story that John Hunter asked the publisher, John Nicols, to 'lend him five pounds and go shares', and when Nichols asked what he was to have a share in, the reply was, 'In a magificent tiger, now dying in Castle Street.' These rare occasions when dissections could be made from the less well-known species, and in particular wild animals like

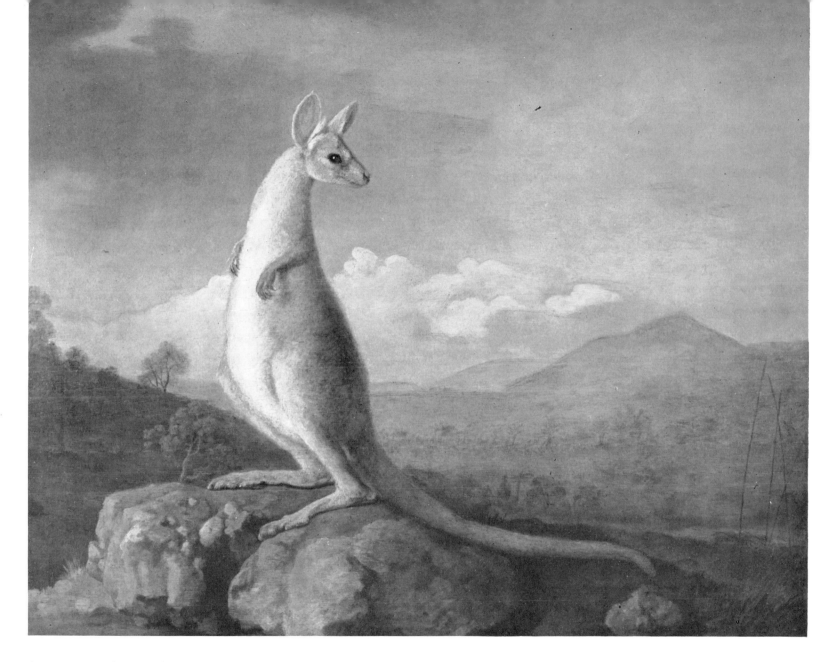

A Kangaroo. $23\frac{3}{4}in \times 27\frac{1}{2}in$. *From the collection at Parham Park, Pulborough, Sussex.*

tigers, must have been extremely exciting for men like the Hunters and Stubbs. In fact, it was probably his connections with the Hunters that stimulated Stubbs towards his last great project—the comparative anatomy of a man, a tiger and a fowl. As well as the yak and the rhino, he was commissioned to paint two monkeys, a male and a female, the property of Lord Shelbourne. One was a baboon and the other was an Albino Macaque monkey. These paintings, done for John Hunter's museum, were left to the Royal College of Surgeons, where they still are. Hunter evidently had other paintings by Stubbs, as he wrote the following in a letter to Edward Jenner; 'I have a picture by Barret and Stubbs. The landscape by Barret; a horse frightened at the first seeing of a lion, by Stubbs. I have got a dearer one, and no use for two of the same master's, but do not have it excepting you would like it, for I can get my money for it.' Curiously enough, there was until recently one of the 'Lion and Horse' series at the Royal College of Surgeons, part of the Down House Collection, a little octagon in enamel on copper,[1] of the lion on top of the horse. It is probably the painting bought from Stubbs by Lord Melbourne for 100 guineas—no small sum, in those days, for a painting $9\frac{1}{2}$ inches by 11 inches. It was exhibited at the Society of Artists in 1771, 'A Horse and Lion in enamel (£105 with frame)'. This is the one that Horace Walpole called 'Very pretty'. Could this have ever been Hunter's 'dearer one'. The Royal College of Surgeons are not certain about its history.

Stubbs painted many pictures of big game, lions and tigers and leopards. The tiger was one of his favourite wild animals. The shape obviously interested him and the play and design of the characteristic stripes over the form was a challenge. The same interest applies to the lovely zebra,[2] which he painted early in the 1760s—it was exhibited in 1763. This animal, with her mate, was brought over from the Cape of Good Hope and presented to

George III and Queen Charlotte, when Prince and Princess of Wales. It appears to have been painted entirely for Stubbs's own interest and not as a Royal commission. It was in the sale of his works in 1807, and is now in the Mellon Collection, which also has a reclining tiger, outside its lair, in a dark and rocky landscape background. Stubbs's tigers are magnificent beasts, very much the 'Tiger, tiger, Burning bright, in the Forests of the Night'. They are beautiful, awful, and ferocious. In one of the added notes to the Humphry memoir is this story: 'For the Duke of Marlborough Mr Stubbs painted a large Royal Tiger, when it was nearly finished, it happened to stand on the ground in an out building, where some country farmer like men, followed by a little cur dog came to look at it, soon as the Picture caught the dogs eye, he screamed, ran behind his master, trembled, and was guilty of an indelicacy incident to dogs when terrible alarmed, nor would he by any means, be made to look at it again.'

Against the grandeur of his lions and tigers, one can contrast the 'Leopards at play' belonging to Lord Yarborough, who appear almost gentle and cuddly, rolling happily around with a slightly human grin. One of Stubbs's most magnificent compositions of wild animals is 'A Cheetah with two Indians'. This large painting—rather more than 6 feet by 8 feet—was painted for Lord Pigot about 1765. The cheetah in the picture was given to George III by Lord Pigot, who was Governor of Madras during the 1760s and 1770s. It was sent over to England, with its two Indian servants, and a stag-hunt was arranged in Windsor Great Park, to show off its hunting ability, but unfortunately such a large crowd gathered to watch that the poor thing was overwhelmed and refused to hunt. The painting of the cheetah is Stubbs at his most remarkable best. The drawing of the legs, furry, yet powerful and muscular, is so well understood and expressed that it would be easy to model them in the round from

[1] Illus. p. 79. [2] Illus. p. 85.

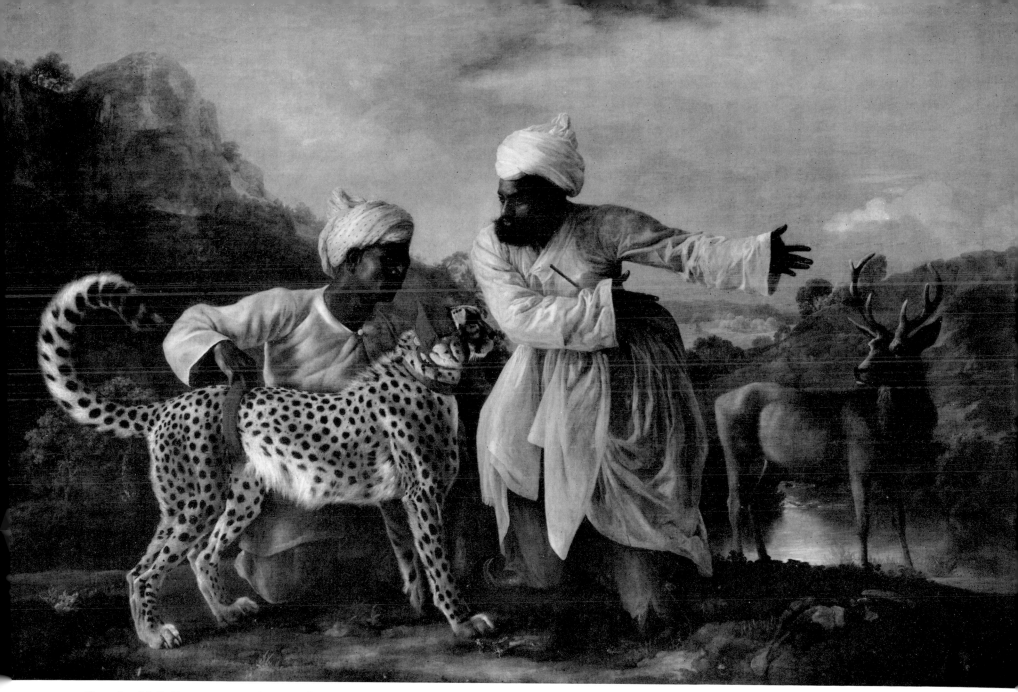

Cheetah with Indian servants. *81in × 107in. Manchester City Art Galleries.*

the information given. But for all this anatomical exactness, there is a simplicity of form, so that neither the furriness, the pattern of spots, nor the structure of the animal become obtrusive and spoil the whole. The group and its background are wonderfully planned and designed to give the impression of an animal, built for power and speed, just about to be released and to bound away after its prey. The cheetah's weight is slightly back on its hind legs; its forelegs are braced against the forward movement to come. The Indian handler is still keeping slight contact by four fingers through the band round its loins. The other servant gestures with eloquent thumbs in the direction the cheetah is to go. The cheetah's hood is raised; he is taking stock of the situation and in a moment or two he will be a streak of spotted gold in the distance. It is a very memorable work.

Another figure of importance in the expansion of eighteenth-century knowledge, and one who was connected with Stubbs, was Sir Joseph Banks—1743–1820. President of the Royal Society from 1778, he was educated at Eton and Christchurch. He studied natural history and travelled widely. After visiting Newfoundland, he accompanied Captain Cook around the world, in the *Endeavour*. While on this trip in 1768–71 he made a very valuable collection of animals. It was during the expedition to the Pacific that Banks became one of the first Englishmen to see the kangaroo. In his diary for 1770 he mentions having seen the animal for the first time, but efforts to catch one alive failed, as they were able to move much faster than the expedition's dogs. However, a few days later he is able to write: 'This day was dedicated to hunting the wild animal. We saw several and had the good fortune to kill a very large one weighing 84 lbs.' Sir Joseph commissioned Stubbs to do a painting of a kangaroo which was exhibited at the Society of Artists in 1773 as 'A portrait of a Kongouro from New Holland, 1770.' It was the first of the species

to be seen in England, and Stubbs must have reconstructed it from the skin of the dead specimen brought home by the expedition.[1]

After painting this curious creature, all others must have seemed quite ordinary by comparison, though Stubbs did paint a dingo for Sir Joseph, as well as the delightful drawings of lemurs, which are in the British Museum, where his collections of specimens and his library are housed.

The Walker Art Gallery, Liverpool, have the beautiful portrait of the little green monkey painted when Stubbs was seventy-three. It was in the Stubbs sale, when it was described as 'Portrait of a Monkey gathering Fruit—an upright, an exceeding high finished Picture'. It sits on a stone by a tree-trunk, gathering peaches, and looking out of the canvas with a sad and harassed little monkey face. It is a lovely representation, most sympathetically seen and brilliantly executed.

Also in the same gallery is the famous 'Lincolnshire Ox',[2] another portrait, though not perhaps quite a wild animal. It was bred at Gedney in Lincolnshire, in 1782, and when it was fully grown measured 19 hands. It was brought to London in 1790, and was exhibited at the Lyceum in the Strand. Stubbs painted it with its owner and breeder, Mr John Gibbons of Long Sutton, in St James's Park. With them is his fighting-cock, a proud fearless little bird, crowing at the enormous ox, who continues to munch placidly. The heavy, massive beast was painted almost as an advertisement for the cattle breeder; in fact, in a press cutting of 29th April 1790 'Stubbs has given the Proprietor of the Lincolnshire Ox a most efficacious advertisement', and the engraving by G. T. Stubbs was used as part of a publicity campaign to promote the breeding of prize cattle. Stubbs painted a number of other pictures of cattle, including one of fighting bulls, which was exhibited at the Royal Academy in 1787 and was much criticized

[1] Illus. p. 87.

[2] Illus. p. 93.

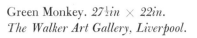

Green Monkey. *27½in × 22in.*
The Walker Art Gallery, Liverpool.

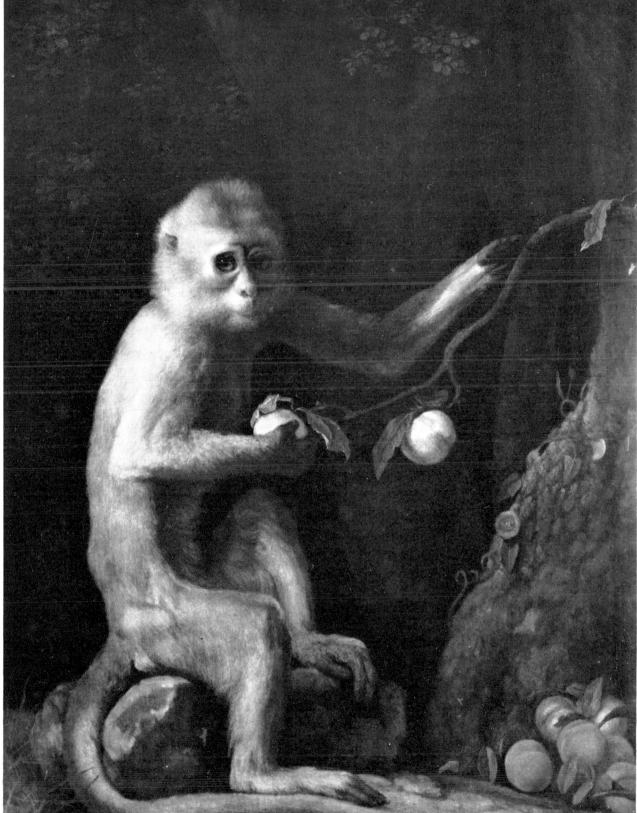

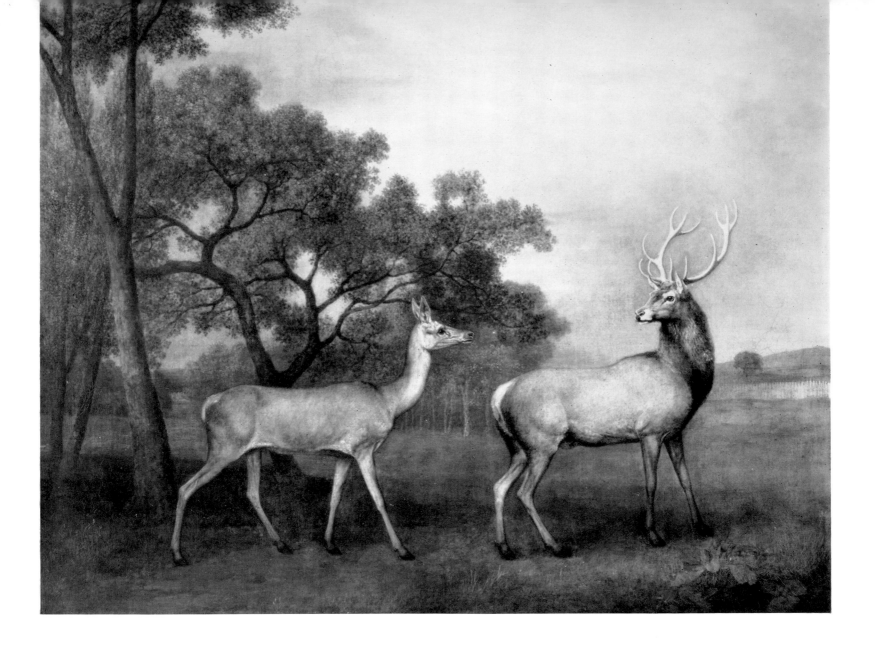

The Red Deer, Buck and Doe. *39¾in × 50½in. Reproduced by Gracious Permission of Her Majesty the Queen.*

92

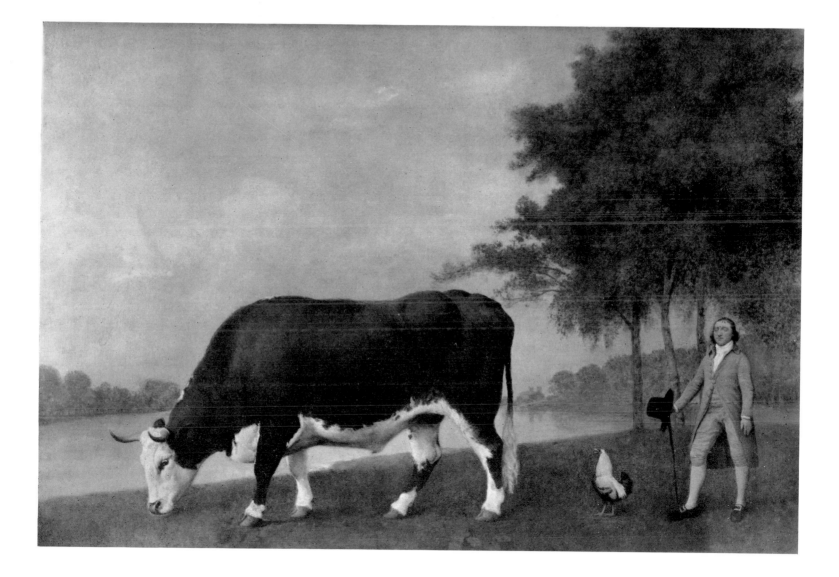

Lincolnshire Ox. *26in* × *38in. The Walker Art Gallery, Liverpool.*

at the time as being undramatic and tame, though the engraving of it gives the impression that it conveyed the colossal strength and power of two evenly matched bulls, clashing head on, and continuing to push each with every ounce of available weight. It was an observation from life and not a melodramatic fight; it was just a couple of animal battering-rams in deadlock.

At the same period as the Lincolnshire Ox was painted Stubbs was working for the Prince of Wales, later George IV, and as well as the horse portraits there is a painting of 'Red Deer, Buck and Doe'. They emerge from a clump of trees, the buck leading, turning his head and neck back to see that all is well. The doe trustfully follows him. Their characteristically slender legs and graceful carriage has been caught and drawn with his usual precision. They were probably bought for the Prince in 1790, when 'five Brace and a half of Red Deer at 50 guineas per Brace' were supplied by John Brookes, and four more brace were bought from Paris. Some of the deer were taken to Bagshot, Brighton, and Kempshott, and Stubbs may have painted them at one of these places—perhaps Brighton is the most likely, as he put a coast scene very like Brighton in the background of 'William Anderson with two saddle-horses' which he painted a little later on.

Many of Stubbs's paintings have dogs in them. Often portraits of pets, but always cleverly used as links in the main design, as well. Look, for example, at the part played by the little dog in the centre of the painting of 'Two Horses and a Groom'; take him away and the whole arrangement splits in two. Even lower his head a little and the movement of the design is lost, for it depends on the poise of his head, looking upwards, leading the eye up to the groom's arms and through to the horse, and echoing the curved branch of the trees beyond, to give the picture its expressiveness and interest.

In the picture of John and Sophia Musters[1] the dog in the centre links the couple at ground level and breaks up the line of the foreground, as does the second dog, who leads the group along. In one of the notes in the Humphry memoirs the following may perhaps refer to the centre dog: 'Another incident still more extrodenary [sic] is of a terrier dog the property of Mr Musters—he had two of them (I believe, brother whelps) which could never agree but were continually fighting, for which reason, one of them was committed to the charge of the Huntsman, and was constantly in the Kennel or Stables, whilst the other was a favourite in the house. Mr Stubbs having painted a horse for Mr Musters, the portrait of the house terrier was introduced, (not exceeding an inch or so in height), the picture was hung over the parlour chimney piece, when not withstanding the height it was hung, or the smallness of the dog, the other terrier never came into the room (which he frequently did with some or other of the grooms) but he looked up at the picture, setting up his bristles, growling and giving it every challenge in his power.'

In the 'Melbourne and Milbanke family'[2] the dog in the right-hand corner returns the eye to the centre of the picture, and the exact placing of the pointers in the portrait of Sir John Nelthorpe out shooting, make the picture into a distinguished design.[3]

As well as adding small portraits of pets to his larger groups, Stubbs painted many pictures in which the dog was the principal feature, real portraits of the animal, treated with as much thought and care as he gave to his other work. The Mellon Collection has three notable Stubbs dogs. One of these is a water-spaniel, and is the only known portrait of a dog without a background.

The other brown and white water-spaniel has a landscape background[4] with a stretch of water and a weeping tree. He is perched on a bank, above the water, among the wild flowers. His spotted curly coat is most decoratively painted, though without losing the solidity of the structure beneath the wool. Dog por-

[1] Illus. p. 174. [2] Illus. p. 162. [3] Illus. p. 102. [4] Illus. p. 97.

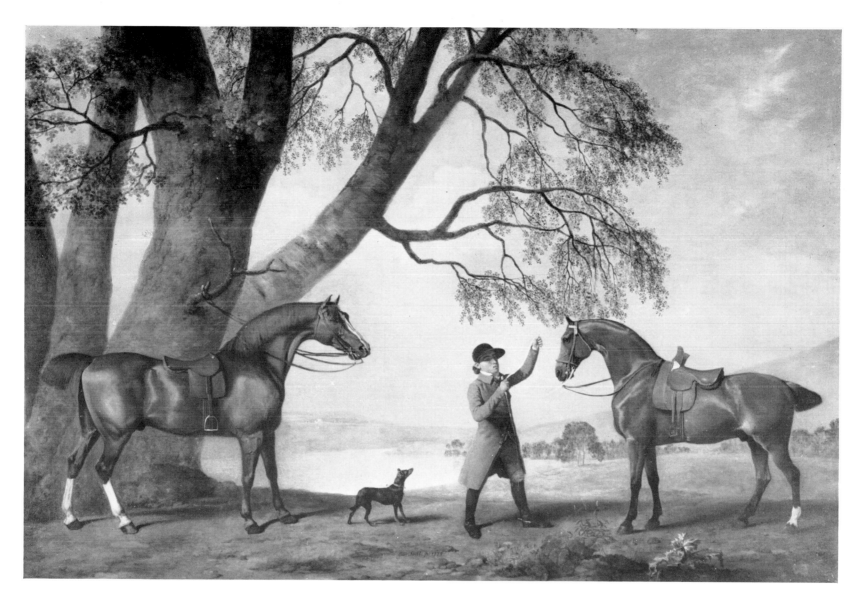

Two Horses and a Groom. *35½in × 53½in. From a Private Collection.*

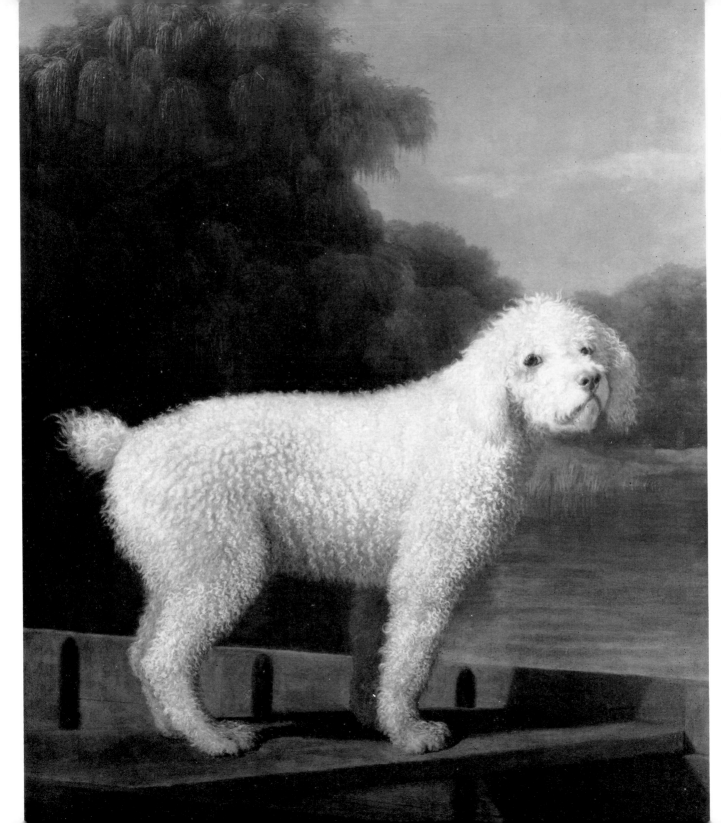

White poodle in a boat.
50in × 40in.
From the collection of
Mr and Mrs Paul Mellon.

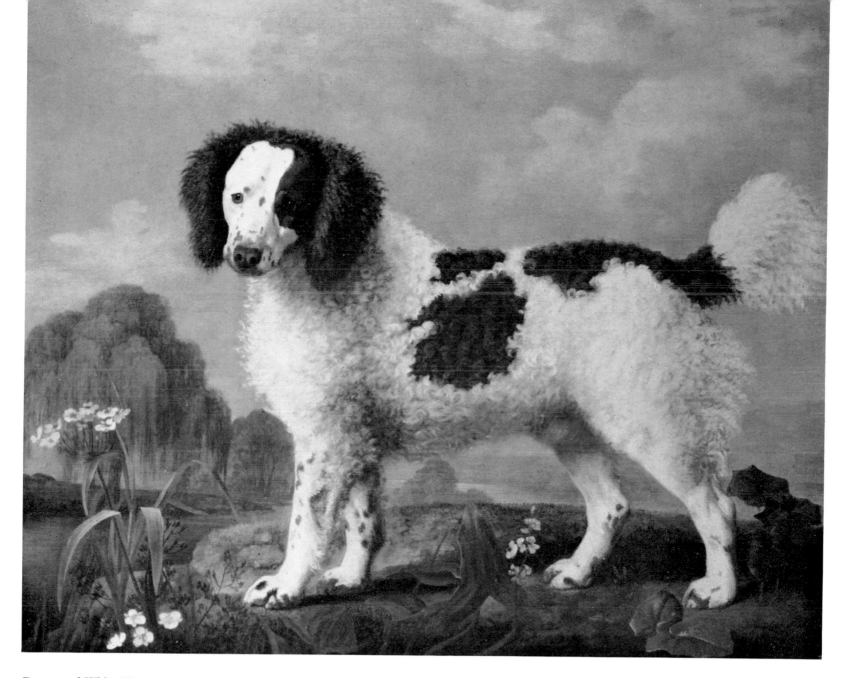

Brown and White Water Spaniel. *31¾in.* × *38¼in. From the collection of Mr and Mrs Paul Mellon.*

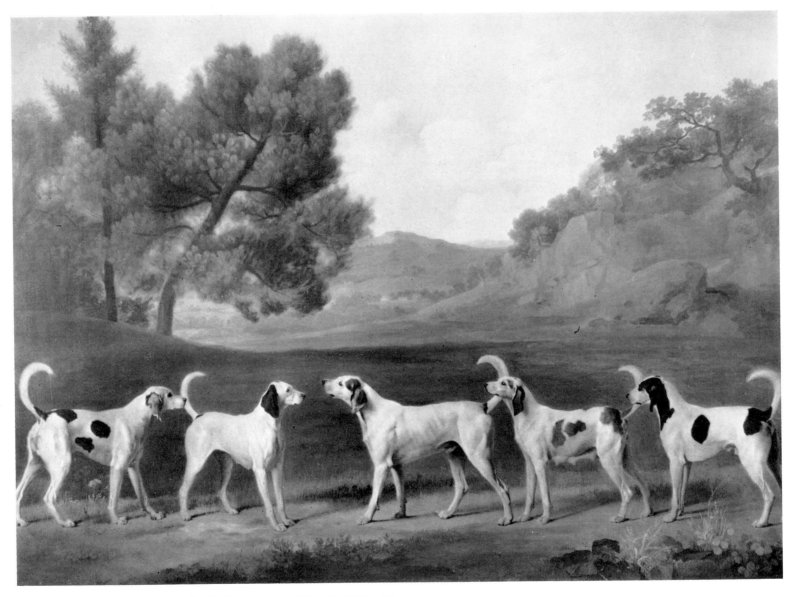

Frieze of Hounds. *40in × 50in. By kind permission of The Earl Fitzwilliam.*

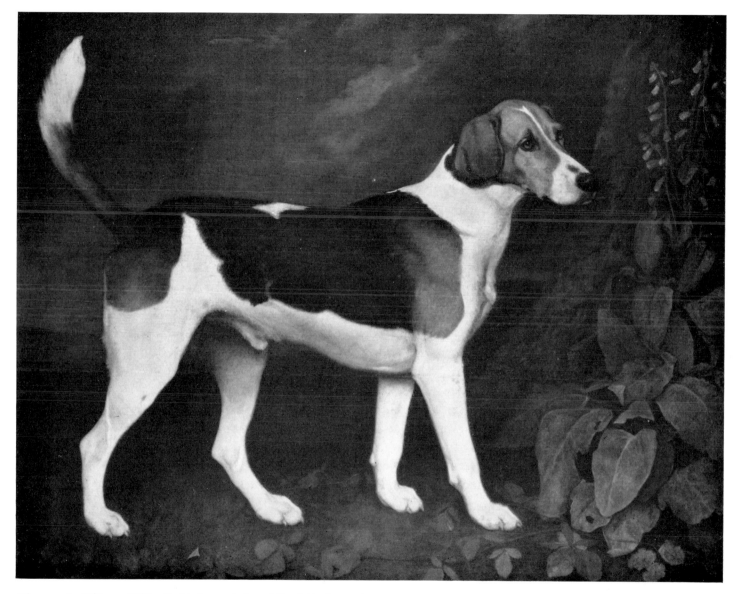

Ringwood. *47¼in* × *57½in. By kind permission of Lord Yarborough.*

traiture really began in the reign of Louis XIV in France, when he had his own dogs painted, and it was carried on and developed in Louis XV's reign by such painters as Oudry. The third portrait is a portrait of a poodle in a punt, painted in the 1760s. Stubbs has brilliantly caught the odd position of a dog trying to balance himself against the rocking of the boat, forelegs braced, hind legs wobbly, with his chin stuck out and a miserably sick expression on his face.

In the cluttered, grubby parlour-cum-studio of the sculptor Nollekens, famous for his many busts and his miserly ways—he would always pinch the nutmegs used for the mulled wine at the Academy Club dinners—was a painting by Stubbs. It was on the west side of the parlour over 'Mr Taylor's drawing of Mr Pitt's statue, in a black frame which almost destroyed its effect: and over it were two pictures, one of Nymphs by "Old Nollekens" and the other was of a dog by Stubbs'. Perhaps it was a portrait of Mrs Nollekens's pet poodle.

Another dog portrait, which Stubbs painted for the Prince of Wales, is that of 'Fino'. He appears twice, once in the 'Prince of Wales's Phaeton',[1] where he is a most important link in the composition and in the whole incident. And secondly in a life-sized painting of himself being teased by an engaging small spaniel called 'Tiny'. He is the most attractive animal, large and black and white, rather like a panda; he is very much bigger than the little poms of today, though he is described as a 'Pomeranian'. Stubbs has treated his long, fluffy coat most decoratively and has enjoyed himself painting the fur.

The following story is told of Lady Spencer's Pomeranian: 'Mr Stubbs painted the portrait of a large dog (laying down) a setter, belonging to Lord Gormanton. This picture stood on the floor when Lady Spencer, with a favourite Pomeranian dog, called at his house, the moment she entered her dog flew into a violent passion at the picture of the setter, and tore off the paint about the ears, her Ladyship expressed much concern for the mischief he had done, but said the only apology she could possoble [sic] make was, that her dog had paid him a very great compliment, this picture was sold in his sale.'

For Lord Spencer, Stubbs painted a portrait of his Dutch barge dog, Mouton. He was a great pet of the first Earl, who is said to have drawn his sword in Piccadilly and chased all the way to Hyde Park Corner after a man who had kicked the dog. He is portrayed with his paw firmly on a piece of toast—there must surely be a story behind the gesture, but it has not survived.

One of the most beautiful of Stubbs's dogs is the foxhound, Ringwood,[2] painted for Lord Yarborough in 1792. It is a magnificent portrait of a hound—and also a magnificent portrait of a foxglove, large and upstanding, which balances the tail of the hound on the opposite side of the canvas. Stubbs did quite a lot of work for Lord Yarborough at Brocklesby. Some years earlier he had painted a portrait of another famous hound, Driver, greeting an old pony, a tubby pet Shetland. On the back of the canvas is written, 'This animal was a present from Mr Viner to Mr Pelham when a child. He taught him and his brother to ride, and in gratitude for past services had his picture drawn in the Twenty eighth year of his life. The hound, Driver, was a famous Dog of Mr Pelham. The Landscape is a view of Brocklesby Hall. Jan. 12th 1777.'

It would be unforgivable to leave out the beautiful frieze of hounds painted for Lord Rockingham, at the beginning of Stubbs's career, after he made his London début. This is a particularly lovely arrangement, planned like the 'Mares and Foals' theme, with rhythmically flowing lines across the long canvas, and with interesting arabesques of heads and tails. Each hound is an individual with a personality of its own.[3]

[1] Illus. frontispiece. [2] Illus. p. 99. [3] Illus. p. 98.

An Old Pony and a Hound.
23½in × 27¼in.
*By kind permission
of Lord Yarborough.*

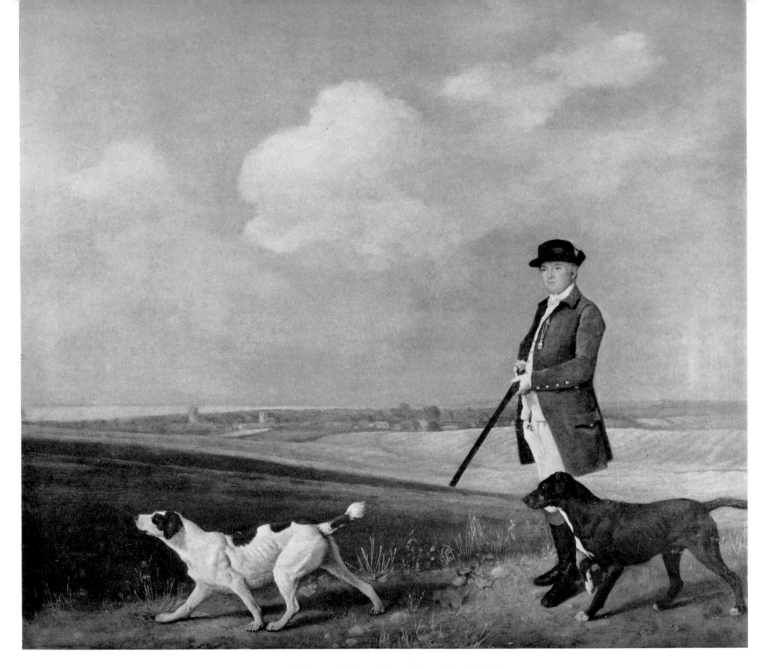

Sir John Nelthorpe out Shooting. *24in* × *28in. By kind permission of Lt.-Colonel R. S. Nelthorpe.*

102

Eleven · Enamel Painting

One can divide Stubbs's labours into three; firstly, portraits and other commissions; secondly, themes and variations, painted mainly to please himself, and, thirdly, experimental projects of a scientific nature. One can then divide the projects into five: project one, the midwifery undertaking in York; project two, the experimental work done to find a suitable method and technique by which to etch and engrave the plates; project three, a very major and long-term undertaking—*The Anatomy of the Horse*. This finished in 1766 with the publication of the book, and though Stubbs had many commissions, his restless energy and inquiring mind were no longer completely occupied and at full stretch. It was some time during this period, late in the 1760s, that he became involved in his fourth project—the fifth project was, of course, the *Comparative Anatomy*, which he did not live to finish—but this fourth project was triggered off by the miniaturist, Richard Cosway.

Cosway, 1742–1802, the 'Macaroni Miniature Painter' as the caricaturists nicknamed him, was famous for his love of elaborate clothes and became known as one of the most foppish men of the day. He was also called 'Tiny Cosmetic' by his less kind friends. He always wore a dress sword, even appearing with one in Zoffany's painting of 'The Royal Academicians in the Life-School'. It caused his downfall on one occasion, when the Prince of Wales visited the Royal Academy and Reynolds (the President) was having an attack of gout. To his great delight, Cosway was asked to deputize for him and receive the Prince. Gorgeously arrayed in dove-coloured court dress, lavishly embroidered with silver, and with his sword at his side, he pompously escorted the Royal Party round the Exhibition and all went well. Then, as the Prince was leaving, poor, grand little Cosway, backing ceremoniously to the Royal Carriage, got his sword between his legs and fell flat on his back in the mud. Angelo records the Prince as saying with glee, as he drove away, '*Just* as I anticipated. Oh ye Gods!'

Not perhaps the kind of man that one would imagine Stubbs to have much time for, though Cosway lived quite near him for a time; in fact, Farington says he actually lived in Somerset Street, though it was probably Orchard Street, just round the corner. They were both connected with the Society of Artists and served together on the hanging committee of 1769.

Cosway had received some 'loose and amorous subjects from abroad' as commissions to paint in enamel, and while discussing this with Stubbs he suggested his working in enamel, too. He usually worked on ivory himself, producing dainty, rather exquisite little portraits, but he had made some experiments in enamel painting, on snuff-boxes.

Stubbs was quite interested in the idea, and agreed to try it out. In keeping with his usual approach to the unknown, he stipulated that he would only do so if it were possible and practicable to produce pigments to work with that would remain the

same colour when fired, his other condition being that grounds of a suitably large size should be obtained. There was a difficulty attached to the question of size. The ground, or support, for an enamel painting has to withstand firing, and is normally metal. Sheets of copper are usually the ground for enamel miniatures, but the size of the painting is limited by the fact that the metal support has to be thin, otherwise it becomes too heavy, and if the size is increased warping takes place. So, though it would have been perfectly possible to procure quite big sheets of copper, the largest size that was technically suitable was 15 inches by 18 inches.

It took Stubbs a couple of years of chemical experiments and research to arrive at a complete set of pigments that remained constant and did not alter during firing. 'For this purpose he set about to make himself a complete set of colours upon a new principle, and after a series of attempts with various success, which continued the space of near two years, with great expence and endless labour and study, generally making Memorandums of his preparations and his experiments. He at length completed a set of colours for this, having out of more than 100 lbs weight of colour produced about eighty one pounds, some ounces, fit for his purpose, making in all nineteen different tints . . . It should be noted that these experiments were made, as his engravings had formerly been, at leasure days and hours between the commissions he held and was executing, never laying any task aside. By which it would seem from the time that required to do them, that his general business for oil pictures was beginning to fail him.'

In the Society of Artists Exhibition of 1770, 'A lion devouring a horse, painted in enamel' was shown, of which Horace Walpole said 'very pretty', and 'a singularly large piece of enamel and fine'. This was signed and dated 1769, although Humphry mentions the year that Stubbs first started his chemical experi-

ments as 1771. The painting used to be in the collection of the Royal College of Surgeons, and was probably the one bought by Lord Melbourne for 100 guineas, 'being the first picture in enamel that our author sold'. The size is 10 inches by 11 inches and is an octagonal shape—practically all the enamels on copper are rounded or octagonal, and are about this size. In the following year he exhibited 'A horse and lion, in enamel (£105 with frame)', of which Walpole noted 'exhibited last year—very fine'. This was probably a duplicate, or a very similar painting, rather than the same one.

The method or technique of painting in enamels on copper was roughly like this—the copper plate, which had to be slightly convex to prevent it warping, was coated with a layer of white opaque enamel or flux, almost a white glass. This had to be fired on to the copper base; then it was ready for the painting, which was done with pigments, mostly metal oxides, mixed with oil—usually spike oil. Once the painting was completed, the whole thing had to be fired again to fuse the pigments with the flux beneath. It was often painted in several stages, a new firing being needed after each stage.

Stubbs was not really happy when he was confined to the almost miniature proportions of copper plates, and he conceived the idea of painting in enamels on a ceramic or earthenware tablet. This created its own problems of how to achieve a large flat plaque in pottery, unwarped and uncracked. Stubbs applied to various potteries and to the Artificial Stone Manufacturers, but they were not at all interested in the undertaking. It was a difficult technical problem and an experimental job that was unlikely to be profitable, and there would be no great desire for the article once it was successfully produced, unless, of course, Stubbs started a fashion for painting on pottery, and even then the market would be very limited.

Eventually, somewhere about 1776, Josiah Wedgwood agreed to see whether he could produce something suitable. Wedgwood was a man somewhat like Stubbs in character. He had a scientific and inquiring mind; his motto, 'Everything yealds to experiment', might have been said by Stubbs. He was elected a Fellow of the Royal Society in 1783, which is a tribute to his qualities of mind.

Born in 1730, the last of thirteen children, whose father died when he was only nine, he had to leave school and start work under his elder brother Thomas. Five years later he became his brother's apprentice, but in 1749, when his apprenticeship ended, his brother did not take him into partnership. After working for a while with Thomas Whieldon, one of the foremost potters of his time, he set up on his own. He made his name through the manufacture of 'useful' ware, and devoted a good deal of time and many experiments to improve the design and quality of cream-coloured earthenware. He was so successful that in 1765 he opened a London showroom and received an order for a tea-service in green and gold from Queen Charlotte. The service pleased her so much that she ordered a set of cream-coloured ware as well, and allowed Wedgwood to christen it 'Queen's Ware', as it is still called today. About five years previously, on one of his business trips, he met Thomas Bentley, a Liverpool merchant, who had travelled abroad and spoke French and Italian, and in addition had a great interest in and knowledge of Classical and Renaissance Art. He was highly intelligent, with excellent taste and courtly manners, and the friendship that grew up between them led to a partnership in 1769. They wrote to each other practically every day, and though Bentley's letters to Wedgwood have not survived, Wedgwood's to Bentley have been preserved. Bentley took over management of the London showroom, and supervised the painting and design that was done by their craftsmen in Chelsea. Wedgwood stayed at home doing his experiments at Etruria, as he called his new house and factory, between Hanley and Newcastle under Lyme. They were named after the province in Italy where Etruscan pottery was made.

It was through Bentley that Wedgwood met many of the great men of the period, particularly of the arts and sciences, such as Sir Joseph Banks, Matthew Boulton, who had a factory producing ormolu and the new 'Sheffield Plate', recently discovered by a cutler wedging a silver knife in his vice with a penny; when the silver was heated it fused to the copper penny, and from this discovery that thin sheets of silver could be fused to a copper base the idea of Sheffield Plate was born. He also held a share in the patent of James Watt's steam engine and went into partnership with him. He said to James Boswell, 'I sell here, Sir, what all the world desires to have—POWER.' Bentley knew Watt and Dr Erasmus Darwin, who pioneered so many subjects, and who supervised the amputation of Wedgwood's leg in 1768. His daughter Suzannah married Darwin's son and was the mother of Charles Darwin—the biologist. They were also acquainted with James Priestley, who discovered 'dephlogisticated air'—better known now as oxygen. These were all men with whom Stubbs had much in common, an independence of thought, and of philosophical inquiry into the secrets of nature, by the correlation of facts.

Wedgwood was an artist-craftsman, who had a deep appreciation of shape and design, and both he and Bentley realized the value of using first-rate painters and sculptors, so, when Stubbs applied to them for help in making large earthenware plaques for his enamel paintings, they were both sympathetic towards the idea. Unfortunately there are no letters from Stubbs in the Wedgwood archives and the only references to him are in Wedgwood's to Bentley. The production of these large plaques

or tablets, as Wedgwood called them, was not an easy matter, and it took a long time and much trouble to perfect them. From October 1777 he was experimenting with the plaques, first to try to find suitable materials, as the ordinary cream or white ware would not do for the purpose. He even tried out some special earth or clay from the estate of the Duke of Athol. In 1777 Wedgwood wrote to Bentley: 'My complements to Mr Stubbs. He shall be gratified but large tablets are not the work of a day and we have been labouring at the apparatus for the purpose from the day I came down and can report some progress.' In another letter he wrote: 'We have fired three tablets at different times for Mr Stubbs, one of which is perfect and the other two are cracked and broken all to pieces. We shall send the whole one 22″ × 17″ on Saturday and are preparing some larger.' These early 'tablets' were all about this size, but a couple of years later he says: 'I wrote to you by post this morning but wish to say a word or two concerning Mr Stubbs and his tablets. We shall be able now to make them with certainty and success of the size of the three in this invoice and I hope soon to say as far as 30″—perhaps ultimately up to 37″ × 24″, but that is at present in the offing and I would not mention to Mr Stubbs beyond 30″ at present.'

The experiments had to take place when business would allow, and when the kilns were available. In October 1779 he writes: 'My first attempt has failed and I cannot well proceed in my experiments till we put by work for Christmas when our kilns will be at liberty for my trials.'

Stubbs stayed with the Wedgwood family at Etruria in 1780 and painted portraits of both Josiah and his wife Sarah in enamel on oval tablets, 20 inches by 16 inches. It was this year that he began to use them seriously and was pleased with the result. The following year he started to exhibit them at the Royal Academy, and he must have felt he was succeeding after all his time and

trouble, to say nothing of the really surprising amount of expense that was involved in the production of the tablets. On 30th May 1779, Josiah wrote: 'If Mr Stubbs succeeds he will be followed by others to which he does not seem to have the least objection, but rather wishes for it and if the oil painters too should use them they may become a considerable object. At present I think we should give Mr Stubbs every encouragement to proceed and establish the fashion. He wishes, you know, to do something for us by way of offsetting against the tablets. My picture and Mrs Wedgwood in enamel will do something. Perhaps he may take your Governess and you in by the same means. I should have no objection to a family piece, or rather two, perhaps in oil, if he should visit us this Summer at Etruria. These things will go much beyond his present trifling debt to us. Now I wish you to see Mr Stubbs, and if the idea meets your approbation, tell him that if it is convenient for him to pay in money for what he has hitherto, it will pay something towards the kilns and alterations in kilns we have made, and other expenses we have been at in essays, and the next £100 or £150 in tablets, perhaps more, shall be work and work—we will take the payment in paintings.'

In an account in Stubbs's own handwriting which is with the Humphry manuscripts in the Picton Library, it can be seen that he charged £19 13s. 9d. for Mrs Wedgwood's portrait. He charged rather more for the portrait in oils on a panel of Richard Wedgwood, Josiah's father-in-law. It was a 28 inch by 23 inch, so it was bigger than the pair of enamels of Mr and Mrs Wedgwood; it cost £26 5s. and was mentioned on the same bill. He was painting him at the beginning of October 1780, as Josiah wrote to Bentley . . . 'Mr Stubbs has made some progress in a portrait of my father-in-law which will be a very strong likeness.' This is obvious from the painting of the old man, who comes across most sympathetically, and is as fine a portrait as any done by the

A Lady reading in a
Wooded Landscape.
$24\frac{1}{2}$ in. \times $29\frac{1}{2}$ in.
*The Trustees of the
National Trust (Bearsted
Collection, Upton House,
Nr Banbury).*

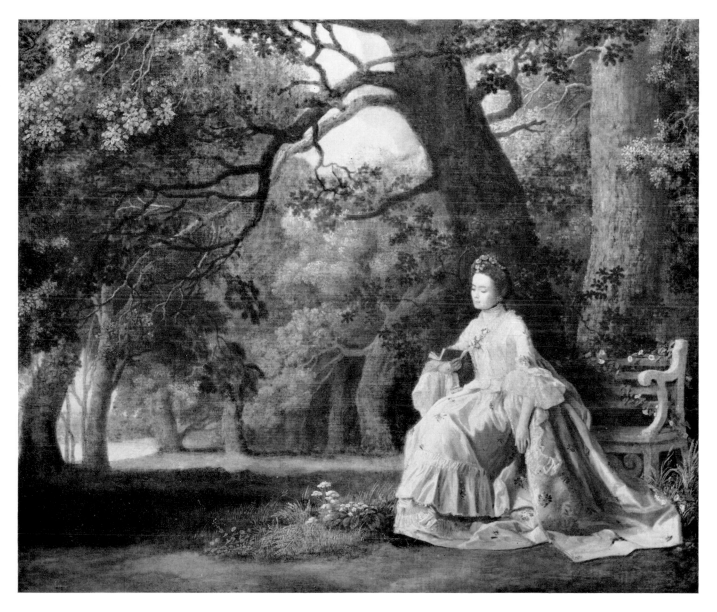

fashionable face-painters of the age, who were so highly thought of in comparison with 'mere animal painters'. It shows great perception and insight into the character of Mrs Wedgwood's father. He also said: 'The likeness of those that approach towards being finished grow weaker as the painting increases. Mr Stubbs says the likeness will come in and go off many times before finishing . . . the first sketches were very strong likenesses, and the after touches have hitherto made them less so, but I dare say he will bring them about before he takes his final leave of the picture.'

Stubbs was by this time in his career very well established publicly as a painter of animals, wild ones as well as horses, and still had plenty of work. Unfortunately, the taste of the time placed the animal painter at the very bottom of the list. The French Académie Royale, founded in 1648, had graded subjects in aesthetic importance, starting with what they considered to be the highest form of art—history-painting, followed by portrait-painting. A very long way below came animals and landscapes. They were even against the inclusion of 'vulgar beasts' in paintings at all. This undoubtedly affected the position of the animal-painter in England in the eighteenth century. The whole situation must have been very frustrating to Stubbs, who had been exhibiting at the Royal Academy for a number of years, yet had not been elected a member. This was partly because animal-painters, no matter how good their work, tended to be passed over. He had firmly established himself in one type of work and it proved impossible to change his public image and turn into an accepted portrait-painter. It was a source of great disappointment and annoyance to him that he had been unable to make the art world of his day consider him equally competent as a history- and portrait-painter, as well as a horse-painter. Wedgwood wrote in 1780 that he hoped the portraits that Stubbs was painting of

the family would 'give him a character which is entirely new to him, for nobody suspects Mr Stubbs of painting anything but horses and lions, dogs and tigers, and I can scarcely make anyone believe that he ever attempted a human figure. Indeed Mr Stubbs resents much his having established this character for himself, and wishes to be considered an history and portrait painter. How far he will succeed in bringing about the change at his time of life I do not know.' Stubbs was then fifty-six years old.

The critic, 'Peter Pindar', whose *Lyric Odes* (to the Royal Academicians) were usually unkind, cutting (and popular) and were published between 1782 and 1786, wrote the following lines about Stubbs:

> 'Tis said that naught so much the temper rubs,
> Of that ingenious artist Mr Stubbs,
> As calling him a horse-painter—how strange,
> That Stubbs the title should desire to change!
> Yet doth he curses on the occasion utter,
> And foolish, quarrel with his bread and butter.
> Yes—after Landscape, Gentlemen and Ladies,
> This self same Stubbs prodigious mad is,
> So quits his Horse, on which the man might ride
> To Fame's fair temple, happy and unhurt;
> And takes a hobby-horse to gall his pride,
> And flings him, like a lubber, in the dirt.

'Pindar', was the *nom de plume* of Dr Wolcott, who brought the painter Opie to London. His wit, according to Angelo . . . 'seemed not to kindle until midnight, at about the period of his fifth or sixth glass of brandy and water'. He wrote a second Ode to Stubbs:

> Well pleas'd, thy Horses, Stubbs, I view,
> And eke thy Dogs, To Nature true,

Let modern artists match thee; if they can:
Such animals thy genius suit.
Then stick, I beg thee, to the Brute,
And meddle not with Woman, nor with Man.

Poor Mr Stubbs, he never really threw off the title 'Horse-painter'; it even pursued him right up to the present day. Though now it is said in admiration, rather than the reverse. The low repute in which the animal- or sporting-painter had been held for so long obscured a true appreciation of his work and continued to do so until the Whitechapel Gallery Exhibition in 1957 opened the eyes of the art critics and the public. It is only recently that his work is beginning to be taken really seriously as a major contribution to not only British Art but to European painting as well. But in his lifetime, like so many of the really great painters, he was not appreciated for his qualities, which were unfashionable. He remained unmoved and unchanged, or practically so, by the cult of the picturesque that was so popular in the eighteenth century. His scientific mind had no time for the false and faked Gothic ruins, dead trees, and broken-down ivy-covered walls beloved by William Gilpin and Uvedale Price, whose romantic ideas demanded the destruction of symmetry by decay. The ancient, gnarled, and knobbly was infinitely preferable to the young and smooth, whether it was a tree or a horse.

Was he really so resentful at being categorized as an animal-painter? He found the subject so much to his taste and though his interests were widespread his love of animals brought them into practically all his work.

It is doubtful whether Stubbs would have achieved great success as a history-painter, which demanded a slightly theatrical sense of the dramatic and an imaginative and inventive mind. He was no story illustrator in the grand manner; his whole training and his beliefs in the absolute supremacy of nature, would have fought against the artificiallity of the subject. On the other hand, he could have become a very great portrait-painter. From the few actual portraits that are known, like those of the Wedgwood family, it is obvious that his appreciation of form and his masterly drawing was accompanied by an ability to perceive the complete and inner character of his sitter with intuition and sympathy. 'Portrait' here refers solely to 'face-painting' in its restricted sense, for broadly speaking everything that Stubbs painted was a portrait of the object he saw in front of him, whether it was a dog or a dandelion.

There are many small-scale human portraits of all kinds in his conversation pieces, and there are numerous portraits of grooms holding horses, and of stable-boys. There are two beautiful little heads of stable-boys—one in the painting of Pumpkin, where the boy wears a bright pink coat which sets off the whole painting, and the other is in the portrait of Scapeflood, both painted in the 1770s. Another stable-lad peers out from under Gimcrack, while the man that holds him is also beautifully drawn and realized. Stubbs has caught his exact pose, the angle of his stance makes all the difference to the composition, and the light on the face against the rubbing-house is judged with an incredible tonal accuracy. There is immense character in the little portrait of the red-faced groom, in the later painting of Gimcrack, as an older horse, when he had turned a very light grey. The portrait of the man in the top-hat holding Hambletonian's reins is unforgettable. He has the most penetrating and self-assured gaze, and it is this expression which contributes greatly to his function in the composition, acting as he does as a kind of human buttress to the whole group.[1] There are innumerable delightful small portraits in his conversation pieces that repay careful study, and make one aware of his potentiality as a portrait-painter.

[1] Illus. p. 194.

His 'Lady reading in a wooded landscape' shows clearly that he was able to convey a serene femininity with grace and delicacy. The design is based on a triangle within a triangle, the lady forming a pale, solid shape, set against a more linear shape made by the dark, slanting trunk and overhanging branches. Stubbs has been more concerned with the play of light through the trees than is usual in his landscapes.

There is quite a glow of sunlight on the figure and her surroundings, as she sits among the wild flowers in her flowered brocade dress. The painting used to be known as the Princess Royal in Kensington Gardens.

It was while he was staying at Etruria that, as Wedgwood said, 'his ambitious tooth which started up at least an eighth of an inch above its own level has fallen to its level again and permits him to eat his bread in peace'. If in wishing to make his name in the more elegant pursuits of history-, narrative-, and portrait-painting he was ambitious, it is most understandable that he would wish to be taken seriously at what he considered to be the highest possible level.

Stubbs must have been very decided with Mr Wedgwood about the family painting, for originally Josiah had conceived two very detailed pictures of the children, and was undecided as to whom he should give the commission, as he rather favoured Mr Wright (of Derby). He wrote to Bentley about it . . . 'The children only, and grouped in some such manner as this: Sukey playing upon her harpsicord with Kitty singing to her, which she often does, and Sally and Mary Ann upon the carpet in some employment suitable to their ages. This to be the one picture. The pendant to be Jack standing at a table making fixable air with the glass apparatus etc and his two brothers accompanying him. Tom jumping up and clapping his hands in joy and surprise at seeing the stream of bubbles rise up just as Jack has put in a little chalk to the acid. Joss with the chemical dictionary before him in a thoughtful mood which action will be exactly descriptive of their respective characters.

'My first thought was to put these two pictures into Mr Wright's hands (Joseph Wright of Derby, of course); but other ideas took place and remembering the 'Labourers and cart' in the exhibition, with paying for tablets, I ultimately determined in favour of Mr Stubbs, and mentioned a fine piece to Mr Wright in a letter I wrote him the last week to tell him I shall be glad to see him here in a fortnight or three weeks. But what shall I do about having Mr S. and Mr W. here at the same time.'

Wright of Derby had a certain amount in common with Stubbs; he, too, was a realist in the best sense of the word. His interest in scientific matters and in industry led to an original treatment of an unusual subject. He loved the effects of candle-light and such works as the 'Orrery' and the 'Ironforge' combine his curiosity about new industrial invention with his romantic sense of dramatic lighting.

The two paintings for Wedgwood eventually turned into an equestrian conversation piece. On 7th August 1780 Josiah wrote to Bentley: 'Our family piece is just as you left it for we have not been able to procure a panel which we dare trust with so capital a treasure as our dear selves.' A week later he wrote: 'We have made but little progress with the family piece at present. Mr Stubbs talks of laying to in good ernest soon' . . . Then . . . 'Our three little lasses and their coach are just put into colours and the characters of the children are hit off very well. I have given him one sitting and this is all we have done with the picture. The Stable is preparing and the horses are to sit this week.' The next instalment was as follows . . . 'Our picture proceeds very slowly, but we have begun to make the horses sit this morning and I write by Mr S. in the new stable which is to be

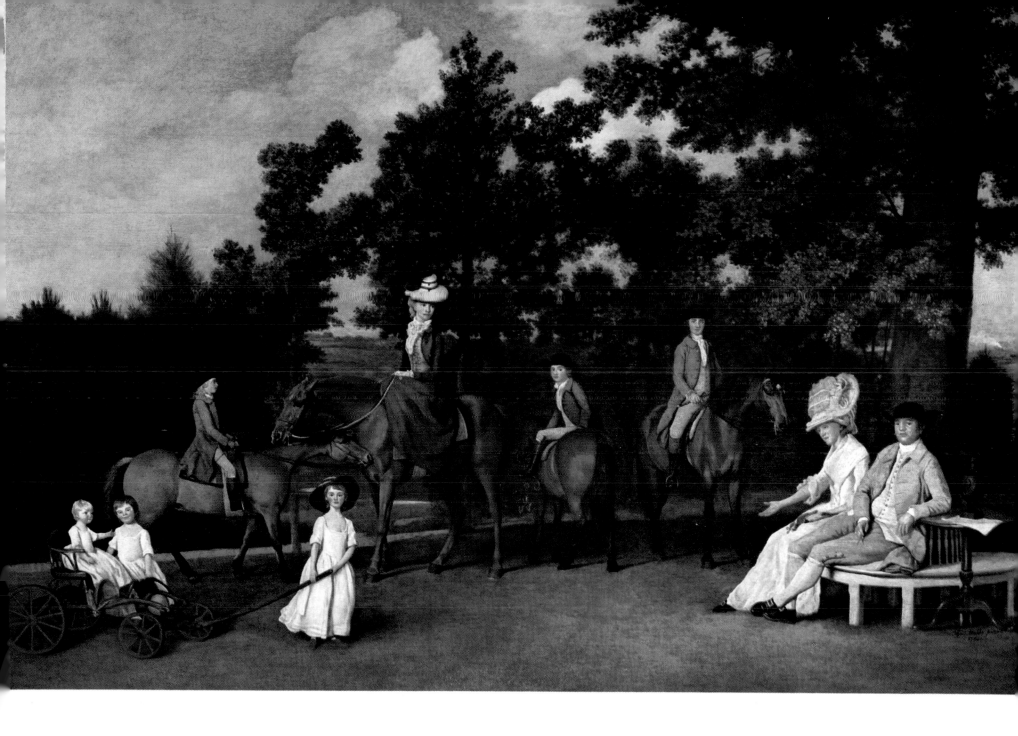

Josiah Wedgwood and Family. *47½in × 59½in.*
Josiah Wedgwood & Sons Ltd.

my study whilst he is painting here.' The arrangement of the nine portraits and four ponies is designed with all the usual care.[1] A frieze of ponies and their riders in the centre is balanced by the group of three little girls and their baby carriage on the one side, and on the other by the two senior members of the family, Mr and Mrs Wedgwood, sitting under a tree, with a black basalt vase on a table at Josiah's elbow. Her right arm and hand lead the eye back into the centre of the picture, and back to her distinguished family. The girl riding side-saddle is Susannah, who became the mother of Charles Darwin. The boy on the left is Thomas Wedgwood, who invented photography; the boy on her right, Josiah II, became Member of Parliament for Newcastle under Lyme, and the boy next to him is John, who became a founder member of the Royal Horticultural Society. Stubbs gave the boys lessons in perspective, for Wedgwood says: 'We must find time for a lecture on perspective, which science Mr Stubbs has kindly engaged to teach my boys.'

Finally, he wrote . . . 12th September 1780: 'Mr. Stubbs is still at Mr Fitzwilliam's, only he sleeps here, but Mr FW. is now in town and I intend to take the opportunity of his absence to prevail upon Mr S. to give us another day or two at our family piece which does not appear to me to be quite finished. My wife I think very deficient—Mary Ann more so, and Susan has not hit well at all. I say nothing myself, but upon the whole agree with Mr Edgeworth that there is much to praise and little to blame. As soon as I think the picture finished I will hie away to kiss your hand at Turnham Green.' Stubbs must have thought the painting quite successful, as he charged £236 17s. 6d. for it.

Wedgwood had been working towards the achievement of really large tablets for some years. He wrote, at the end of 1779: 'When you see Mr Stubbs pray tell him how hard I have been working to furnish him with the means of adding imortallity to his very excellent pencil. I mean to arrogate to myself the honour of being his canvas maker. But alas, this honour is at present denied to my endeavours though you may assure him that I will succeed if I live a while longer undisturbed by the French, as I only want an inclined plane that will stand our fire.'

Finally, he was able to produce oval ceramic plaques as large as 40 inches by 30 inches and Stubbs used them for his rural subjects in the 1790s.

Stubbs became fascinated by clay and modelling materials while he was staying with the Wedgwoods at Etruria. Eventually, he began to work seriously on a low-relief, not the easiest type of sculpture to start on, but nearer in approach to the work of the painter and draughtsman than sculpture in the round. The subject of the low-relief was his pet 'Lion and Horse' theme[2] and evidently one which Mr Wedgwood thought difficult to translate into the new medium, for he wrote to Bentley . . . 13th August 1780: 'He has fixed upon the subject for modelling, the lion and horse from his own engraving. He objected to every other subject so I gave it up and he is laying in the horse whilst I write a few letters this good Sunday morning. He does very well so far, and with a little practise will probably be as much master of his modelling tools as he is of his pencils. I will write you further as we proceed . . .' The following week he wrote: '. . . Tuesday and Wednesday Mr Stubbs modelled a little, and on Thursday and Friday nearly finished his tablet while I was at Stafford making peace between Mr Adderly and Mr Sparrow . . . later, Mr Stubbs has now quite finished his tablet and we will send you a copy very soon either in blue & white, or to save time in one colour.' Mr Stubbs's relief of the lion and horse is somewhat handicapped, one feels, by lack of technical skill in handling his materials. Also, the sculptural problem of creating an illusion of depth and solidity of form has not really been solved, and he has

[1] Illus. opp. p. 110.

[2] Illus. p. 112.

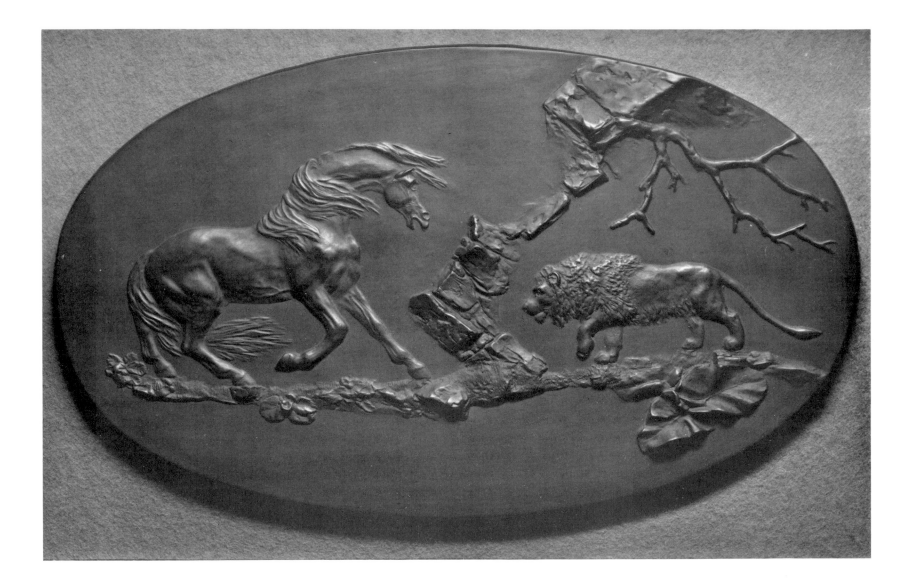

Lion and Horse (Black basalt plaque). *15¼in × 9in. Josiah Wedgwood & Sons Limited.*

112

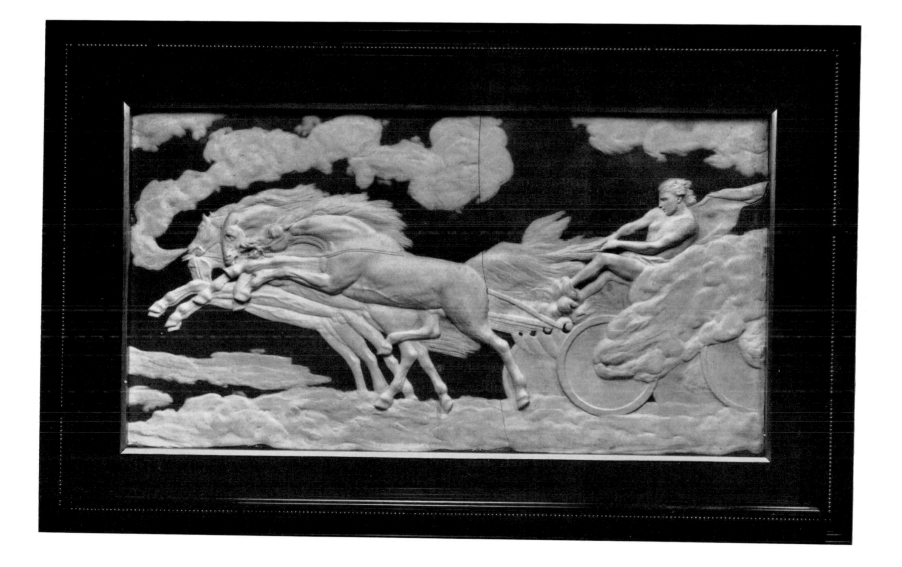

Phaeton and the Chariot of the Sun (Plaque). *12in × 21½in. Josiah Wedgwood & Sons Limited.*

treated his design rather too pictorially. His paintings and engravings have a far greater sculptural and monumental feeling than his modelled reliefs. It is probable that he realized that the limits imposed by low-relief were too constricting for him, for he produced very few. This lion and horse relief is very similar to the painting in the Mellon Collection, except that it is in reverse. The horse is divided from the lion by a ribbon-like effect of modelled rocks and a few plants, with a curiously upside-down tree or overhanging branch at the top of the plaque. A fortnight later he was modelling again; this time the subject was Phaeton and the horses of the sun, and Josiah wrote: '. . . he sleeps with us and wishes to employ some of his evenings in modelling a companion to his Frightened Horse, and has fixed upon one of his Phaetons for that purpose.'[1] A few days later he wrote: 'The model of Phaeton is in some Forwardness—he works hard at it every night almost till bedtime.' The four horses prance across the sky on a level bank of cloud, with more thin clouds above them, used like the rocks in the frightened-horse plaque to connect and to fill up the empty spaces, Phaeton leans back in the chariot, trying to control his team, but the composition is not entirely happy.

As well as these two plaques, there are a series of nineteen little cameos, single horses, less than an inch long, all in different positions. It is recorded that the sculptor Edward Burch received sixteen shillings each for modelling them, but it seems that Stubbs might have designed them.

Wedgwood also used transfers, of engravings made by Woollett of some of Stubbs's shooting scenes, on cream-ware mugs and punch-pots. He also prepared some large 'jarrs' for Mr Stubbs to have 'some subjects besides tablets to paint on'.

On 7th May 1796 Stubbs received 'from the Executors of the late Josiah Wedgwood by the hand of John Wedgwood Esq. £471. 16. 3. in full of all demands'. This sum comprised the payments for the portraits of Mrs Wedgwood and of her father, and the family piece, as well as the painting of the labourers, for which he paid £189 (see page 115). On the same account there is a rather muddled note about certain unsatisfactory tablets. 'Of 5 tablets charg'd £53. 8. 0., 3 were crack'd, one of them is take off the acct. £10. 5. 0. the other two spoil'd £21. 7. when Mr Wedgwood saw that which taken off the acct. The other two I had not found out.' It seems to have been a somewhat expensive business, painting on large-scale Wedgwood plaques, and, judging by the number left in his studio at his death, it was not a very profitable undertaking.

According to Humphry, he had not only solved the problems attached to the making and firing of the enamel colours, but had also discovered how to make his own tablets, 'of very large dimensions, even larger than those which have ever been made in the Manufactory of Messrs Wedgwood. The substance of the plates was a composition of burnt and crude clay wth. occasionally a little white sand'. From the account of 1796, it seems as though he continued to have his tablets made by Wedgwood until that date, even though he might have managed to make them himself.

He was evidently much annoyed and distressed by the adverse reception of his enamels at the Royal Academy Exhibitions. This must have stopped him producing quite as many as he might have done had they become as popular as he and Wedgwood had hoped. They were said to be 'hurtful' to the other paintings in the exhibitions, and were badly hung high up on the walls. There is no doubt that the colours would have stood out bright and luminously clear against the heavier oil paintings. They must have been almost as surprising and unwelcome to the eighteenth-century Academicians—even though Stubbs's colour was restrained and subtle—as the Pre-Raphaelites' colourful work was to some of the R.A.s of the mid-nineteenth century.

[1] Illus. p. 113.

Twelve · The Royal Academy

Stubbs's association with the Royal Academy of Arts started in 1775. He had remained faithful to the Incorporated Society of Artists for thirteen years, even though most of the more important artists of the time had changed over to the R.A. soon after it was established. Eventually he, too, began to exhibit at Pall Mall instead of Spring Gardens.

The Royal Academy had started with rather cramped premises, in 1768, when they took over Lamb's Auction Rooms on the south side of Pall Mall, which had been used as a print warehouse and then as an academy, or art school, for a couple of years. By 1775 the R.A. had spread; the annual exhibitions were still held in the Auction Rooms, but the Schools, the Library, and the administration had all been moved to the old Palace of Somerset House, by kind permission of George III. This old palace was to be rebuilt and was to include a permanent home for the whole of the R.A., exhibition-rooms as well. As Sir William Chambers, their Treasurer, was the architect, the R.A. was rather well placed to get the kind of accommodation they needed.

Stubbs, who had only exhibited one painting the year before, at the Society of Artists, 'portrait of a horse', sent four paintings to the R.A. Exhibition. He was represented by two portraits of dogs, one belonging to Lord Spencer and the other to Mr Cosway, and a portrait of a monkey, and Euston, a horse belonging to Mr Wildman. The following year he again sent four works, a 'Mares and Foals', 'Tygers at play', and two more dog portraits. He had six paintings in the Exhibition of 1778, but in the year after he had troubles, for it is recorded in the R.A. Council Minutes of 11th April: 'Resolved that the following Indulgency's be granted Viz. . . . To Mr Stubbs, being disappointed of Pictures. The gentleman to whom they belong being out of town.' In this case the 'Indulgency' was that of being allowed to send in work after the proper date for submitting prospective exhibits. Six days later poor Mr Stubbs was still 'disappointed of pictures', for a 'Request from Mr Stubbs of sending Pictures in 3 or 4 days' was read out at the meeting, and it was resolved that 'No answer can be given'. What exactly this meant is not quite clear. There might or might not have been time for them to be included in the Exhibition. In the end he showed four pictures, 'Mare and a dog', 'A Dog', 'A Gentleman on horseback', and 'Labourers'. Whether these belonged to the gentleman who was out of town is not certain. The painting of the 'Labourers' was the version of the subject painted for Lord Torrington at Southill about 1767.[1] According to Humphry, it 'appeared in the Exhibition many season later, with universal admiration'. He gives quite a detailed account of the birth of the idea and the picture: 'At Southill, the seat of Lord Torrington, Mr Stubbs painted the celebrated picture of the Bricklayers and Labourers loading Bricks into a Cart. This commission he received from the Noble Viscount in London, who had often seen them at their Labours appearing like a "Flemish subject" and therefore he desired to have them represented. Mr

[1] Illus. p. 116.

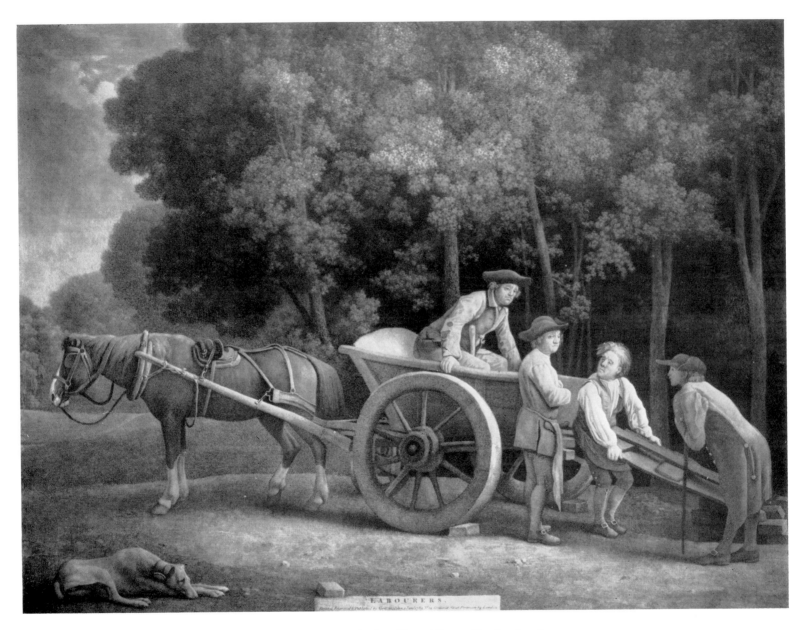

The Labourers. *36in × 54in. The National Trust. (Bearsted Collection, Upton House, Nr. Banbury.)*

116

Stubbs arrived at Southill a little before dinner where he found Lord Torrington with the Duke of Portland and other Noblemen and Gentlemen. During Dinner the old men were ordered to prepare themselves for their labours with a little cart drawn by Lord Torrington's favourite old Hunter which was used only for easy tasks, this being the first horse his Lordship ever rode. It was the present motive for ordering this picture. Mr Stubbs was a long time loitering about considering the old men without observing in their occupation anything that engaged them all so as to make a fit subject for a picture, till at length they fell into a dispute about the manner of putting the tailpiece into the cart, which dispute, so favourable for his purpose, lasted long enough for him to make a sketch of the picture then, Men, Horse and Cart, as they have been represented. Thus having settled the design as time and opportunity served, he removed the cart horse and men into a neighbouring Barn where they kept well pleased and well fed till the picture was completed as it appeared in the Exhibition.' There were several versions of this subject, including one in enamel which was bought by Wedgwood for £189.

Whether it was the 'universal admiration' of the 'Labourers' at the Exhibition of 1779 that helped, or not, the following year, on 16th October, Mr Stubbs's name was at long last entered on a list of twenty-one candidates for two vacancies for Associate Members of the Royal Academy. The actual ballot took place on 5th November, when George Stubbs received 16 votes and De Loutherbourg 13. On 12th January 1781 De Loutherbourg was admitted as an Associate, and 'A note was read from Mr Stubbs'—presumably explaining his absence, for less than a month later, on 2nd February, at a Council Meeting, it is recorded that 'Mr Geo. Stubbs (elected one of the Associates of the Royal Academy by the General Assembly of Academicians held on the 5th day of November last) attended and being introduced by the Secretary—after hearing the Instrument of the Institution read—he subscribed the Obligation and had his Diploma given him by the President, who declared Mr Geo. Stubbs to be duly admitted an Associate of the Royal Academy'. His signature, Geo. Stubbs, appears on the Roll of Members between De Loutherbourg (and a note to say that Mr Jos. Wright resigned) and Farington.

Very shortly after, only just over a week later, at the General Assembly of 13th February 1781, there was an election of Academicians. At the first ballot, Stubbs got 12 votes, De Loutherbourg 5, and Ozias Humphry 3. At the second ballot Stubbs got 14 to De Loutherbourg's 3, and was duly elected an Academician. At the ballot for the second place De Loutherbourg was also elected, and for some reason, though Stubbs had already been elected, he got 2 votes.

The rules governing the election of Royal Academicians had been laid down carefully and precisely in the Instrument of Foundation of the Royal Academy, which was duly approved and signed by King George III on 10th December 1768. Section III reads as follows:

'III. After the first institution, all vacancies of Academicians shall be filled by election from amongst the exhibitors in the Royal Academy; the names of the candidates for admission shall be put up in the Academy three months before the day of election, of which day timely notice shall be given in writing to all Academicians; each candidate shall, on the day of election, have at least thirty suffrages in his favour, to be duly elected; and he shall not receive his Letter of Admission, till he hath deposited in the Royal Academy, to remain there, a Picture, Bas-relief, or other specimen of his abilities, approved of by the then sitting Council of the Academy.'

By 1770 it had been decided to create Associate Members from

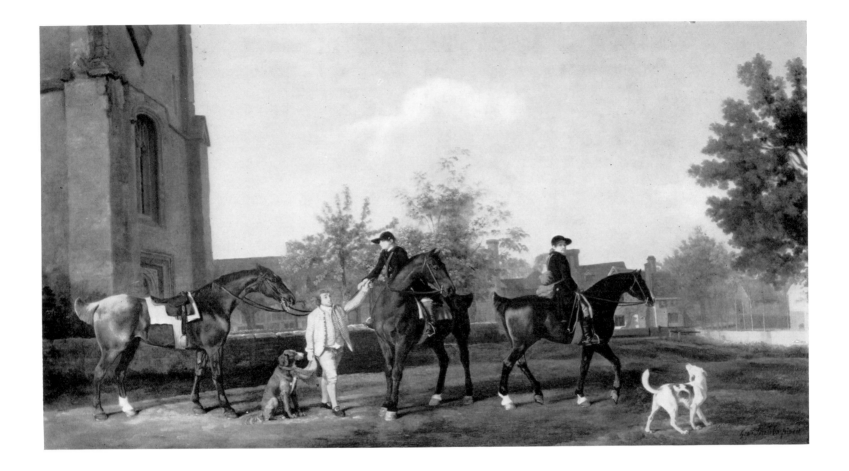

Huntsmen setting out from Southill, Bedfordshire. *24in* \times *41½in.*
By kind permission of the Marquess of Bute.

118

whom the full Academicians would in future be elected. Their Diplomas were signed by the President and not by the King, and they did not have to deposit a work. On 5th November 1781 De Loutherbourg's 'specimen of his abilities', or Diploma Work, was submitted to the Council for their approval and he 'attended a General Assembly on December 10th in order to be admitted, he being introduced by the Secretary. The President reported to the General Assembly that his Performance had been received by the Council, and that His Majesty had been graciously pleased to approve him as an Academician and to sign his Diploma, dated 29th November, 1781.'

At a time when there was no National Collection of works of art, like the National Gallery, the idea behind the giving of a Diploma Work was to form a representative permanent collection, and it was quite a novel one. In the early days, when the collection was small, the works furnished the walls of the Royal Academy's apartments and Council Rooms, and were shown to the public during the Annual Exhibition. A newly elected Academician was even allowed to deposit a work and change it later for something more suitable to represent him, so the rule was fairly flexible. However, Stubbs had not produced a picture by 10th December, having had nine months in which to find something which would do. Evidently the Council were accustomed to this late delivery, but at this General Assembly the following law was read:

'Whoever shall be elected an Academician or an Associate of the Royal Academy and does not take up his Diploma within one year from the Day of his Election, shall be considered as declining to become a Member of the Academy and another shall be elected in his room unless such an apology be made for the Omission, as shall or may be deemed sufficient by the Council.'

This seems a reasonable enough law, not spitefully directed at any individual, yet it seems likely to have been the main cause of Stubbs's annoyance with the R.A. Humphry is very confused at this point, and gives the impression that the reason that Stubbs fell out with them was that he resented having to present a Diploma Picture, but as this rule had been in operation since 1768, it could hardly have been considered a new arrangement. It must have been the law limiting the time for 'taking up the Diploma' that Stubbs considered to have been directed against him, yet it was applicable to both Academicians and Associates, who had no 'specimen of their abilities' to find and present.

Humphry says: 'In the year 1781 he was elected an Associate of the Royal Academy, and finally an Academician, which was never completed by the delivery of the Diploma with the Royal Signature, for reasons which it is hoped the following sketch will serve to explain. The Elections of the R. Academicians always take place on the 10th of Feb. and it is necessary after the choice is made, for the successful Candidate to send a Picture for his Majesties approbation, previous to his Diploma being signed by the King, which complets the Honor of the Election and qualifies the new Member for all the Duties required by the Institution. Whilst the subject of these Memoirs was considering what picture he should send, whether in Oyl Colours or Enamel, the season arrived when the Annual Exhibition opened, to which many of our authors Works were sent in both species of painting, with suitable explanations of the subjects as is usual; but he had the mortification to find that almost all his pictures were so unfavourably placed, particularly those in enamel and most of the Quotations (the subjects of the pictures) in the Catalogue omitted, all of which conduct he considered as highly disrespectful to himself and it was also very much resented by his friends, for whom the pictures were painted. This treatment he felt with particular sensibility, and he still considers it cruel and unjust, for it has tended more than any other circumstance could have done, to

discredit his enamel pictures and to defeat the purpose of so much labour and study, not to mention his loss of time and great expence. This unkind conduct in the Members of the Royal Academy, added to the original unwillingness with which he suffered his name to be entered among those who were candidates for the Honor of the Diploma, determined him with an *unconquerable resolution* not to send his picture to be deposited in the Schools of the Royal Academy, and more especially not to comply with a law made the following year to compel every candidate elected to send a present of a picture to the Academy there to remain forever the property of the Institution, because he considered the law unjust and thought he had reason to suppose it was levelled particularly at him, and moreover, it was an expost facto law, calculated to punish a supposed offence in him that was committed before the law existed. Mr Stubbs will therefore never consent to allow that he is yet less than an Academician elect, wanting only the Royal Signature for its confirmation, as the law by which he is disqualified had not been made when his refusal to send a picture was known to the Royal Academy—and in this disqualified condition he wishes always to remain.'

There are a number of odd statements in this account; most important is the fact that the necessity for giving a 'specimen of work' to the R.A. is mentioned in the Instrument of Foundation, which was read to Stubbs before he signed the Obligation on his election as an Associate Member. He really had no case for saying that the law was in any way connected with him personally. Humphry makes it sound as though two paintings had to be presented, one for the Schools and one for the Academy, but there is no confirmation of this in the R.A. archives. Another curious statement is that while Stubbs was deciding what picture to present he sent to the Summer Exhibition 'many works in both species of painting', of which the enamels were badly hung and

the 'Quotations' left out of the Catalogue. He was elected in 1781, but only exhibited one painting that year, 'Two horses; in enamel'. The year before he had six works in the Exhibition, but his name appears on the list of candidates for Associateship in October, so if he had been so hurt by the hanging of his work in April, would he have allowed his name to go forward for election? He seems to have been treated quite fairly by the Council of 1782, because before the Exhibition they granted, on 12th April, 'Mr Stubbs leave to send two frames (on Monday next)', again permitting him late delivery of work for the show. But he did send seven paintings in that year, of which five were in enamel. 'Una', 'A gentleman shooting', 'The Farmer's Wife', 'Portrait of an artist', 'Portrait of a dog'. Presumably it was this collection which was badly hung, though the catalogue entries do not seem very different in length from other years. According to the *Sporting Magazine*, the Royal Academy wanted Stubbs to give them 'The Grosvenor Hunt', but it had been sold for £170 and so Stubbs offered them another work which was rejected. In one article the enamel of 'Una and the Lion' is mentioned as the rejected work, but there is nothing to confirm or deny this in the Royal Academy archives, and so it seems that if anything was said to Stubbs about the acceptability or otherwise of his work it was said privately to him. There must, subsequently, have been a ruling against admitting 'painting on pottery', for it was allowed again in 1879, providing it was properly framed. This ruling would have prevented Stubbs exhibiting any more enamels and may have been another reason for his huff with the R.A. He certainly never exhibited enamels at Somerset House again, though at the first exhibition of the British Institution in 1806 he exhibited eight paintings, six of them in enamel. As this was the year of his death, he never exhibited there again. The six were: 'Horse and Lion', 'Haymakers', 'Harvesters', 'Haymakers', 'Two horses

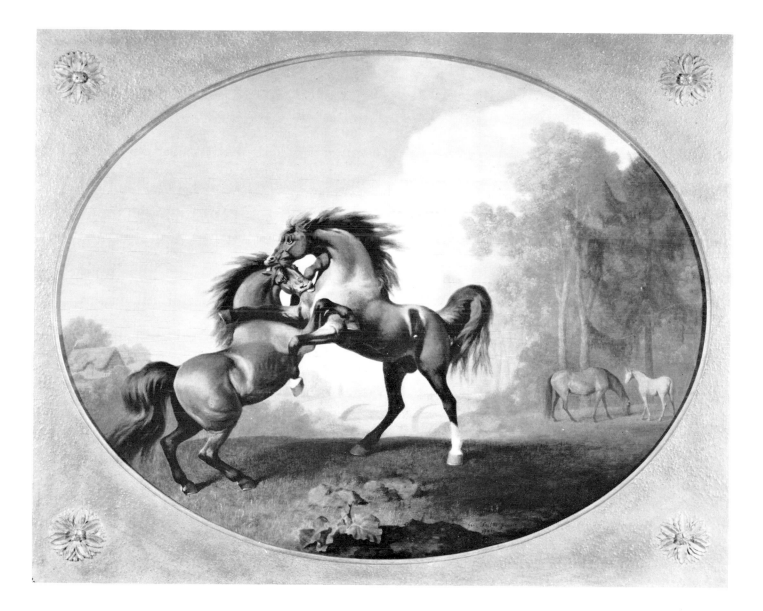

Fighting Stallions (Enamel). *29in × 37in. By kind permission of Miss Clara S. Peck, U.S.A. (Photograph by courtesy of E. J. Rousuck.)*

fighting', 'Fall of Phaeton', and two oils, 'Landscape' and 'The Farmer's Wife and the Raven'.

It was not till 31st December 1782, nearly two years after Stubbs's election, and more than a year after the law obliging an Academician Elect to take up his Diploma within a year, that the Council 'Ordered that the following letter be sent to Mr Stubbs; "Sir, I am ordered to acquaint you that the time for receiving your Picture will expire on the 11th Inst."'

On 11th February 1783, at the General Assembly: 'The President declared two vacancies of Academicians, one on the death of Mr Moser and one by Mr Stubbs not having complied with the laws relating to the Election of Academicians.' The following year at the General Assembly on 10th February Joseph Wright and J. F. Rigaud were elected 'in the room of Mr Stubbs and Mr Moser'. Curiously enough, Wright of Derby also refused to complete the formalities and suffered the same fate as Stubbs, though in his case he became huffed through a confusion over signing the Obligation, and eventually resigned.

Finally, the last instalment of the story came on 12th November 1784, when the Council ordered that 'the following letter be sent to Mr Stubbs: Sir. I am desired by the President and Council to request that you will inform them by letter (having declined accepting being an Academician) if you wish to continue your name on the list of Associates.'

He was described in the catalogues for 1781–2 as R.A. elect and then he did not exhibit again until 1786, when he was back to 'Associate'.

There is no doubt that Stubbs felt very hurt by the bad hanging and poor reception of his enamels, but perhaps the R.A. was not really so unkind and unreasonable as he thought. In any case, he did not break with them for long, but continued to show work fairly regularly till the end of his life. It is significant that when the British Institution started he immediately sent a large proportion of enamels there.

The Royal Academy had made their attitude towards enamels quite clear, but so, also, did the Press. For example, in 1791, there was this criticism: 'No. 7. Pomeranian Dog. G. Stubbs. A.—This picture is a convincing specimen of this Artist's superiority as an animal painter; nothing can exceed this just imitation of nature, when engaged in this line of art the painter is mounted on his proper Pegasus; and will never experience the disgrace which must be ever attendant on mounting his hobby-horse of enamel portrait painting.' In the same year there was another remark in the Press, directed against his enamels. 'We congratulate Stubbs on his pictures, and are happy to find the rage for enamels has so prudently subsided.' Also, 'Stubbs evinces talents unimpaired.' Unimpaired by enamel painting? It certainly affected his style to a considerable extent, but in any case his development tended towards a more highly finished and a smoother and more skilful and sophisticated technique. One has only to look at his engravings to realize this. Not all critics were unkind about his enamels. Woolcot, who was never afraid to be cutting, has this to say in *The Earwig*, 1781 . . . 'No 17. Two horses in enamel. —The largest piece of enamel we have ever seen. This acquisition to the art could not have been discovered more opportunely, nor better applied, than in perpetrating this picture. There is no gloss on this beautiful piece of enamel; and the colours are as mellow, as rich and harmonised, and the tints as soft as in the finest painting on canvas.' But still the fact remains that after his death a great many of his large enamels on Wedgwood plaques were left in his studio unsold.

Stubbs's third theme, which came after the 'Mares and Foals' and the 'Lion and Horse' themes, was that of the series of agricultural subjects with which he became involved in the 1770s.

From a Private Collection

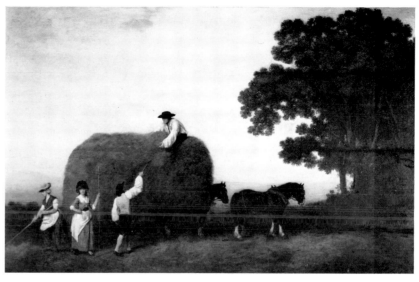

From the collection of the National Trust (Bearsted)

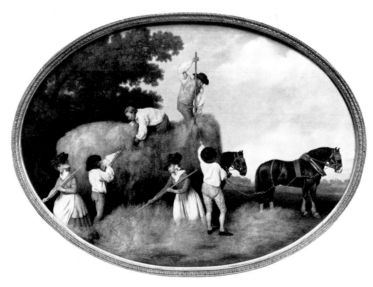

From the collection of the Lady Lever Art Gallery

123

This series is the last of his themes. The 'Mares and Foals' had occupied him for about ten years, his 'Lion and Horse' continued to interest him for many years, and he worked on these agricultural subjects, in various media, for about fifteen years, the earliest in the series being the painting of the labourers loading bricks into a cart. The account of the incidents that led to this painting are given on page 115. This first of the series was exhibited at the R.A. in 1779, though it was painted for Lord Torrington much earlier, and was the one which aroused 'universal admiration'. The other rural paintings are of reaping corn, and two versions of haymaking, both cutting and carting. These rustic paintings have a calm, peaceful, and almost sad air. Their quietude is rather moving. Stubbs painted a number of different variations on each of the subjects within the main theme, and a study of the differences in their composition and organization gives an insight into the very carefully worked out designs that he used.

In a number of his rural pictures the triangle is used for the figure grouping and the diagonal is used in the background. For example, in the oil painting of 1785 of the 'Haymakers'[1] the dark mass of the trees are contrasted with the simple luminous sky. The man with the pitchfork, on the haycart, holds it exactly vertical and is placed in the very centre of the panel. The horizontal line of the hay in the cart divides the panel in half from top to bottom. Practically all the 'busy' part of the painting occurs in the left-hand half of the canvas, balanced by the plainness of the sky and the single silhouette of the leading cart-horse in the right-hand half. The arrangement of the figures of the haymakers have been very carefully planned to fit into a triangular pattern. The lines of the rakes leading up to the bent-over figure on the haycart produce a diagonal up from left to right through the upraised arm of the man standing on the cart and the edges of the dark mass of the trees follow down through the central figure and

the horse's ears, the whole design being stabilized by the two vertical lines of the woman with the rake and the man with the pitchfork, and the two horizontals of the top of the haycart and the edge of the darker-toned middle distance. The movement in these paintings is obtained through the repetition and linking of lines. The figures are quietly posed, giving the pictures a tranquil serenity. There is in this farming series a gentle, pensive melancholy, with a feeling of approaching evening.

It is interesting to contrast and compare this haycart scene with the earlier painting of 1783 and the much later enamel in the Lady Lever Art Gallery. In each, the leading cart-horse is a portrait of the same animal. The figure holding her rake upright appears in the two oils, and again in the haycutting painting, though she is left out of the enamel of the haycart scene. Evidently this series was produced from drawings, sketches, and studies. In the earliest haycart picture[2] the dark mass of the trees is on the right-hand side and separated from the foreground group by sky. The cart and figures make a less obviously triangular arrangement. The enamel[3] painted on an oval plaque is very similar in composition to the 1785 painting, but the centre woman is now bending towards the left, raking up the hay, and the woman on the far side has been omitted. The design is held firmly by the vertical pitchfork of the man standing on the hay in the exact centre of the oval shape, and is steadied horizontally by the line of heads and the silhouette of the horses, again bisecting the oval exactly in half. The tablet, one of Wedgwood's largest efforts, being 30 inches by 40 inches, was painted nearly ten years later, in 1795. It is highly finished and beautifully designed, and forms one of a series of rural scenes in enamel, all oval and painted in the mid-nineties.

Another subject in the rural series is that of the 'Reapers' cutting corn. There are again two versions in oils, also painted a

[1] Illus. p. 127. [2] Illus. p. 126. [3] Illus. p. 125.

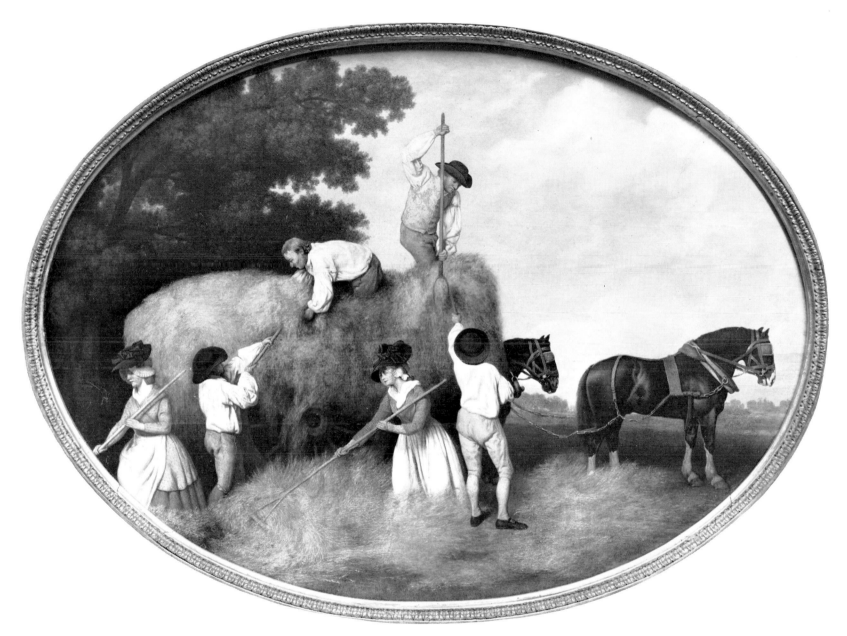

Haymakers (Enamel). *28½in × 39½in. The Lady Lever Art Gallery, Port Sunlight.*

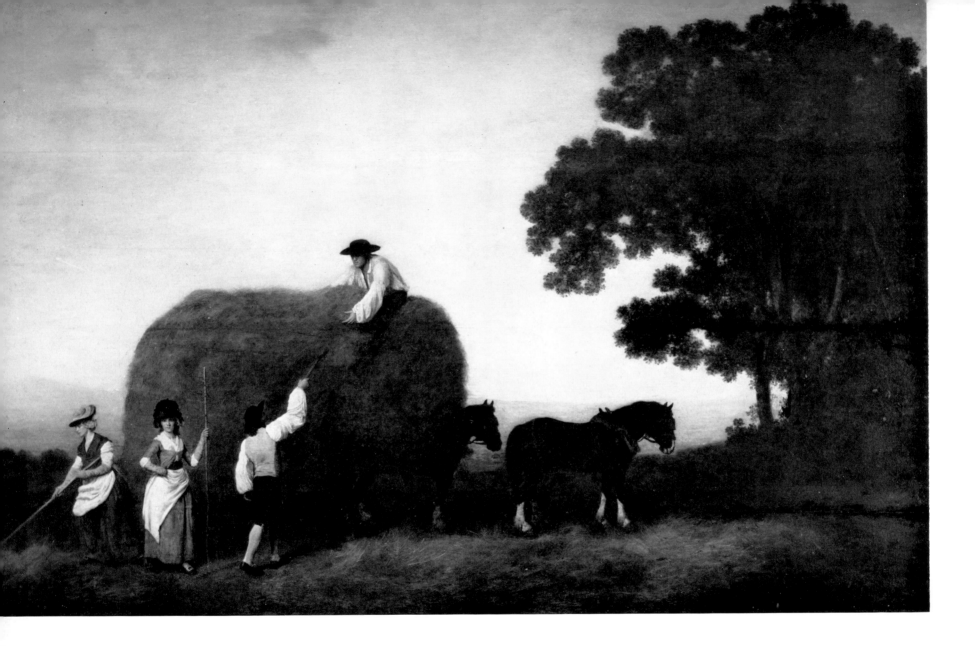

The Haymakers (1783). *36in × 54in. The National Trust. (Bearsted Collection, Upton House, Nr. Banbury.)*

126

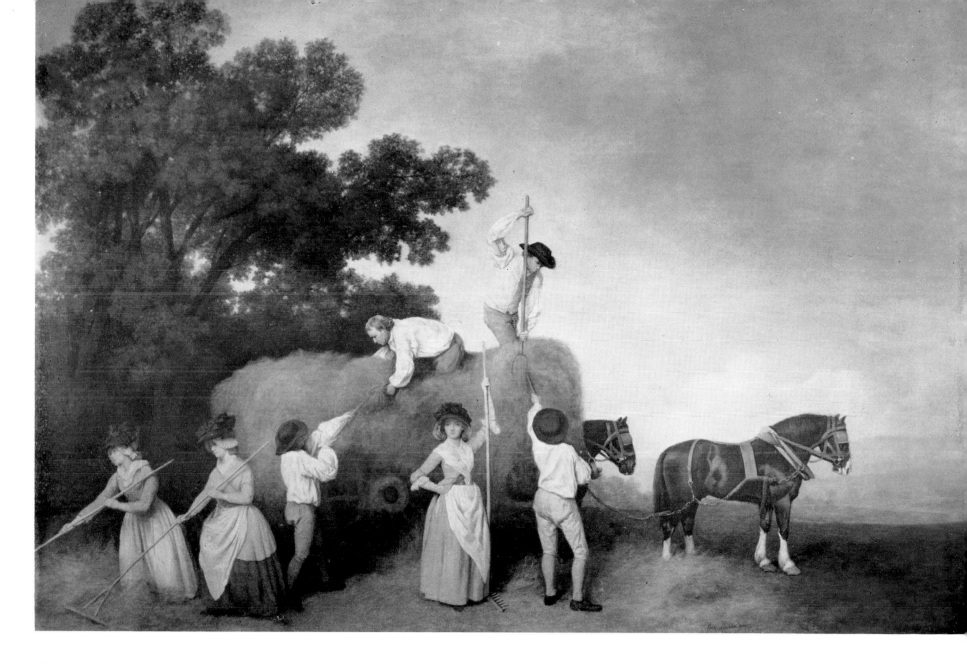

The Haymakers (1785). *35½in × 54in. From a Private Collection.*

year apart in 1783 and 1784, and again they each have the trees massed on opposite sides of the composition, and are designed to make a pair with the haycarting scene. The two early ones balancing each other, 'Reapers' on the left, the 'Haymakers' with their cart to the right. The compositions are open towards the centre edge and closed by the weight of tone produced by the trees on the outer edges. In the later pair more figures are introduced, seven instead of four for the 'Haymakers' and seven instead of five for the 'Reapers'. The farmer on his horse is a different man; both horse and rider change, though they occupy the same pose and place in the designs.

The fourth subject is that of the haymakers actually cutting the grass. The men are scything, and turning the hay, and the women are raking it up. The enamel is the same size and shape as the enamel of haymaking and both are now in the Lady Lever Art Gallery.

In 1787 Stubbs sent up to Liverpool two of his rural scenes, a 'Reapers' and a 'Haymakers', for an exhibition held in the premises of the Public Library in Lord Street. There were 140 exhibits, including a number from London, from artists of importance, such as Reynolds and Gainsborough. Stubbs wrote to a member of the committee, Dan Daulby, as follows:

Sir, I have sent two Pictures to Liverpool which I wish may meet with your approbation. I fear you will disapprove of the plainness of the frames, but they are what I had made on purpose to Exhibit my Pictures in here because I experienced so much mischief done to a lesser sort.

Sir, your humble servant

Geo. Stubbs.

London, July ye 23d 1787.

Among the local exhibitors was a young man, catalogued as 'C. Town'—probably Charles Towne—who showed one landscape. According to a story related in *The Annals of Sporting*, Vol. IV, Towne was so impressed by Stubbs's two paintings that he visited the exhibition daily, making studies and sketches from them, till he had practically learnt them by heart. He ended up by making complete copies of each picture. This caused something of a fuss with the management, as Towne had no permission from Stubbs to copy his work, and when asked to destroy them he refused. Stubbs is said to have written to the committee 'in terms of severe reprehension' and to have declared that he would never again send a picture to Liverpool. But, for all his irritation with the unfortunate occurrence, it was an expression of intense and sincere admiration on the part of the young man, and must have had its gratifying side.

As well as painting this agricultural theme in oils in the 1780s and in enamels in the 1790s, he also engraved it. He made very ambitious mezzotints from the paintings. The size was large, 19 inches by 27 inches. He had intended, originally, to make mezzotints from all his enamel paintings, whatever the size or subject, and to engrave them the same size as the actual picture, however large, but he discovered that 'prints on so large a scale were unlikely to be saleable on account of the very large glasses they will require'. So his scheme was curtailed by economic considerations and during his life he produced nineteen engravings altogether—not, of course, counting the many plates he executed for the various anatomical books.

He published, by subscription, the last two of the set, and in the advertisement dated 24th June 1788 he says that they are 'To be engraved by Mr Stubbs from Two Pictures of his Own Painting that have been exhibited at the Royal Academy, London, and Liverpool'. The price was £2 10s for the two prints, the size of

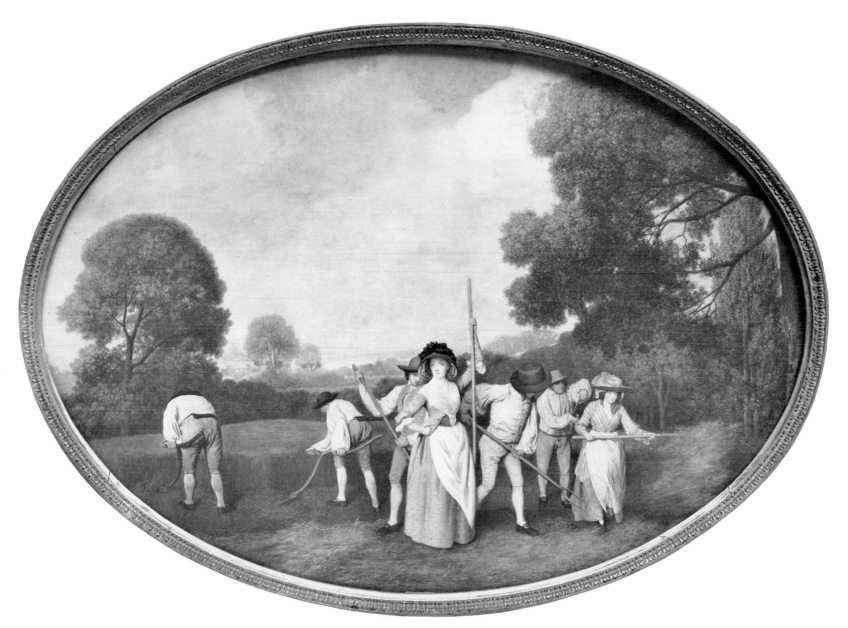

Haycutting. *28½in* × *39½in*. Enamel. *The Lady Lever Art Gallery, Port Sunlight.*

each plate being 27 inches by 19 inches. The delivery was to be 'in the Course of the Next Year'. It was also possible to obtain from Mr Stubbs the following list of his prints:

		price of each
The Farmer's Wife and Raven with its Companion The Labourers[1]	28″ × 21″ . . .	£1. 6. 0.
A horse affrighted by a lion with its Companion Tygers at play	—19″ × 15″ . . .	7. 6.
A Lion devouring a Horse, A Horse affrighted at a Lion, Two Tygers, A lion, and a Tyger	—12″ × 9″ . . .	5. 0.
A Lion, a Tyger, and two dogs	—8½″ × 6½″ . . .	2. 6.
Three prints of single dogs	—5″ × 4″ . . .	1. 6.
and his Book of the Anatomy of a Horse	. . .	£5. 5. 0.

Stubbs's engravings, the single prints, not the illustrations to the *Anatomies*, are extremely interesting. Technically, he pushed forward towards the fullest possible range of tonal effects. From the linear hatching of *The Anatomy of the Horse* he experimented with every subtlety of texture. His desire to express a painterly richness of tone led him to explore the possibilities of all kinds of stippling and mezzotinting, and these he used in conjunction with line-engraving and pure etching. Many of the prints have a singularly beautiful quality, and even if Stubbs had achieved no other work these should have been sufficient to earn him a place in the history of graphic art. Unfortunately, they have been largely ignored.

Stubbs's passion for improving on existing methods, and his refusal to be limited to any restrictions imposed by his chosen media, make his prints a fascinating subject for study. It is difficult to sort out the processes by which he achieved his effects; he is so clever in his handling of the different methods of tooling,

which are most expressive, but never obtrude. He worked lovingly with scraper and graver to give the sensitive gradations of silvery greys, and contrasted smooth softness with precisely engraved detail. His velvety blacks and delicate nuances of palest grey could only have been accomplished by inking and wiping the plates himself. If he had any assistant, it would probably have been his son, who was a competent engraver himself, but even he could hardly have produced quite such perceptive prints.

At least half his prints relate closely to paintings, some having 'painted, engraved and published by Geo. Stubbs' inscribed on them. Yet the engravings are by no means mere reproductions of the paintings. The compositions are carefully reconsidered, translated, and then redesigned to suit the medium.

These individual plates occur mostly between 1788 and 1791, though his 'Horse frightened by a lion' is dated 1777, and 'Leopards at play' sometimes referred to as 'Tygers', was published in 1780. Then follow nine works all published in 1788; two more from the 'Lion and Horse' series, five plates of wild animals, lions, tigers, leopards, and cheetahs, four plates of hounds and the large print of the 'Farmer's Wife'. In the next year came the 'Labourers',[1] the subject which he had already painted in three different versions, the last, in enamel, being painted eight years before. The print is probably the most successful of all the versions. The figure on the right, leaning over his stick, gossiping, is magnificently observed and expressed with a simple, sculptural dignity. In 1791 the other two prints of rural subjects were published, the 'Reapers' and the 'Haymakers'. There is a long gap till the publication of his last print, in 1804, a mezzotint of the 'Keeper', Freeman, with a hound and a deer. This is after the painting[2] probably executed for Lord Clarendon, and is similarly dark, mysterious, and gloomy.

It is intriguing to speculate as to why Stubbs produced these

[1] Illus. p. 116.

[2] Illus. p. 193.

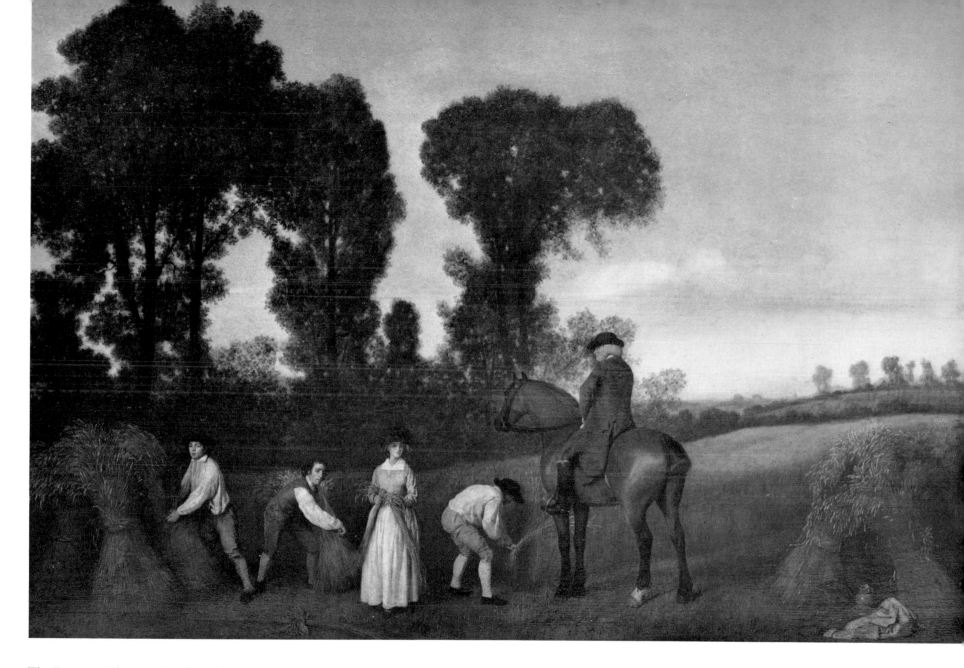

The Reapers. *36in × 54in. The National Trust. (Bearsted Collection, Upton House, Nr. Banbury.)*

plates. Was it to advertise himself and his paintings? Did he hope for financial reward? Or was he just enjoying another battle for self-expression in a different medium? Humphry does not mention these individual prints at all. Perhaps the sudden increase in 1788 came from an idea that he might engrave his own paintings for the Turf Gallery project. In which case, it is curious that he never tried to engrave anything from his 'Mares and Foals' compositions. These would have made interesting prints. Nor did he produce any horse portraits, which would surely have had saleable qualities, particularly if they were of the more famous racehorses of his day.

According to the Stubbs sale catalogue, he was in the habit of using his own prints as grounds for oil-paintings. It was a labour-saving device that meant that he had an exact replica of his design printed on to his painting ground. Whether he had some means of printing straight on to a panel or fine canvas, or whether he printed it quite normally and painted on the paper, is not clear. He used his favourite 'Lion and Horse' subjects in this way, as Lot 45 was 'Two paintings in oil, upon prints. A lion devouring a horse, and A horse affrightened at a lion'. Lot 46 consisted of 'Three paintings in oil, upon prints, A lion, and two Sleeping tigers'. Of course, it may merely mean that the paintings were based upon the design of the prints, though that would be the reverse of his normal procedure.

Sketch of a Horse's Head used for
the picture of the Labourers. *4in × 3in.*
Brown, Picton and Hornby Libraries, City of Liverpool.

Thirteen · The Turf Gallery

Humphry says that Stubbs's commissions were beginning to fail him as early as the 1770s, but there seems reason to believe that he had rather more spare time after he broke his association with the Society of Artists, for whom he must have devoted quite a lot of leisure and energy. There seems to be no doubt at all that, unfortunately, Stubbs was not quite as busy after the end of the 1770s, and that his noble patrons were no longer giving him the same number of commissions as he had had immediately before and after the publication of *The Anatomy of the Horse*. His feud with the Academy did nothing to help his failing image, and by the end of the 1780s he was not as flourishing financially as he could have wished. Therefore, it must have been something of a relief to him when, in 1790, an unidentified gentleman, referred to by Humphry as 'Mr Turf', put forward a suggestion to him. The gentleman proposed to commission him to paint a series of portraits of famous racehorses, starting with the Godolphin Arabian. The scheme was ambitious, and might have provided Stubbs with a little extra work and a little extra income for years to come. The portraits were to illustrate a History of the Turf, which was to be published in about forty numbers. The paintings were to be engraved in two sizes, a large one, suitable for framing, and a smaller one which was to accompany the text. This was to consist of three sheets giving all the details of the horse, its pedigree and its racing records, as well as any anecdotes, and any other facts that would contribute to the 'Chronological History of the Turf'.

The sizes of the engravings were to be 20 inches by 16 inches and 10 inches by 8 inches. The paintings were to be exhibited as an advertisement for the scheme. Subscribers to the whole publication were required to pay 2 guineas for each complete number, which was to contain three of the large prints and their accompanying reading matter, illustrated by the small prints. If however, the subscriber did not wish to have the large unframed prints, he could have the text and illustrations for 18s. a number. Should anyone wish to purchase a single number, this was £2 12s. complete, or 1 guinea for the small prints and the text. Large single prints were to be obtainable at 13s. and small ones at 6s. The subscriber to the complete set was required to pay 1 guinea when giving the order and the other guinea when he received his copy.

After four years, in 1794, Stubbs had completed sixteen paintings of racehorses for the *Turf Review*, and these were exhibited at the Turf Gallery in Conduit Street. The arrangement was that they were to be augmented occasionally until the paintings for all the numbers were completed.

Financially, it appeared quite a profitable undertaking for Stubbs, as the sum of £9,000 was to be deposited with a banker and, as the various paintings were finished, 'Mr Stubbs was to have the privilege of drawing for their respective amounts'. Unfortunately for the success of the project, not enough attention was paid to the selection of horses to be portrayed.

The series started off well enough with the Godolphin Arabian, who is essential to any history of British Turf and to the development of the English thoroughbred. Stubbs could conceivably have seen the old horse. He was said to have been foaled in 1724, the same year as Stubbs himself. He could hardly have been painted from life for the Turf Gallery, as he died in 1753, in his twenty-ninth year. It is probable that Stubbs had to consult other portraits of the horse, before starting his version for the scheme. There were a number of paintings of the Godolphin by such painters as James Seymour, Wootton, David Morier, and James Roberts. The Arabian—who may have been a Barb rather than an Arab—was said to have drawn a cart in the streets of Paris. He was a dark bay of about 15 hands, with good bone and substance. His crest was exceedingly high, and his neck was elegantly curved. He had good strong shoulders, his muzzle was delicately shaped and tapered, and was a rusty brown, as were the insides of his dark ears. Though his legs were short, he covered as much ground when standing as a horse of 16 hands. His hoofs were small, jet black, and quite naturally polished. He was given to Lord Godolphin by the keeper of the James's Coffee House, and was originally kept as teaser to Hobgoblin in the Godolphin Stud, but from 1731 he produced a succession of distinguished offspring. He formed, in later life, a tremendous friendship with a cat; they were inseparable, and when he died she stayed by his body till it was buried, then she disappeared and was never seen again. Stubbs's painting shows her just emerging from the stable door, with the Godolphin rolling a wicked eye at the painter. The painting was much criticized at the time for being out of proportion, particularly about the neck and crest, which was said to be exaggerated. Yet those who had seen the horse, and remembered him, were all agreed that his crest was outstandingly high, and that the painting was a good likeness. Even Landseer copied it, and the result was exhibited at the Landseer Exhibition in 1874. John Lawrence says in his *History and Delineation of the Horse*, published in 1809: 'It is doubtless an admirable piece; but the artists say that Stubbs saw all proportions through magnifying optics, and that the crest of the Horse is quite out of nature.' He also reports a 'common objection to the works of our late celebrated horse painter Stubbs, whose superior genius and professional skill, have been acknowledged by all Europe, and it is, perhaps, that peculiar line of painting alone, in which the artists of this country can pretend to any superior claims. It is probable, there is not in England, so bad a painter as I am a judge of painting; and the sum total of my connoisseurship amounts to this: I can discover whether nature has been well copied, and in the next, whether there be any great breach of proportions. The reader will thus at once, see the extent of my right to call in question the justness of the present prevailing opinions, so inimicall to the reputation of Stubbs. These opinions seem to be spreading beyond the professional line, and to have become, in a certain degree, fashionable. It has been lately discovered, that Stubbs was merely an anatomist, without any genius as a painter; that his Horses are all alike, and that after you have looked over his portraits of Marske, Protector, Shark, Gimcrack, and others, all that you shall have seen, is the anatomical figure of a Horse by Stubbs, under different names. I have been told particularly, that his Shark is quite a different thing to the real Horse which my informant saw, a fine, gallant gay and airy stallion. Shark might appear so in the company of a mare, but whenever I saw him, and I saw him several times, he appeared precisely in that sober attitude and character, in which our great painter drew him; nor can I conceive a more correct, or more natural likeness, of this favourite Racer, to ride which a sweat, how freely would I have journeyed several hundred miles. In my Treatise on Horses I gave a speci-

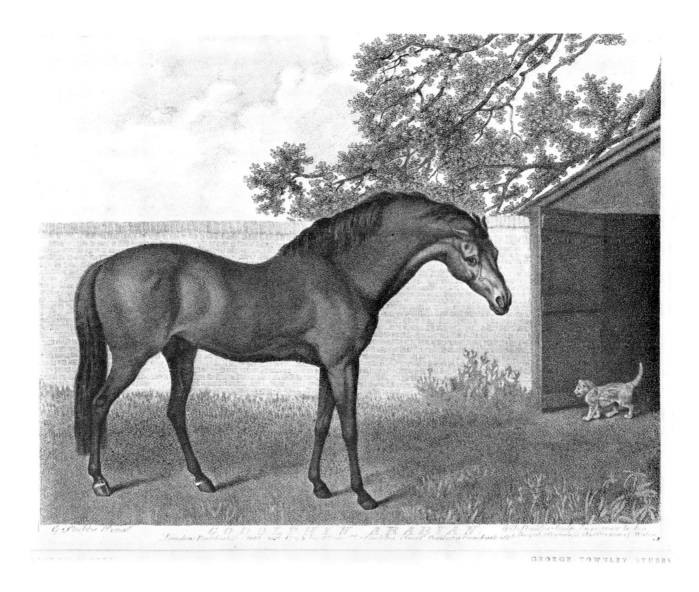

GODOLPHIN ARABIAN

GEORGE TOWNLEY STUBBS

Godolphin Arabian. (*Engraved by George Townley Stubbs.*) *The British Museum, London.*

135

men of the accuracy of a criticism on a picture of Bulls fighting, exhibited by Stubbs. It was a most correct copy of nature, as everyone knew, who had been accustomed to see bulls fight: but the critics found it tame, and did not stay to reflect, that it was no fault of the painter, if bulls were not in the habit of fighting with all the animation and fierceness of tigers or stallions. We have here a new edition of the ancient story of the Countryman and the Pig. I have heard it objected also, that in the portrait of Mambrino, the painter had exhibited a war-horse, or coach-horse, rather than a racer. Once more, Stubbs ought not be be blamed, because Mambrino was a grandson of Sampson. Is it not the grand defect of this painter, that he imitated nature too closely for the taste of the times? With respect to the crest of the Godolphin Arabian, supposed to be over-done by Stubbs, and out of nature, the character of the painter may be successfully defended, both from the original portraits, and by a living example from nature. A short time since, I saw at Tattersall's, a stallion belonging to the late Duke of Portland, got by some son of Eclipse, I think Volunteer, out of a hunting mare, with a crest to the full as lofty, swelling, and thick, as that of the Godolphin Arabian appears from the pencil of Stubbs; and not only so, but in the tapering of the neck, in the head and in the smallness of the muzzle, together with the general air in those parts, the Horse so strongly resembled Stubbs's picture of the Arabian, that I could not help calling Mr. Tattersall and another gentleman, who instantly recognized the likeness.

'But the posthumous fame of Stubbs, is safe in the keeping of such patrons as those who possess an inestimable treasure in his pictures. His Royal Highness the Prince of Wales, His Royal Highness the Duke of York, Earl Grosvenor, the son of Stubbs's first patron.—The Dukes of Queensbury, Richmond, and Grafton, the Earl of Egremont, Sir Joseph Banks, Colonel O'Kelly, Colonel Thorton, Christopher Wilson Esq. General Stibbert, and a Lady, Miss Saltingstone, of Cobham. His Royal Highness the Prince possesses the portrait of his horse Baronet, with Chifney upon his back, as winning the Oatland stakes; this I formerly recommended as a model of the true jockey-seat on horseback. Earl Grosvenor's and Colonel O'Kelly's, are the largest collections of the works of Stubbs. Earl Grosvenor has two portraits of Gimcrack, that of Gimcrack preparing to start, is reckoned a chef d'oevre. The two portraits, it is said, represent this Horse in different shades of grey, the iron grey of his youth, and the hoary white of his old age. I remember that the last proprietor of this famous Horse, left him a length of time at Tattersal's, for the inspection of the public. Colonel Thornton has Knawpost, purchased I believe, at Stubb's sale, where Scrub, and a variety of other paintings and sketches were also purchased by Miss Saltingtone. The laborious and regular Stubbs, a young man at ninety years of age, supposed that life might be prolonged by art, to an indefinite and far distant period; but he found nature stood in the way. His death was gentle.—May we all die like Stubbs!'

His statement that Stubbs imitated nature too closely for the taste of the times is particularly interesting and acute. Stubbs's life was just a little too late to prevent a falling-off of his clientele. He was active too long, and the mid-eighteenth century, the period when he was so highly thought of, had passed. The eighteenth century was giving way to the nineteenth century, with its rapidly changing tastes. Stubbs's independence of thought did not permit him to jump on the bandwagon of fashion, and he remained practically uninfluenced by the art forms that were newly in vogue. It must have been disappointing and frustrating for him to find his patrons moving on to other, younger painters, and to find his commissions falling away. The *Turf Review* should have been a great help to him during his last fifteen years,

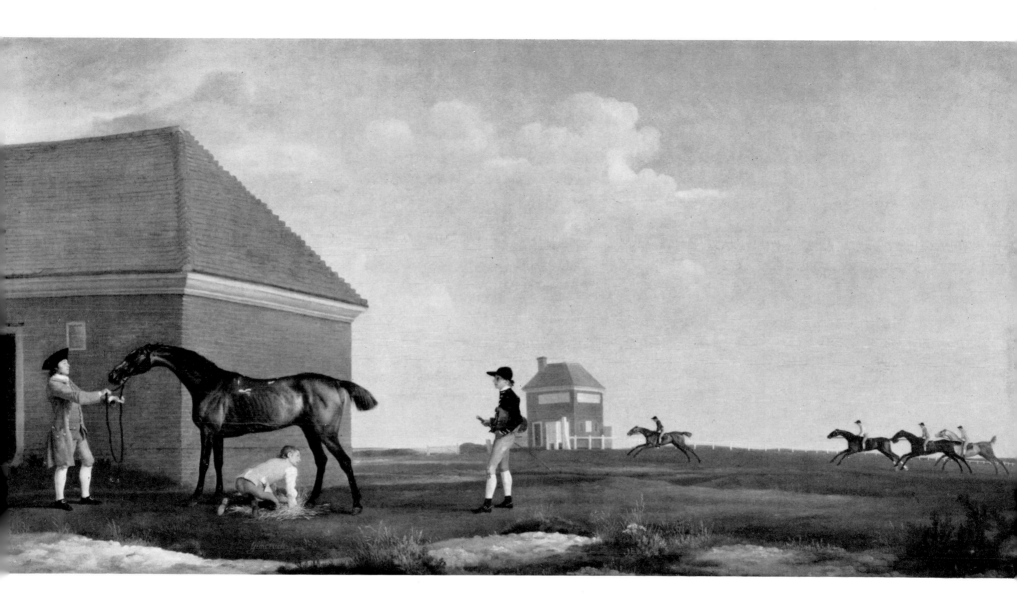

Gimcrack. *40in × 76in. By kind permission of the Stewards of the Jockey Club.*

but because there seems to have been very little forethought and planning done for the project it was not to be anything other than a further disappointment to him. The choice of thoroughbreds to illustrate the history of the Turf over the second half of the eighteenth century was somewhat haphazard, and was not sufficiently carefully considered. Though they were all well-known horses of their time, some were hardly everyone's choice, and there is a feeling that the decision was perhaps dictated by Stubbs, who, in many cases, selected the more famous racehorses that he had already painted and repeated their portraits for the *Turf Review*. The complete list of the sixteen that were exhibited, were as follows: The Godolphin Arabian, Marske, Eclipse, Dungannon, Volunteer, Gimcrack, Mambrino, Sweetbriar, Sweet William, Protector, Shark, Baronet, Pumpkin, Bandy, Anvil, and three colts—one called Gnawpost.

One has to bear in mind that with the development of interest in racing portraits of horses of the calibre of Eclipse and the Godolphin were as popular as engravings of famous men. In Stubbs's lifetime so much had happened that is now racing history; for example, the first racing calendar was in 1727. The Jockey Club was founded in 1750, the first steeplechase was run in 1752, from St Buttevants to St Leger. The first St Leger was run in 1778, and the Oaks in 1779, and the Derby in 1780. There was a tremendous upsurge of activity; breeding, training, and racing.

Little Gimcrack,[1] in whose honour the Gimcrack Club in New York was founded, was another distinguished horse that Stubbs painted a number of times. The earliest portrait, painted in the 1760s, of which there are two almost identical versions, is one of Stubbs's masterpieces. The composition is quite remarkable in its sophisticated design. The picture shows two scenes; in the foreground to the left Gimcrack stands by the rubbing-house, pant-

ing, after winning his race. He is held by his trainer, with a stable-lad on his knees making a wisp to rub him down with. His jockey, saddle under one arm and whip under the other, stands in the centre of the rather long-shaped canvas. Behind him, to the right, can be seen the four small figures of racing horses, Gimcrack well in the lead, passing the winning post. The two separate events are so carefully designed and constructed that they make one complete whole, and a composition of spacious tranquillity. The eye is led, by the busy repeating pattern of the little horses in the distance, galloping, in towards the middle of the picture, where it is halted for a moment by the upright figure of the jockey, who by his pose directs the eye on to the dominant foreground group. The trainer's authoritative stance holds both the horse and the composition firmly and leads the eye back to the lad, whose upward glance at the jockey returns it to the start, to continue to enjoy the whole work. The design is daring, the broad expanse of simple sky is beautifully balanced by the solid structure of the rubbing-house, and by the figures of widely differing sizes. The foreground has a decorative treatment, also carefully planned to give interest and texture to the painting, by means of patches of light stones and darker clumps of vegetation and wild flowers. The colour is extremely quiet; olive greens and browns, creamy beiges and dove greys predominate against a calm pale blue sky, yet there is no monochromatic feeling in the colour scheme. Gimcrack himself is a strange iron grey, almost like pewter, certainly not blue roan, and not at all like an ordinary dark grey. There is no effect of dappling or of white hairs. He reads as well very close to as he does from far away and from a short distance. The paint is smooth, with the brushwork hardly visible, except where tiny details, like spurs, have been touched in with crisp command of the medium. The jockey wears Lord Bolingbroke's colours. Gimcrack was owned by him at one time, in fact, he had

[1] Illus. p. 137.

Gimcrack (when white). *34in* × *44in. By kind permission of Lord Irwin. (Photograph by courtesy of Arthur Ackermann & Son Ltd.)*

a number of owners. He was bred by Gideon Elliott of Murrell Green, and then passed to Mr Wildman, who also owned Eclipse, then he went to Lord Bolingbroke, followed by a period in France with Count Lauraguais, for whom he won a bet that no horse could travel $22\frac{1}{2}$ miles in an hour. Then he was sold back to England, to Sir Charles Bunbury. Lady Sarah Bunbury remarked in a letter: 'There was a meeting of two days at Newmarket this time of year to see the sweetest little horse run that ever was. His name is Gimcrack, he is delightful—Lord Rockingham, the Duke of Grafton and General Conway kissed hands that day that Gimcrack ran. I must say I was more anxious about the horse than the Ministry.' That particular race was probably the one commemorated in the painting, and was run at Newmarket in July 1765. Stubbs made a special little study in oils, of the famous rubbing-house there, which appears in a number of his racing pictures, and is now in the Mellon Collection. The horse was finally owned by Lord Grosvenor. He was foaled in 1760, and was by Cripple. He ran his last race at Newmarket in 1771.

Stubbs painted two other portraits of Gimcrack; in the one he is ridden by a jockey in a red jacket, and in the other, he is held by his groom[1] at Lord Grosvenor's Stud Farm at Oxcroft, near Newmarket. He is shown in this as having changed considerably with age. He is now almost white, except about the legs and muzzle. This was painted in 1770, and was the portrait used for the Turf Gallery. It was engraved and published on 30th July 1796. The engravings for the *Turf Review* were executed not by Stubbs himself but by his son, George Townley Stubbs, who engraved a good deal of his father's work.

When the scheme came to an end twelve of the large plates had been engraved, and thirteen of the smaller ones. They were published between 1794 and 1796 by 'Messers Stubbs'.

There is bound to be a certain amount of sameness evident in a set of racehorse portraits, for the angle or viewpoint is necessarily a well-lit straight-on side view; anything else fails to show accurately the all-important conformation. This restriction imposed upon the subject limited the possibilities of really interesting composition. The background to a single animal cannot quite compensate without dominating the picture, which is then no longer satisfactory as a portrait. Some of these Turf Gallery paintings succeed, as in the majestic Mambrino, painted in 1779, whose personality and presence are outstanding. His powerful front and shoulders, and his richly curved crest and neck with his elegant little head, give him an impressive, sculptural quality. He was a colt by Engineer and was the sire of Messenger, the stallion who became famous in the history of American bloodstock.

Marske was bred by John Hutton of Marske, near Richmond, Yorkshire. He was sired by Squirt, son of Bartlet's Childers. He was exchanged as a colt, by his breeder for an Arab belonging to the Duke of Cumberland. The Duke called him Marske after his birthplace, but he turned out to be uncertain as a racer and at the Duke's sale he was sold at Tattersall's to a Dorset farmer, for a song. He stood as a stallion at fees of half a guinea, till he was sold to Mr Wildman for £20, the farmer thinking this a good price for him. However, he had, while with the Duke, sired a colt that turned out to be outstanding. He was foaled during the great Eclipse in 1764 and was named after it. Mr Wildman was delighted to get his father, Marske, and as Eclipse's reputation became more widely known Marske's stud fees rose accordingly from half a guinea to 100 guineas. At this point he was sold to Lord Abingdon and was considered the first stallion in the country; in fact, for one season his fees were 300 guineas for each mare. In twenty-two years he sired over 150 winners, amongst them Shark, who was also painted by Stubbs, first in 1775 and again, a very similar

[1] Illus. p. 139.

Mambrino. *33in × 44in. By kind permission of Lord Irwin.*

portrait, for the *Turf Review* in the 1790s. In the painting he is shown with his trainer, Price, who is holding out a sieve to him. He was sold to America in 1786 and died in Virginia ten years later. The setting is very typical of Stubbs's landscape backgrounds, with a lake in the misty distance and a clump of trees occupying one side of the picture. Pumpkin is another portrait with the same design units, used in much the same way. The painting of him for the *Turf Review* shows him being ridden at Newmarket by South, the well-known jockey.

To return to one of the really great racehorses, Eclipse. Stubbs made a study of him without a background and also painted him with his groom and jockey outside the rubbing-house at Newmarket Heath, now in the Jockey Club Rooms. He shows him as rather long backed and perhaps slightly common. Probably one of the most famous portraits of all racehorses is the portrait of Eclipse with Mr Wildman and his sons. It was this painting of which Sir Alfred Munnings said: 'I know of nothing better than those three figures in the picture, let alone that of Eclipse, which is the most honest portrait of a racehorse ever put on canvas.' He was sold after the Duke of Cumberland's death and according to the old story Mr Wildman was determined to acquire him. On arrival at the sale, he produced his watch and insisted that the auction had started before the time announced in the advertisements, and that the horses already sold should be put up for sale again. It was agreed by the auctioneer and company, to avoid a row, that Mr Wildman could have a choice of any special lot that he had had his eye on. So, by rather doubtful methods, he managed to obtain Eclipse for a very moderate sum, around 75 guineas. Col. O'Kelly bought a half-share in him for 650 guineas, and later paid a further 1,100 guineas for the other half. Eclipse won £25,000 and eleven King's Plates; he was never beaten and his speed and stamina were quite outstanding. In twenty-three

years he sired 344 winners, who produced for their owners over £258,000.

Two horses from the Turf Gallery Collection that were both sired by Eclipse, and owned by Col. O'Kelly, were Volunteer and Dungannon. The latter is shown as a nice little bay[1] with an extremely pretty head, one of the most attractive Stubbs ever painted. He stands in a paddock by the stable wall, with his special friend, the lamb, facing him. Neither would stay in the paddock without the other. The sheep, who originally strayed into the field by accident, has D. O'K.—Col. Dennis O'Kelly's initials—on his side. Dungannon won the King's Plate at Newmarket in 1786, and was said to have been one of the most famous of Eclipse's sons.

The other son chosen for the *Turf Review* was Volunteer, out of a mare by Tartar. He was foaled in 1780 and was originally called Comet. In the painting he trots briskly up to Col. O'Kelly's stud-groom, who stands waiting for him with a halter. His action is a little exaggerated, with his foreleg raised rather high, but this may well have been a characteristic of the horse. Stubbs gave much the same action to the horse ridden by the Prince of Wales.

Sweet Briar, who was a strange slaty colour, almost black, was bred and owned by Lord Grosvenor, who also owned Protector, and Mambrino. The backgrounds are of Lord Grosvenor's estate at Oxcroft, and Stubbs painted a briar rose in the foreground of the picture.

The painting of Baronet is rather different from the others because it is one of Stubbs's few galloping-horse portraits. Baronet, called after his breeder, Sir Walter Vavasour, Bart., was foaled in 1785, and was sold as a four-year-old to H.R.H. the Prince of Wales. He won the Oatlands Stakes at Ascot in 1791, the value of which was 2,800 guineas and also the King's Plate at Newmarket. He later went to America. He is ridden by the very

[1] Illus. p. 144.

142

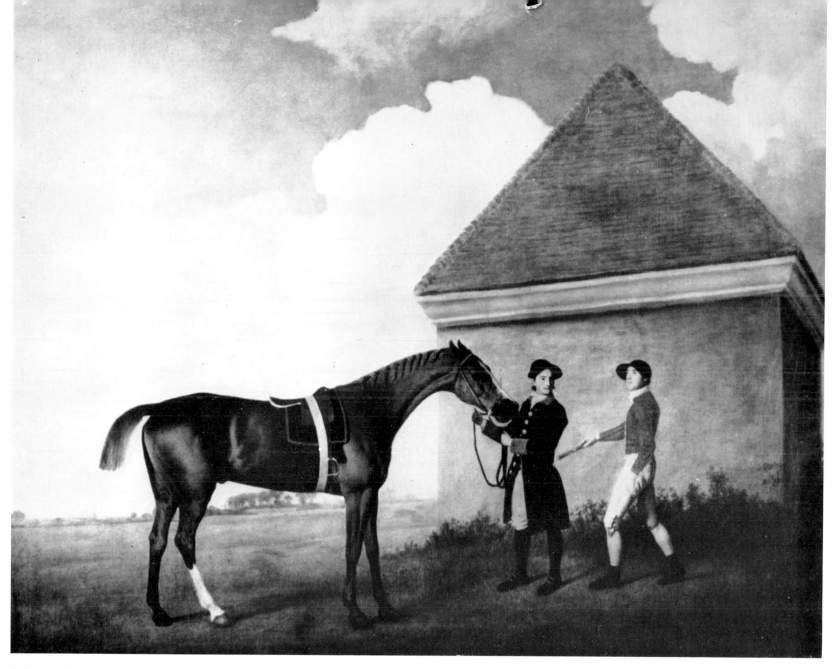

Eclipse. *39in × 49½in. By kind permission of the Stewards of the Jockey Club.*

Dungannon. *40in × 50in. By kind permission of Lord Irwin. (Photograph by courtesy of Arthur Ackermann & Son Ltd.)*

144

Baronet. *40in × 50in. By kind permission of Lord Irwin. (Photograph by courtesy of Arthur Ackermann & Son Ltd.)*

well-known jockey, Sam Chiffney. According to the *Sporting Magazine*, 'Mr Stubbs has taken great pains to give the character and style of riding of this celebrated jockey.' Chiffney, who sits bolt upright in the painting, was famous for his good seat. There is a curious lack of proportion in the drawing of the figure; he is given a tiny head and very small feet and he has almost doll-like arms and hands. The rest of the body belongs to a man more in proportion to his mount. Stubbs occasionally tended to give his figures these quaint proportions, particularly the small heads and hands, which produces a very elongated effect and great tallness. Baronet is seen in the classical conventional gallop, front legs stretched forwards and back legs backwards, all four feet off the ground at once. This convention gives an unusually 'old-fashioned' look to the painting. Stubbs's work normally has a timeless quality. The *Sporting Magazine* comments: 'There is something very singular in the picture; the horses legs are all off the ground. That moment when raised by the motion of muscular strength, a bold attempt, and as well perfected: this attitude has never yet been described but by Mr Stubbs.' There is another painting of Baronet in the Royal Collection. He also painted Bay Malton for Lord Rockingham, galloping along the rails in the same attitude. He is ridden by John Singleton, who looks altogether happier than Chiffney. He stands in his stirrups and leans a little forwards, as he goes with the movement of the horse.

Although so much work had gone into the *Turf Review* project, it eventually came to grief. The reasons given by Humphry were: 'The success not reaching the hopes of the projector on account of the stop which the war has given to the exportation and to the state of works of art of every description, the scheme is in a considerable degree suspended till the hoped for peace.' In one of the transcripts it says: 'This scheme has in some degree been executed and is now proceeding on by his Executrix, Miss Spencer.' This is crossed out and 'since his death been discontinued' has been substituted. There is a note as well, presumably in Mary Spencer's own handwriting: 'Turf Gal, Miss Spencer does not go on with this work, sixteen have been Painted and exhibited and 12 only Engraved of the Large and 13 of the Small. Miss S. has all the Plates and Prints, as the proprietor never settled with Mr Stubbs and only paid in part. The pictures were all sold at Mr Stubbs's sale.' It was not the triumph that Stubbs had hoped for, to re-establish him, and bring his name to the public eye and his work back into fashion. Apart from that, it was obviously not a success for him financially, and this must have been a big disappointment. By no means all of his patrons paid immediately for all they had commissioned, even the Prince of Wales owed him a large sum in 1793.

He had said about the Turf Gallery project: 'It may be deemed extraordinary to submit a work of so unusual a kind to the public consideration: where the chief merit consists in the action and not in the language of the Heros and Heroines it proposes to record, and with whom, possibly, Literature may exclaim "She neither desires connection nor allows utillity".'

It was a great pity the public did not consider it worthy of subscribing to in sufficient numbers to keep the scheme going. Stubbs was the perfect painter to undertake the work; even Fuseli said: 'None ever did greater Justice to the peculiar structure of that artificial animal, the Race-courser and to all the mysteries of turf-tactics.' Though one has to admit that he went on: 'Unfortunately for the artist, they depend more on the facsimilist's precision than the Painter's spirit.'

That Stubbs painted what he saw is true, but to this is added so much that cannot be, under any circumstances, called facsimilist's art. He painted with such deep knowledge and understanding of what he saw that the two were fused into one vision.

Jupiter and a Mare. *37½in × 48in. By kind permission of Sir Martyn Beckett, Bt.*

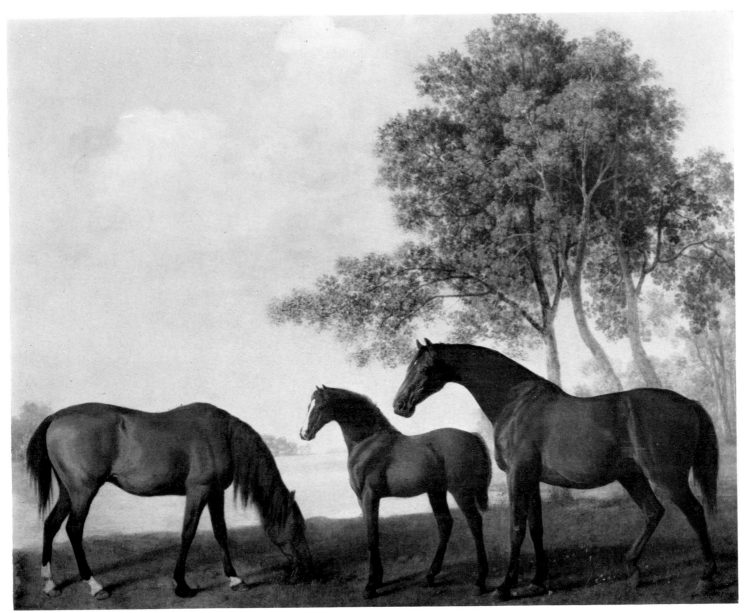

Pumpkin with
a Stable Lad.
$32\frac{3}{4}in \times 39\frac{1}{8}in.$
*From the
collection of
Mr and Mrs
Paul Mellon.*

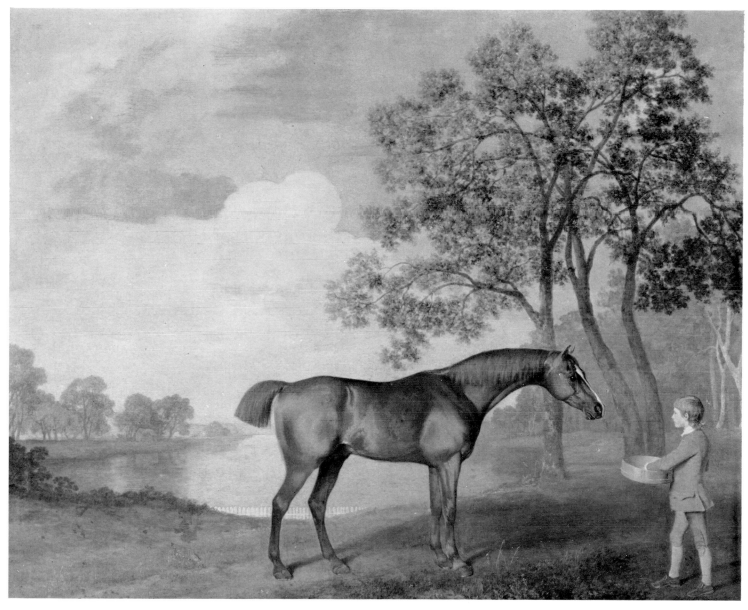

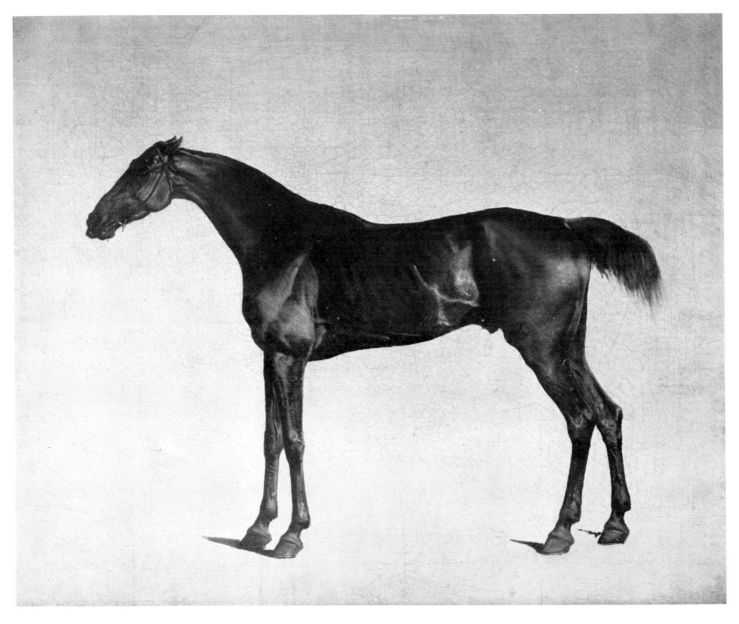

Rufus.
23½in × 30½in.
Herron Museum of
Art, Indianapolis,
U.S.A.

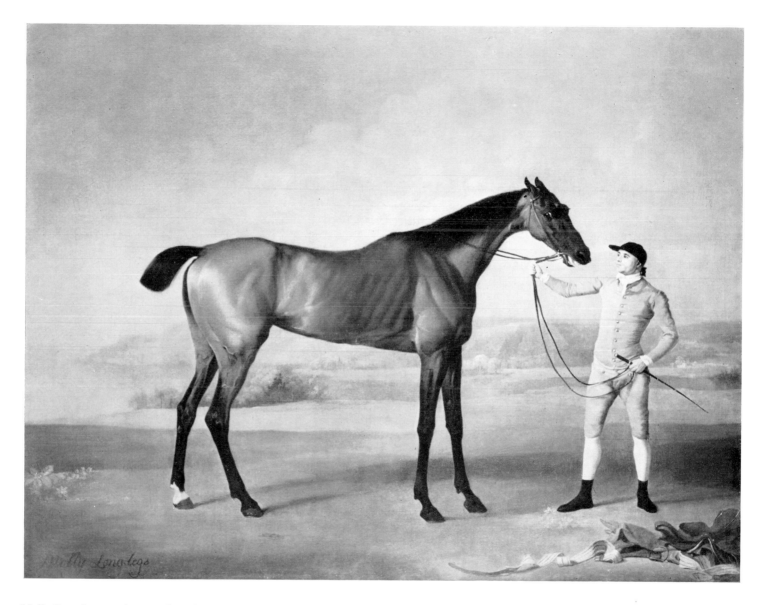

Molly Longlegs. *40in × 50in. The Walker Art Gallery, Liverpool.*

Before making a statement, he considered and contemplated, like the child: 'First I think, then I draw my think.' Stubbs's 'think' was an ordered, intellectual creativeness, allied to sensitivity and sympathy, but he was completely objective and without sentimentality. As Meyer says: 'He never painted an immortal soul in a poodle's eye.' He never added a hint of extra pathos or false nobility to his animals.

Single portraits of racehorses do not have quite the attraction of, for example, the portrait of Jupiter[1] and a mare, where the flaunting action of the stallion approaching the mare makes him a most decorative shape, contrasting with the prim and stiffly unwelcoming mare. Jupiter was yet another of Eclipse's successful progeny and won the Thousand Guineas at Newmarket. He appears as a light bay, almost a dun, with a black mane and tail.

The painting of Goldfinder is nearer to the theme of the 'Mares and Foals' in its design of the stallion, with mare and foal, arranged in an interesting pattern across the foreground. The background is extremely similar to that of Pumpkin, painted in the same year, 1774. Goldfinder was sired by Snap, who was painted for his owner, Jenison Shafto, by Stubbs, in 1771, in very much the *Turf Review* kind of portrait. Two early horses, painted in the 1760s, were Rufus, a backgroundless study of a typically gaunt and much-sweated racehorse, and Molly Longlegs, whose legs were undoubtedly long and who had even less flesh on her than Rufus. There is an excellent portrait of her jockey, who holds her as she rolls a wicked eye at Mr Stubbs. The landscape is delightful, pale and delicate, with an early-morning tranquillity about it.

[1] Illus. p. 147.

152

Fourteen · Exhibitions and Technique

Stubbs's works are to be found in many private collections, often still belonging to the descendants of those who commissioned them originally. There are comparatively few of his works in public galleries. He is poorly represented in our National Collections: the Tate Gallery has five paintings and the National Gallery only one. It is sad that so many have found their way to America. One can blame high prices now, but considering that twenty years or so ago his works could be acquired for a relatively small sum, it is a pity that those who are entrusted with the building and adding to of this country's National Collections had such a lack of appreciation and foresight.

Stubbs's paintings have not been very frequently shown in loan exhibitions over the years. The Royal Academy Winter Exhibitions have recently shown quite a number of his major works, and in 1965 the exhibition of English painting in the eighteenth century from the collection of Mr and Mrs Paul Mellon gave a splendid chance to see the largest single collection of his works and a wonderful opportunity to study paintings now resident in America. He was quite well represented in the great British Art Exhibition at the Royal Academy in 1934, when seventeen of his paintings were on view. In 1885 there was a comprehensive exhibition at Messrs Vokins in Great Portland Street, when over sixty paintings and engravings were on view. Since the last war there has been a reawakening to his qualities, and with it has come a better public showing of his work. In 1951 a large exhibi-tion was mounted at the Walker Art Gallery, Liverpool. The lovely Fitzwilliam Collection has been on view twice, at Messrs Ellis and Smith in Grafton Street in 1946 and at the Graves Art Gallery, Sheffield, in 1952. The Durdans Collection of paintings were shown at Ackermann's in Bond Street in 1966. These paintings from the *Turf Review* set were particularly interesting, as they had not previously been shown, even in the marvellous Whitechapel Art Gallery Exhibition of 1958. This outstanding exhibition was a revelation, even to those who had always admired Stubbs's work. It helped to bring him back to the notice of connoisseurs and lovers of good painting who had pre-viously considered him to be merely a good eighteenth-century painter of animals. The most noticeable thing about the exhibition was its very wide range and scope, and it brought about a long-overdue reassessment of Stubbs's work. The subject-matter was far more varied than that of most animal painters, and was cer-tainly not limited to horses. It was partly due to the influence of this eye-opening exhibition that prices for Stubbs's pictures began to change dramatically. Whereas in earlier times prices were low, they now started an upward spiral; a spectacular price was paid in 1966 for the portrait of Goldfinder with mare and foal, £72,000. These very high prices are perhaps due in part to the subject-matter. When the painting is of a noted stallion, whose bloodline can be traced to the present day, the market price is undoubt-edly affected by it. Whereas, when the painting is of equal

153

aesthetic quality, but without the bloodstock interest, the price is likely to be quite noticeably lower. Paintings like Gimcrack which were sold in 1943 for £4,200 appreciated rapidly, and eight years later fetched £12,000. Gimcrack was sold by auction on 2nd July 1812 by Peter Coxe for 21 guineas, and at the same sale three paintings of horses that were represented in the Turf Gallery were also sold: Sweet William for $17\frac{1}{2}$ guineas, Protector for 12 guineas, and Sweet Briar for $16\frac{1}{2}$ guineas.

Very different was the price paid this year for the 'Cheetah with two Indians', which realized £220,000, one of the highest prices yet paid for a British painting. Though, even if the *Turf Review* paintings went cheaply, Stubbs, in his lifetime, received very good prices for his work.

Stubbs usually signed his paintings and dated them, though there are a number unsigned. These are more frequently to be found fairly early in his career, though he continued to leave occasional works unsigned all through his life. His favourite form of signature was 'Geo. Stubbs pinxit', followed by the year. Sometimes he left out the 'pinxit', and he occasionally used his full Christian name.

His paintings are often difficult to identify by their titles. The 'Lion and Horse' series of paintings have been given various titles over the years, for example, 'Lion attacking Horse' and 'Lion devouring a Horse', etc. The many paintings of horses and their grooms, whose names have not survived, are also difficult to identify clearly, and often the only reasonably direct method of identification is to give the name of the owner, rather than a complicated description, and even then paintings can change hands quite quickly and confusion again arises.

Stubbs's technique owed a good deal to his scientific projects; in fact, they contributed greatly to his artistic development. They were by no means isolated research, but were an integrated part of his art studies. It is impossible to visualize Stubbs's work without the immense knowledge that he gained from his projects. There was tremendous leap forward in his grasp of form and structure after the period of intense study, and the vast output of drawings, at Horkstow. His drawings and engravings developed from the vital though somewhat rough and unsophisticated midwifery plates, to the competent and beautifully executed plates for *The Anatomy of the Horse*, and on from those to the elegance of the plates for the *Comparative Anatomy*, done late in his life, with their smoothly gradated tones, made by the most laborious stippling. This change from the comparatively clumsy and rough to the smooth, with an increasing command of form and texture, is echoed in his painting. His earlier work is solidly painted, and rather hard and dry in quality, the foreground details are flicked in with sharp precision and authority. As he became increasingly interested in the possibilities of enamel painting, and experimented with the techniques involved, his style changed. His methods of oil painting were affected by the use of the more creamy, fluid paint used for enamelling. The technique for this was closer to watercolour painting washes, or rather, thin almost transparent glazes of colour applied to the ground, one over the other. This produced a much smoother, glossier, and more highly finished appearance to his work. Once he had started using earthenware plaques as a ground for his big enamel paintings he began to make use of panels as well as canvas for his oils. These were nearer in surface to the hard, close and unabsorbent ceramic ground, and had no roughness of texture to interfere with the smooth finish of the thinner and more liquid paint.

It would appear that though he approved of the changes in his technique, and was determined that his enamels should succeed, in general, they were not popular. They were very different in quality to oil paintings, and stood out as particularly bright and

luminous in colouring, even though Stubbs's colour is very restrained and muted. There was considerable difficulty in hanging them successfully in an exhibition, so that they did not stand out and kill the other surrounding works. All this was a great disappointment to him, after so much effort to achieve a really satisfactory and permanent method. The softening outline and smoother finish never degenerated into slickness and slackness, as can happen when a painter achieves great technical facility. He maintains all his original authority and sensitivity. His paint is always laid on crisply and without hesitancy, and his work is always clearly thought out before making any statement.

In the panels it is possible to see traces of the natural colour of the wood showing warmly though the paint, so it seems as though he did not use a white priming beneath the paint. In his backgroundless paintings the ground gives the impression that, even allowing for the darkening of a pure white ground, the priming started very slightly toned.

At no time does he make any spectacular play with brush strokes, or paint texture. He had the rather unconventional habit of painting his figures completely, and allowing them to dry, before adding the background, and this tends to give a certain hardness of silhouette to some of his horses. However, when one considers the difficulties of undertaking to paint sometimes very large portraits of horses direct from nature, and far away from home and studio, with the problems of transporting canvases back to London by coach, it is hardly surprising that he adopted a method that suited his own way of working out his problems. His judgement of tone was so extraordinarily well developed that he was able to produce in his backgroundless paintings a sense of complete tonal accuracy and extreme sensitivity to what must be an absolutely artificial statement of tone values.

Stubbs's colour is always interesting. Though he is not a great colourist in the Bonnard sense, his colour is very pleasing, with a certain elegance and tastefulness. He uses mellow, quiet tones, and misty-evening colours with a nostalgic air of sadness. Much of his colour is based on olive greens, browns, and creamy beiges and stone-colours, placed against cool greys, dull blues and luminous pale blue skies. He spikes these with ochre yellow, or a delicate but sharp pink, and with black and white. He also sometimes uses an occasional burst of coral or scarlet. He uses wild-bird colourings, like chaffinches or doves, which are very English in their reticence.

His 'Prince of Wales's Phaeton'[1] is a marvellous example of his use of colour. It has an almost Chinese feeling about the simplicity of the carefully chosen and arranged tones and hues. He sometimes gives an unexpected touch of colour, like the little boy in the portrait of Pumpkin, who wears a carnation jacket that triggers off the whole composition, or the bright yellow pants of the groom in the 'Prince of Wales's Phaeton'. His appreciation of tone is so exact that he can give tremendous sensual pleasure by painting the dull black polish of well-kept leather harness against the live sheen of a well-groomed black horse. The subtleties of the horse and harness in the Rev. Carter-Thelwell and Wife and Daughter and of the Prince's Phaeton are most evocative and live in the memory long after the painting has been seen.

Stubbs's compositions were constructed with geometrical precision. He often used the diagonal as a base for his designs of single horses, carrying the dark tones of the foreground upwards and across by means of heavy tree trunks and summer foliage. By very careful placing and planning of his designs, within the restrictions of his commissions, he managed to produce satisfying compositions. If there is a certain sameness about a number of them, this is due to the limits imposed, rather than any formula by which pot-boilers could be turned out. In fact, Stubbs was never

[1] Illus. frontispiece.

guilty of this. No professional painter, working on commissions, and subject to his clients' whims and wishes, can produce inspired works of art on each canvas he paints, but he always did a good, honest piece of work, to the best of his ability. Everything he painted is infused with a rare genuineness, which changes his paintings from mere reproductions of the appearance of objects seen by a trained eye into creations that exist in their own right.

His interest in geometry and perspective are all part of his scientific side and are quite logical in a man of his character. He worked out most carefully the relationships of line and volume, and of tone and colour, dividing up his picture area into pleasing shapes within the context of his subject. Whether deliberate or not, he certainly used the Golden Section as a guide to dividing his work, and to organizing the elements of his compositions. The triangle was a favourite basis on which he would build a picture; this shows very clearly in the portrait of Sir John Nelthorpe[1] out shooting with his dogs. His fondness for a long panel of linked figures, in line and on the same plane, is shown in the Fitz-william 'Mares and Foals'. This demonstrates his use of curving lines and rhythms, and of contours that barely meet, linking up separate units. He also made use of implied lines, created by the pose of a head and the direction of the gaze of the eyes, as in Gimcrack and Hambletonian. As well as this linear composition, he used volume and mass to balance and counterbalance. Light against dark, muscular force thrusting against bone-structure, pattern against plainess and simplicity, and, always, he was very much aware of the interrelationship and opposition of shape against shape, linking and separating forms. His whole approach to composition was treated with the same interest in articulation that he devoted to the drawing of a skeleton or the painting of a post-chaise. He was an architect, rather than a painter, in his construction of a pictorial design.

Though he constructed like an architect, his designs never become static or rooted to the ground; he achieves the movement in his work through his design. He was mainly concerned with pose and poise, fast movement did not really interest him, whether the movement was through rapid action or obtained through wind and weather. His horses in the 'Lion and Horse' series have their manes blown out like pennants in the wind, though their tails are not affected by the same wind. Portrayed in violent action, they are frozen into immobile sculpture. He used movement to further his designs, and his designs gave movement to his compositions, but the reproduction of speed was not, to him, an end in itself.

He was an analytically accurate observer of a pose, but not of the transitions between poses. His paintings of the gallop and the canter have a beautifully balanced but curiously static quality, with a formalized arrangement of the legs—the forelegs pointing forwards and the hind legs straight out behind. This convention was greatly used till the advent, in the nineteenth century, of photography, when such men as Eadweard Muybridge produced series of photographs of each tiny phase of a movement. This formed a complete picture of what was happening to each leg, when the actual movement was too fast for the eye to take in all four legs at once. The publication of these photographs caused a new and fresh observation and appreciation, by artists, of high-speed action in animals, particularly in horses racing. In the eighteenth century the fore and aft legs gave a kind of dead-horse hung-up look to the paintings of racing scenes. Stubbs's draughts-manship avoided this dead look, for the whole of the surface modelling in his paintings of racing horses is alive, and the structure is controlled by a complete knowledge of the form, each muscle contributing to the whole. One only has to look at the lovely 'William Anderson with two saddle-horses'. He was head groom to the Prince of Wales, and he rides one of the nice-looking

[1] Illus. p. 102.

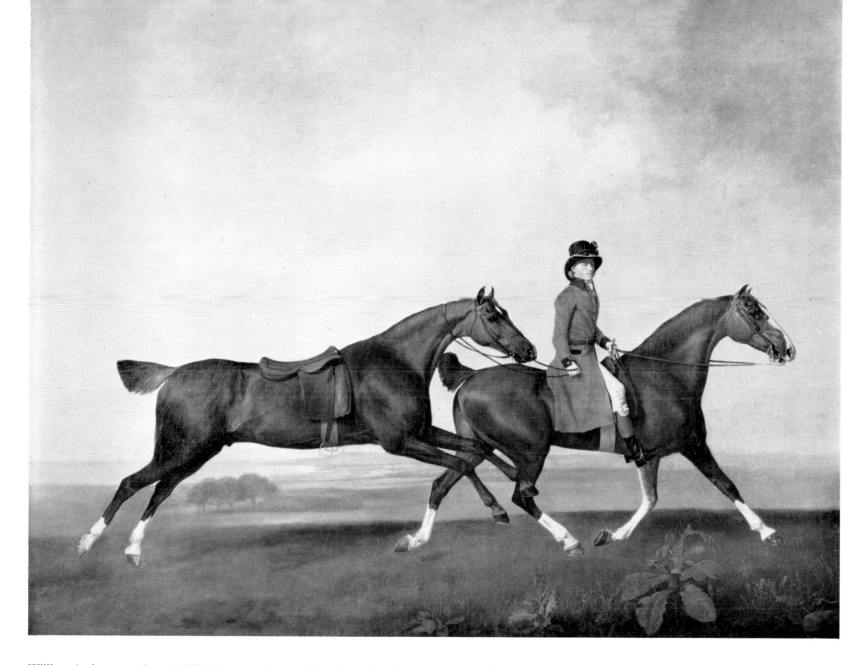

William Anderson and two Saddle Horses. *40in × 50½in. Reproduced by Gracious Permission of Her Majesty the Queen.*

chestnuts, and leads the other. The led horse is beautifully painted, but it has much the same movement as a Victorian lithograph of the dancer, Taglioni, as La Sylphide, charming and graceful, with limp legs floating through the air, suspended centrally by a hidden wire. Neither of them were dead-looking, but there is no evidence of strain, or of weight taken into the air by intense muscular action. This curious motion, which does not actually occur in the movements which go to make up the gallop, was accepted as an accurate description of the ultimate speed of horses racing. It gives a formalized look, and a wooden 'Noah's Ark animal' quality to the racehorses. It was helped in this by the fact that the racing picture was expected to be a side view, showing clearly the winner passing the winning post ahead of all the others. The owner not unnaturally wished for a clear and accurate recording of the happy event. This curbed the compositional inspiration of the painter, who had to work within very restricted limits. This was also the case with portraits of horses, where the owner required all the finer points and virtues of his horse's conformation to be clearly delineated, and which could only be shown off in profile.

It was, apparently, considered by some people that Stubbs was unable to paint a satisfactory landscape background to his figures. Certainly, a number of early paintings are known to have had the background filled in by another painter. For example, Sampson's landscape was said to have been painted by George Barrett, and in The 'Labourers loading Bricks' the landscape was by Amos Green. Georgiana, Lady Carlisle, says, in her MS Catalogue of the paintings at Castle Howard, of the 'Huntsman on a favourite Horse of the 5th Earl of Carlisle': 'Portrait of a favourite horse; the groom is an admirable likeness; the painter's inability to paint landscape or suffer any other artist to supply his defect, which was requested, renders this work less valuable!' It was in 1773

that Stubbs so rightly refused to allow anyone else to play around on his work.

There is a painting in the Royal Collection that has more than the landscape supplied by another hand. It has a most complicated attribution; it is a small portrait of Hollyhock, bred by the Duke of Cumberland and foaled in 1765 by Young Cade, out of Cypron. On the back of the canvas there is an ancient label giving the following particulars: that the horse was painted by Stubbs in London, that the landscape background was by Claude-Joseph Vernet, and the figures of the shepherd, the girl, the dog, and the flock of sheep were all by François Boucher. It was given by Lord Bolingbroke to a 'M. Monet dans un dernier voyage en Angleterre' in 1766. The painting was bought from Colnaghi's in 1810 by George IV. Hollyhock was taken by Lord Bolingbroke to Windsor, and eventually ended up in Lord Rockingham's Stud. It would have been quite reasonable for Stubbs to have painted him, though he does not look like a yearling in his portrait. There was no reason why Boucher and Vernet should not have contributed to the background. The painting was attributed to the three painters in the *Sporting Magazine*, as early as 1803.

There is a particularly charming landscape, perhaps of the downs near Brighton, behind the painting of William Anderson, with the two Royal chestnuts. Certain elements in his open-air backgrounds remain favourites right through his life. A lake, or stream placed at hock level, giving a band of light in the middle distance, appears with great regularity. Some of his rocky scenes must come from a series of studies, and even individual trees can be recognized in various paintings. For example, the group of trees in Pumpkin are repeated in the painting of Goldfinder; both horses were painted in the same year, 1774, though probably not in the same place. Sometimes he uses trees as dark masses, rather simply modelled, not to disturb the patterns created by whatever

is going on in front of them, as in the 'Haymakers'. In other paintings the trees themselves become areas of lace-like pattern, painted delicately against the light.

In his paintings he often sets his main groups very low indeed on the canvas, the 'Lady and Gentleman in the Carriage', the 'Carter-Thelwells', and the 'Melbourne and Milbanke family' are all standing practically on the edge of the frame, with no fore-ground at all. He was fond of giving his work a low eye level, that showed his groups against sky, rather than against middle-distance, squeezing up the landscape into a narrow strip, that appeared behind the horse's legs. His skies are nearly always extremely simple and luminous. He was not particularly interested in painting effects of weather. The sun never shines, the wind never blows and the trees are never shown with bare winter branches.

It is probable that Stubbs would have met and talked with Richard Wilson, when he was in Rome. At that time Wilson was in the process of changing from a portrait-painter into a landscape-painter, a bold and unremunerative action to take. He may well have had some influence on Stubbs's landscapes. There is a distinct feeling that Stubbs saw, at some time, works by Claude and Poussin, and that they made a considerable impression on him, for all his tough independence of outlook. Cuyp, too, has surely contributed to his landscapes, and to his search for truth through nature. Stubbs would have agreed with Pope's line 'All nature is but art unknown to thee'.

In 1766 a pamphlet was published, 'The Exhibition, a Candid Display of Genius and Merits of the several Masters, whose works are now offered to the Public at Spring Gardens'. (This was, of course the Society of Artists.) The following was written about Stubbs:

> The Wide Creation waits upon his call,
> He paints each species and excels in all
> Whilst wondering Nature asks with jealous tone
> Which Stubbs labours are and which her own.

At about that time, in the mid-1760s, Stubbs embarked on a series of shooting scenes, in which the landscape played a rather larger part than just a pleasing background. They show men out shooting with their dogs, small figures in a sizeable landscape, and were engraved by William Woollett.

Fifteen · History and Conversation Pieces

Stubbs felt great disatisfaction with his image and with the way his career was inclined to be limited to one type of commission, through his early success with horses. This was due, in part, to his connection with Angelo's Riding School, and due, very much, to the publicity the publication of the *Anatomy of the Horse* gave him. His regret at the way things were turning out for him became apparent quite early in his success, for he began to paint subjects like 'Phaeton and the Horses of the Sun', which was an approach to 'history-painting'. This was perhaps an obvious choice for a painter whose horses were outstanding, but it was a departure into the realms of fantasy and invention, and something quite foreign to his nature and inclinations. He was no illustrator, nor a narrative painter, his imagination was not highly developed; in fact, it was somewhat pedestrian. So, though Reynolds had been pleased with the 'Phaeton', and Stubbs himself had had an affection for it, sufficient to reproduce it more than once in oil, and again in enamel and even to struggle with it in low-relief, it was not by any means one of his more interesting efforts. He exhibited the subject as early as 1762, and again in 1764.

Six years later he showed another mythological subject, 'Hercules and Achelous', followed, in 1772, by 'Centaur, Nessus and Dejanira' and 'Mother and Child'.[1] These paintings may perhaps have come through his discontent with the management of the Society of Artists, and from a wish to be recognized by the Royal Academy, who were forging ahead, full of new ideals and well in the forefront of fashionable taste. The President, Sir Joshua Reynolds, was busily preaching the Gospel of the Grand Style in his Discourses to the R.A. students, and all this may have tended to make Stubbs aware of the wide gulf between his broad naturalistic outlook and the highly artificial and contrived history-painting that was so much admired on the walls of Somerset House. Sir Joshua said in his fourth Discourse, 'No subject can be proper that is not generally interesting. It ought to be either some eminent instance of heroick action, or heroick suffering.' Stubbs was a man who would have had little time for 'heroicks'. He was far too intelligent and honest to continue with work that was completely against his own individuality and style, and he was guilty of very few of these rather unsuccessful flights of fancy. He was not happy battling with the classic perfections of 'heroick' figure compositions, but, in a way, his Lion and Horse theme was an effort towards the imaginative subject picture. However, because it was so much an animal painting, using nature in the raw as the basis for the whole conception, it suited his talents and became his own independent contribution to the Romantic Movement in Europe. One of the best-known and most effective of his efforts at more illustrative painting is his 'Farmer's Wife and the Raven' painted much later on, in 1786, and it formed part of the series of rural pictures, though it was really quite a different type of subject to the other three farming ones. In this case, it

[1] Illus. p. 182.

160

The Farmer's Wife and the Raven (Enamel). *27½in × 37in. The Lady Lever Art Gallery, Port Sunlight.*

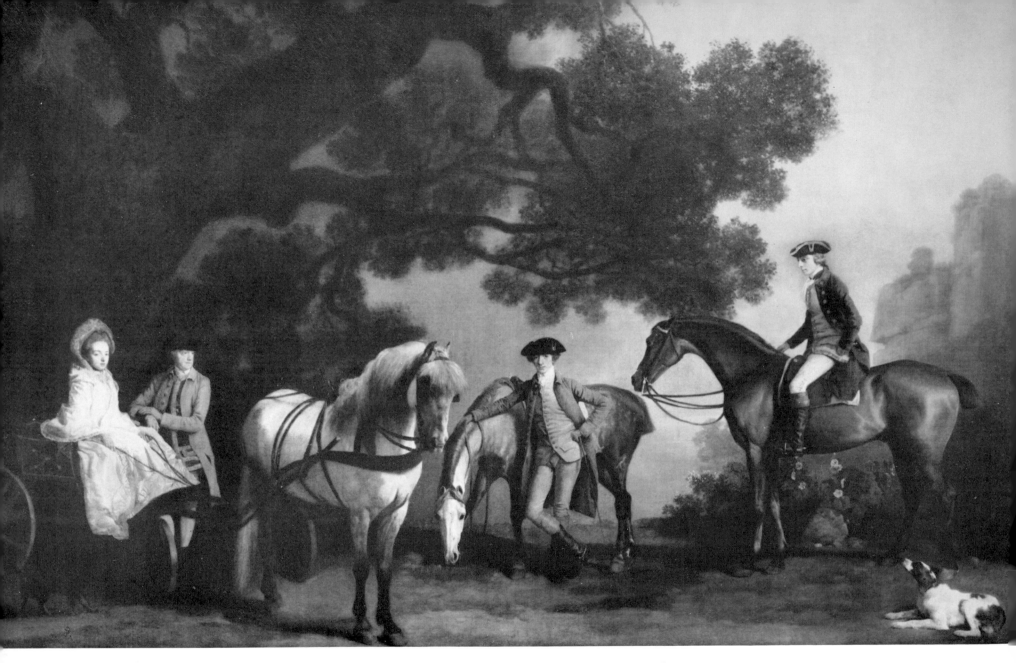

Melbourne and Milbanke Family. *40in × 59in. Photograph by courtesy of the Royal Academy of Arts, London.*

162

derives from the Fables of John Gay, published in 1727. The illustration to this fable was engraved after a painting by John Wootton, and there is a sufficient similarity between this and Stubbs's design to make it fairly certain that he used it as a basis for his own idea. As has already been said, he painted an oval enamel of it in the 1790s, with the other farming subjects, and he made a large engraving of it, as well. The figure of the farmer's wife and her mount, Old Blind Ball, are somewhat stylized in treatment, though set in a naturalistic landscape. She holds up her arm as a sign of protection against the raven.

> That Raven on yon left hand oak,
> (Curse on his ill-betiding croak)
> Bodes me no good. No more she said,
> When poor blind Ball with stumbling tread
> Fell prone.

The pose of the horse is rather unconvincing, as he stumbles on to his knees and nose, but the group has a sculptural quality that is pleasing. In the enamel, the design has been slightly reorganized to complement the oval shape of the panel, and a line of fencing has been introduced to stabilize the design horizontally.

Some of his most attractive works are his open-air conversation pieces. These are particularly happy compositions, giving him scope for arranging horses, riders and carriages in a landscape setting with his usual attention to pictorial design. The 'Melbourne and Milbanke Family' is one of the most satisfying of these. Lady Melbourne sits in her Timwhisky drawn by a charming grey pony. The fact that he is a little out of proportion, in relation to the larger horses of her husband, and her brother, John Milbanke, who stands holding his horse, in the centre of the picture, matters not at all. The group of herself and her father with the pony, is bathed in light against the heavy summer foliage

of the great overhanging tree. Her pink dress makes a note of delicate, positive colour in the subtle browns, olive greens and blue greys of the rest of the painting. The riders are silhouetted against the pale distance and the sky. Stubbs manages to unite the various components into a most harmonious and informal group of great charm and elegance. Another conversation piece in a similar style, with practically the same background of trees, is the portrait of 'Colonel Pocklington with his sisters',[1] now in the National Gallery, Washington. It is equally delightful and the ladies are very graceful and gracious in their poses, one holding out a little posy of flowers to her brother's horse.

A particularly interesting open-air group is the painting at the Holbourne of Menstrie Museum, Bath, of 'the Rev. Robert Carter-Thelwell and his family, of Redbourne Hall, Lancashire,[2] painted in 1776. Father and the girls are perhaps on their way to church, which can be seen in the distance, through the trees. The Rev. Robert is about to put his hat on and mount his fat cob. It is a sturdy and sensible weight-carrier, very suitable for parish visiting, and much the same build as the parson. The girls are driving a more stylish pony, and the contrast between the two animals is beautifully expressed, even to the different quality of the coat of the well-groomed hackney, with his meticulously painted harness, and the stuffy little cob, with his rough and growing winter coat. The landscape background, showing the avenue of trees leading to the church is treated in a rather more impressionistic and less classical way than some of Stubbs's backgrounds. The whole effect in these conversation pieces is of a poetic calmness.

Stubbs was able to produce an interesting pattern and an exciting series of shapes from pony-chaises and carriages. 'The Lady and Gentleman in a Carriage' in the National Gallery[3] is one of the paintings where he has treated the construction of the

[1] Illus. p. 164. [2] Illus. p. 165. [3] Illus. p. 167.

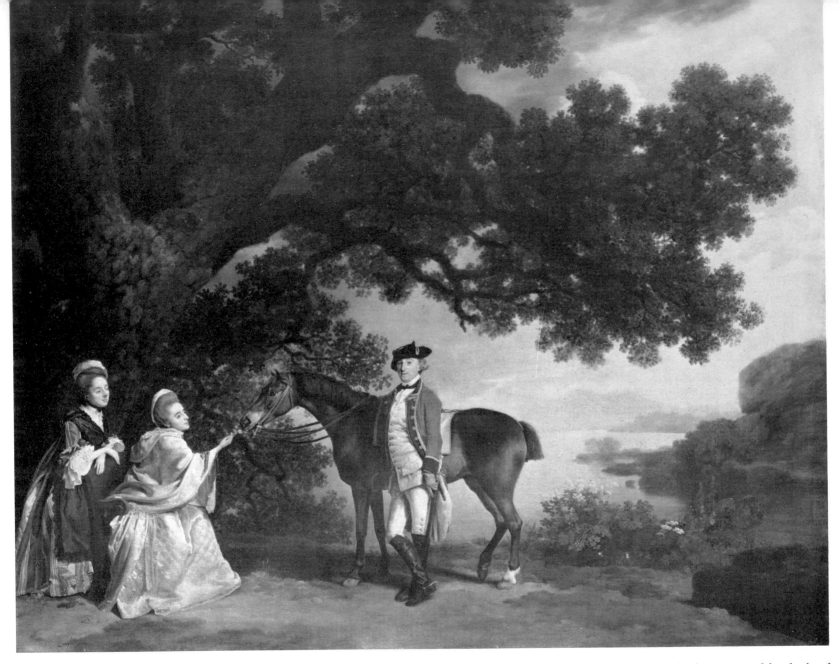

Colonel Pocklington with his Sisters. *38¾in × 48½in. National Gallery of Art, Washington, D.C. (Gift of Mrs Charles S. Carstairs in memory of her husband Charles Stewart Carstairs.)*

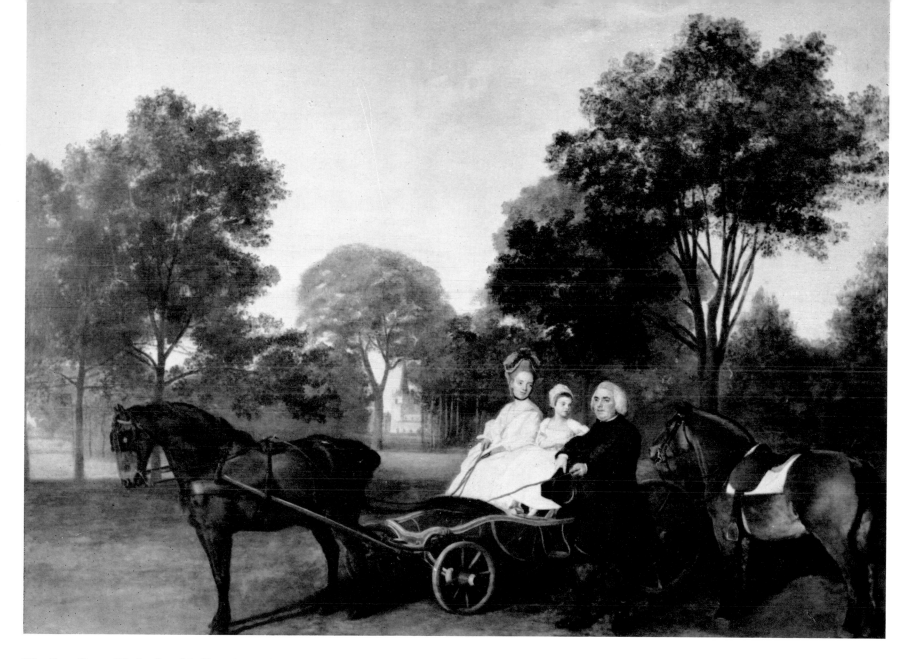

The Rev. Carter-Thelwell and Wife and Daughter. *37in × 50in. Holburne of Menstrie Museum of Art, Bath.*

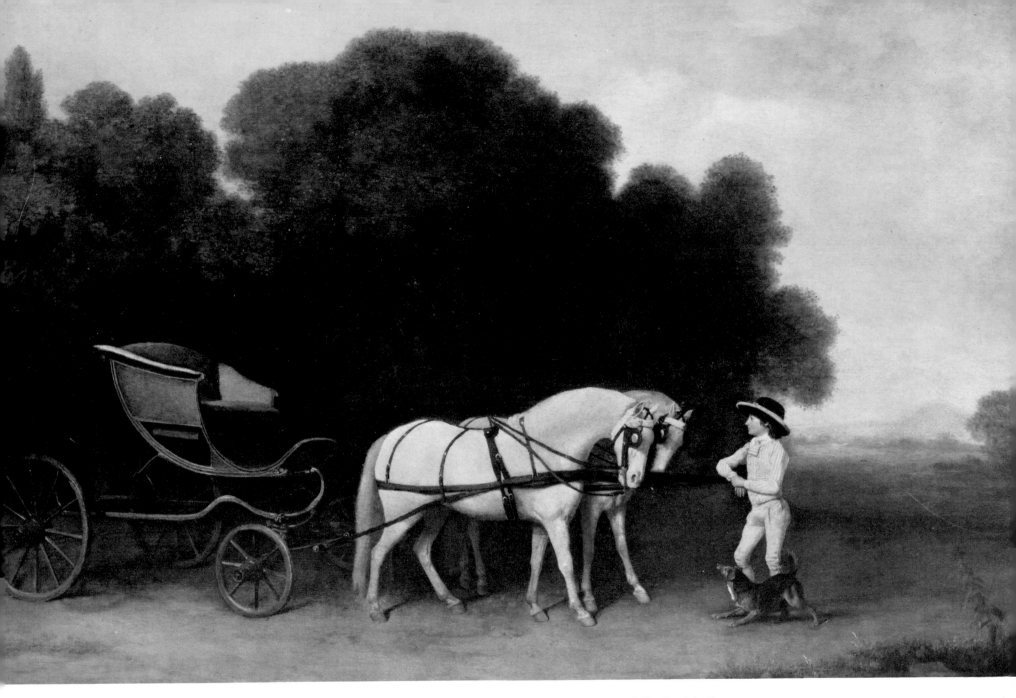

166 Phaeton with Cream Ponies and Stable lad. *35in.* × *53½in. From the collection of Mr and Mrs Paul Mellon.*

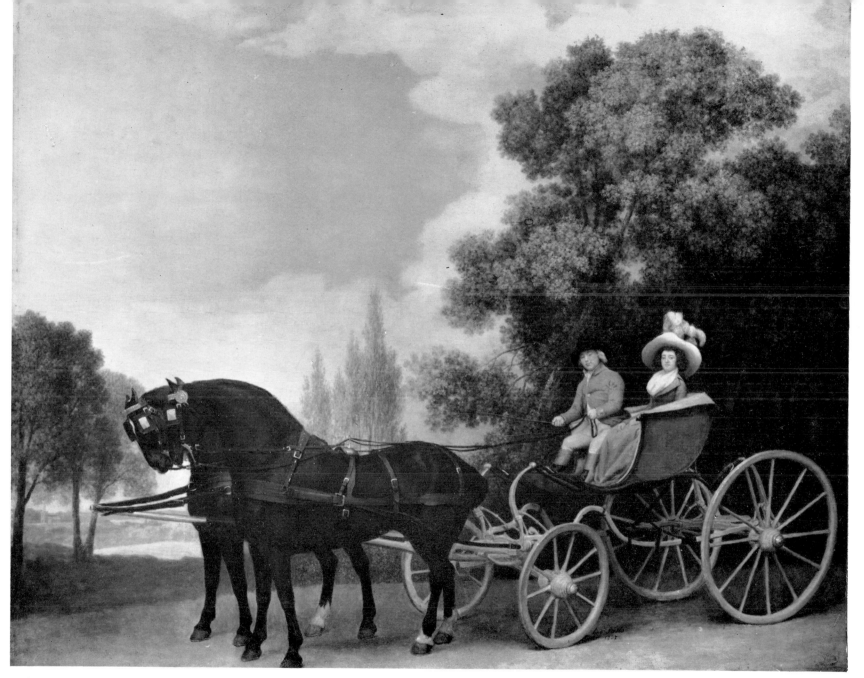

Lady and gentleman in a carriage. $32\frac{1}{2}in \times 40in$. *The National Gallery, London.*

vehicle with the same scientific curiosity that he gave to the articulation of the skeleton of a fowl. There is a resemblance to bone structure in the framework and wheels of the phaeton. The gentleman drives a pair of magnificent and well-matched blacks. They make a most satisfying shape, silhouetted against the park-like background. Their tack is treated with the same intense interest, so that, though it is completely functional, it is also part of the over-all design and composition. The lady is obviously enchanted with the smart turn-out—and with her enormous be-feathered hat. The gentleman is perhaps more concerned with his horses than his lady, but he, too, is very satisfied with whole equipage. He would have agreed with Dr Johnson, who said: 'If I had no duties, and no reference to futurity, I would spend my life in driving briskly in a post-chaise with a pretty woman.'

Another painting which demonstrates Stubbs's preoccupation with the structural intricacies of carriages, is the 'Phaeton with Cream Ponies and a Stable lad'.[1] This is a portrait of the beautifully matched and proud little pair, who are very pleased with themselves, and their stylish blue-painted phaeton, and they are well aware of their rarity and value. They are pretending to be nervous of the little dog who barks at them, though they know him quite well. Their stable-boy, or tiger, watches them all with great affection.

Stubbs was a tremendous believer in the merits of correct perspective; in fact, he considered it to be a fundamental in the training of an artist. This search into spatial relationships is very marked in his paintings of carriages; they stand four-square and firmly based upon the ground.

One of his later carriage paintings was done for George IV when Prince of Wales in 1793 and was called 'The Prince of Wales's Phaeton'.[2] This shows the rotund and self-important figure of Samuel Thomas, his coachman, dressed in cocked hat and red and black livery, holding one of the fine-looking pair of blacks. In conformation they are very similar to the pair in the 'Lady and Gentleman in the Carriage'. They all have small heads, great depth through the withers, and very hefty shoulders. To the right of the picture, the tiger, or groom, holds up the shaft of the phaeton. Linking the group is the pomeranian, Fino, whose portrait Stubbs painted a year or so before. He is the focal point of the entire picture, for, as he jumps up barking at the horses, they back away, startled. This painting is one of Stubbs's most masterly works. The canvas is brilliantly conceived and planned. The colouring contributes to a sense of tranquillity and inevitability. His treatment of the phaeton as a decorative structure is exciting and it sets the colour scheme for the picture. It is probably the most carefully thought out and subtle arrangement of colouring that Stubbs ever produced. The harmony is restricted to various tones of dark charcoal grey, red, and white, set against a pale and muted landscape of cool simplicity. The one note of sharp contrast which prevents the picture from being too restrained is the bright ochre yellow of the tiger's breeches.

Stubbs was busy working for the Prince of Wales in the early part of the 1790s, at the same time as he was working on the *Turf Review* series. He painted a portrait of the Prince out riding in the park with his dogs;[3] the rather Araby chestnut trots out briskly as the Prince flourishes his whip. His hands and head are rather small; this is a noticeable characteristic of Stubbs—he frequently makes extremely small extremities, giving a doll-like look to the rider. It occurs, too, in the portrait of Lady Lade,[4] the notorious Letty, who was a friend of the Prince's and was famed as a fearless rider to hounds, and for her wonderful command of bad language. All the paintings of this date are canvas size 40 inches by 50 inches, as are most of the *Turf Review* paintings.

There is also in the Royal Collection an amusing composition

[1] Illus. p. 166. [2] Illus. p. Frontispiece. [3] Illus. p. 170. [4] Illus. p. 171.

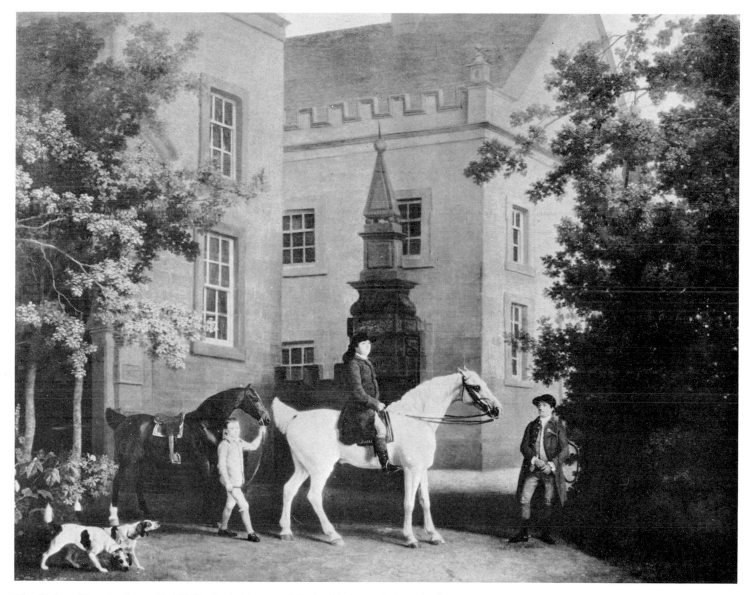

The Duke of Portland outside Welbeck. *38¾in × 48¾in. By kind permission of His Grace The Duke of Portland.*

George IV when
Prince of Wales.
$40\frac{3}{8}in \times 50\frac{1}{2}in.$
Reproduced by
Gracious Permission of
Her Majesty the Queen.

1" />

Laetitia, Lady Lade.
$40\frac{3}{8}in \times 50\frac{1}{2}in.$
Reproduced by
Gracious Permission of
Her Majesty the Queen.

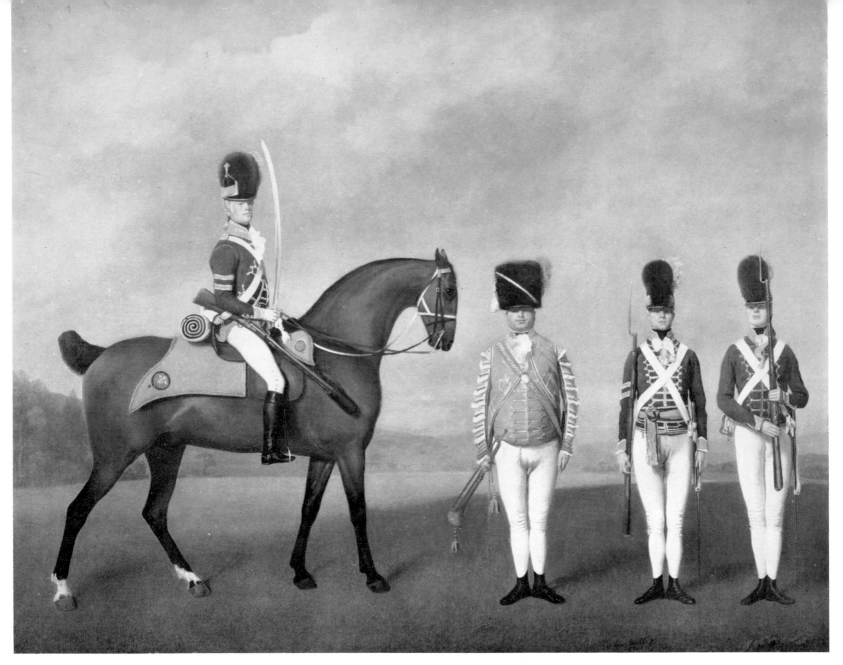

Soldiers of the Tenth Light Dragoons. *40¼in × 50⅜in. Reproduced by Gracious Permission of Her Majesty the Queen.*

172

of a corporal of the 10th Dragoons, mounted on a large and stately charger, inspecting a neat row of soldiers, consisting of a very portly trumpeter and two troopers. Stubbs was much aware that this was a military portrait group, and has infused it with the stiff dignity of toy soldiers standing at rigid attention. The result is almost a mockery—certainly he has brought out these characteristics so strongly that the painting becomes a humorous comment. Their uniform is treated with meticulous attention to detail.

He made two studies of a grey horse also in the Royal Collection, which has been identified as Grey Trentham, who was bred by Lord Egremont. He was by Trentham, out of a Herod mare, and won a number of races between 1791 and 1794. He is shown galloping in one of the studies. The movement has an oddly static and motionless effect, and is very reminiscent of a rocking-horse, rocking backwards and forwards without progressing. There are indications that it originally was painted with a saddle as well as a bridle, but that at some time it has been painted out.

Another instance of painting-out comes in the interesting painting of John and Sophia Musters out riding with their dogs.[1] At some point after the picture was finished the riders were completely blotted out and two grooms were introduced, leading the saddle-horses. In the 1930s it was decided to examine the picture carefully to see whether the old family story that there had once been riders on the horses was correct. The restorer who examined the picture found that there had already been an unsuccessful attempt to remove the overpainting. On removing the layers of paint, the portraits of John and Sophia emerged. She was a well-known beauty in her day and is very charming in her portrait, decoratively dressed in a scarlet habit and black ostrich-feathered hat. They are shown promenading in front of their house, Colwick Hall, which appears between the horse's legs. Stubbs has

taken liberties with the perspective, so that the figures seem to be walking on a mound, on higher ground above the house. It recalls Abraham van Diepenbecke's portraits of the Duke of Newcastle's horses with a view of Welbeck Abbey in the background, also showing behind the horse's legs. It would have been possible for Stubbs to have seen these large paintings and they may have had some influence on the design. It will be remembered that Diepenbecke designed the plates in the Duke of Newcastle's book, *Method de Dresser les Chevaux*, published in 1658.

Stubbs seldom painted architectural backgrounds to his pictures, though in this and in the painting of John Musters with the Rev. Philip Storry, Colwick Hall and the church appear in the landscape. Colwick Hall is very like Hurlingham Club House in design. Another house that Stubbs painted is Brocklesby Park, which occurs in the painting of the old pony greeting the hound. They were all painted in the 1770s. The portrait of the third Duke of Portland[2] has a completely architectural background, showing two wings of the Riding School at Welbeck, with a fountain in the centre. The perspective of the house is a little suspect, and gives a slightly unhappy feeling, which is curious, as Stubbs believed in the importance of perspective as a basic training in art. Wedgwood wrote this about it: 'He began by teaching perspective to his pupils which he believed to be just as rational a method in drawing as learning the letters first in the art of reading, and he would have them learn to copy nature and not drawings. He also said, 'Mr Stub(b)s, it seems, has been a drawing Master at Heath Academy, though he followed that profession but a short time.' It is an interesting revelation of Stubbs's views on teaching art. What a pity he never became an Academician, for had he done so there is no doubt that he would have added some very different notions to the usual teaching of the Visitors at the R.A. Schools. The Visitors, elected in rotation from the full

[1] Illus. p. 174.　　　[2] Illus. p. 169.

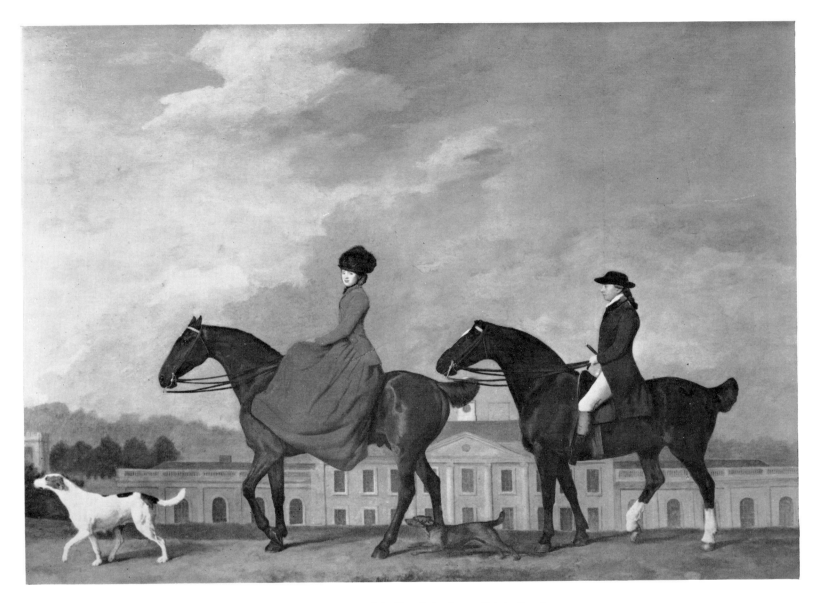

John and Sophia Musters. *38in* × *50½in. Photograph by courtesy of the Royal Academy of Arts, London.*

174

members, 'visited', or taught at the Schools for a month at a time. Stubbs's unusual and fresh approach to art would have swept away a few cobwebs and made the students look again at nature with a far more discerning eye.

The figures in the portrait of the Duke of Portland are all painted with Stubbs's usual attention to character. The Duke, who is short-legged and portly, looks very much at home on his old grey hunter. His head is a superb portrait and he is definitely the focal point of the picture, yet the groom and the stable-boy are equally carefully painted and observed. Sir Alfred Munnings used to say that the clothes in the picture were beautifully treated, and that the painting of the boy's long waistcoat was 'delicious'. The fact that he leads the bay on the offside and is perilously close to the heels of the Duke's hunter helps the composition, and does not worry the spectator in the least. There is another painting of the Duke, this time with his brother, standing by a practice jump of post-and-rails, and chatting together, while their horses have a breather.

It is very noticeable that, when painted by Stubbs, the rider's seat seems to give not only the character of the individual but also his position in life. Contrast the elegance of Warren Hastings on his showy Arab and Baron de Robeck on the crop-eared hunter, with the relaxed positions of the huntsmen, Tom Smith and his son.[1] The older man, comfortably and characteristically slumped, hand in pocket, while his son, about to gather up his reins and move off, leans back to speak to his father, while one of the Brocklesby hounds exchanges a sniff with his horse. They are all most perceptively drawn, the action and poise is exactly and expressively right. The dressage seat of the gentlemen, who have had the benefit, perhaps, of training at Angelo's, appears smart and confident, against the comfortable slouch of old Tom Smith, with his legs well forward and his hand shoved into his pocket.

There is a portrait of Sir Sidney Medows on a grey horse[2] in the Royal Collection. He was a famous horseman, renowned for his schooling and training. His partner, Strickland Freeman, wrote a book entitled *Art of Horsemanship* in 1806, which is based on Sir Sidney's methods. He would ride, or work in hand, twelve horses a day, in his riding school in Half Moon Street. His methods of schooling were somewhat unconventional, his way of 'managing' a horse was entirely his own, both hands were always raised above his ears, he stooped low, and always used a snaffle. His horse in the painting is slightly reminiscent of a Lipizzaner, with its strong thick neck and broad chest.

Stubbs managed to paint an enormous variety of types of horses, from the farm horse to the blood-weed, in his working life, and their individual characteristics are always recorded with deep appreciation and accuracy. There is no such thing as a Stubbs type of horse, though, perhaps he had an extra sympathy for a strong, weight-carrying horse, probably because it was the type he would have ridden himself, being, at any rate in later life, rather stout. He was said to have been interested and impressed by the variety of horses that Thomas Stothard introduced into his painting of 'The Canterbury Pilgrims'. While Stothard was working on it Stubbs, according to Bray's *Life of Stothard*, called to see him, and during the visit asked if he might be allowed to see the picture, saying 'that he felt a great curiosity to see a picture in which nearly twenty horses were introduced'. On looking at it, Stubbs exclaimed: 'Mr Stothard, it has been said that I understand horses pretty well; but I am astonished at yours. You have well studied those creatures, and transferred to canvas with a life and animation which until this moment I had thought impossible. And you have also such a variety of them; pray, do tell me, where did you get your horses?' 'From everyday observation,' replied Stothard; and Stubbs departed, acknowledging that he could do

[1] Illus. p. 178. [2] Illus. p. 180.

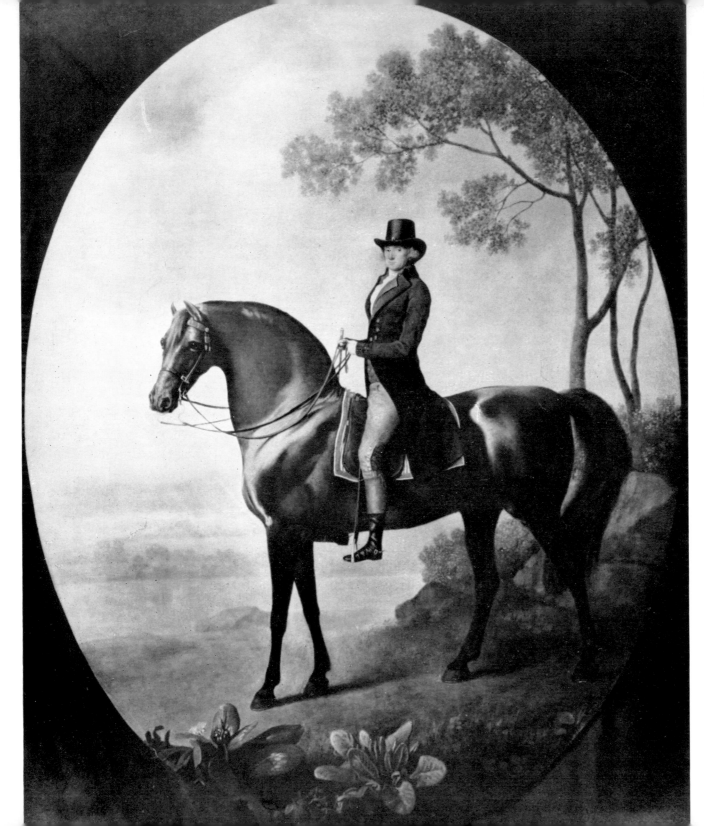

Warren Hastings on Horseback.
34½in × 25½in.
Victorial Memorial Hall, Calcutta.

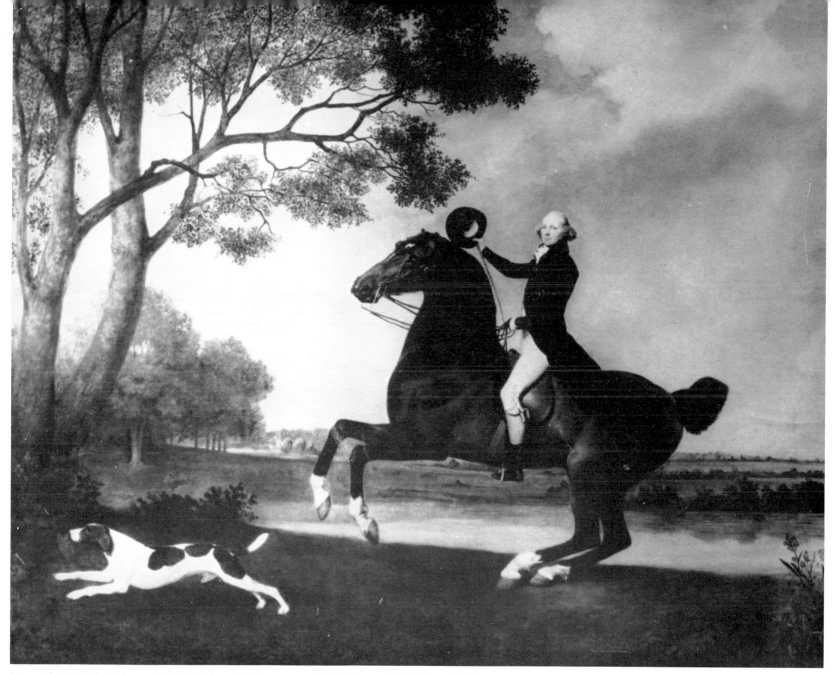

Baron de Robeck. *39in* × *49½in. Photograph by courtesy of The Courtauld Institute, London.*

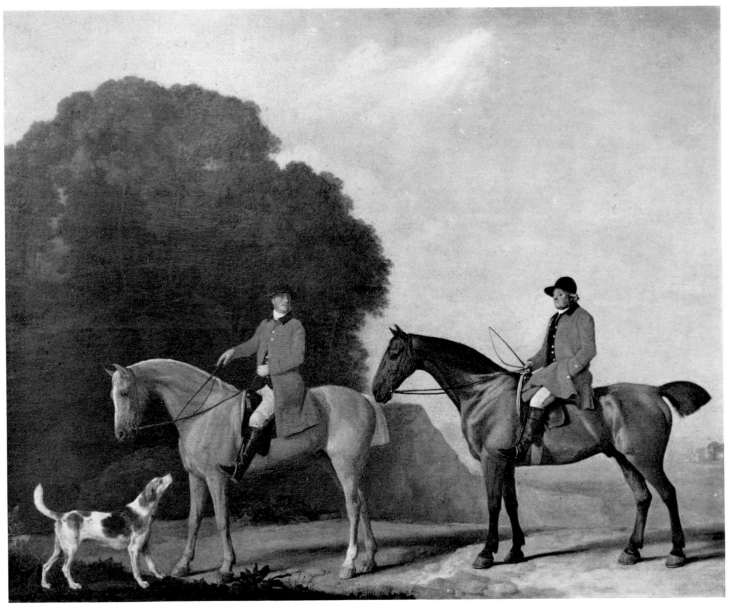

The Brocklesby Huntsmen.
*32½in × 39½in.
By kind permission of
Lord Yarborough.*

178

nothing in comparison with such a work.' This painting of the Pilgrims is now in the Tate; it was engraved at the time, and became extremely popular, large numbers of prints being sold.

Stubbs's work is quite frequently reproduced now. The very first were done as early as the 1780s by the Polygraphic Society. The proprietors claimed to 'Multiply Pictures in Oil Colours by Chymical and Mechanical Process without the least injury to the original and finished by hand'. They said that 'The process which from its nature must transmit every mark and colour contained in the original, and will not admit of error'. This bold claim seems to have been optimistic; the *Morning Herald* in 1789 criticizes the 'Copies made from the Guido head of St John as most palpable evidence of quackery of this scheme to allow the most unpractised eye to be deceived for a moment. Neither the general form of the whole, nor the particular markings of the several parts convey the most distant ideas of the original and from the total difference of the copies from each other, even when assisted by touches of the hand.' The secrets of the methods used do not seem to have been preserved. The copies or reproductions were exhibited, together with the original paintings at 'The Polygraphic Rooms, Strand'. Entrance to the exhibition was 1s., and the copies were for sale, nicely framed in copper gilt.

Quite a few important artists allowed their work to be used; among the first were Sir Joshua Reynolds, Benjamin West, Opie, Beechey, Hoppner, and Cosway, whose portrait of the Prince of Wales was specially painted for the Polygraphic Society. The fashion for Polygraphic pictures lasted for ten years or so; it was alleged that a man might furnish his house with masterpieces for about £20. This was another optimistic assertion, as the copies, though considerably cheaper than the originals, were fairly expensive luxuries. For example, in 1787 Stubbs was represented in their exhibition by copies of three of his paintings. 'The famous Racehorse, Euston, with a pleasing Landscape', 39 inches by 46 inches, was £6 6s., quite a lot of money, even for a fashionable novelty. His other two were 'The Frightened Horse and Lioness, generally acknowledge to be one of the most spirited Performances of that capital Painter in this line', and 'The Tygress, a companion to the above'. Both were to be had for £3 13s. 6d. each.

Stubbs was getting a good price for his paintings at this time. There is a painting of two horses facing each other, which was painted in 1788, now in the Ascott Collection. They were commissioned by John Hanson of Great Bromley Hall, near Colchester, who paid Stubbs the sum of 80 guineas for them. Hanson wanted a portrait of his favourite mare, and the rest of his family thought him quite out of his head to pay as much as that to have Stubbs paint her for him. The old mare must have been a character, for, according to the family story, when her master went on a driving tour of England and Wales, she went, too. The crop-eared coach-horse in the picture with her is presumably the one Mr Hanson drove on the 800-mile trip. During this long excursion the mare ran free all the way. She was allowed to go loose, except when they came to towns where some out of the ordinary excitements were going on, such as fairs, markets or other large gatherings of people. Mr Hanson said: 'She gave me no trouble; sometimes she would keep a considerable distance, but she never lost sight of the carriage.' The Hanson family thought him quite mad to give so much money for her portrait, but he was willing to pay for what he wanted. It was not everyone who was as pleased to pay up for a horse portrait.

Stubbs was involved in a case in 1787, which came before Lord Kenyon in the Court of King's Bench, Westminster. This was between George Garrard, another painter of horses, and later a fellow A.R.A., and his client, a Mr Dan, who had commissioned

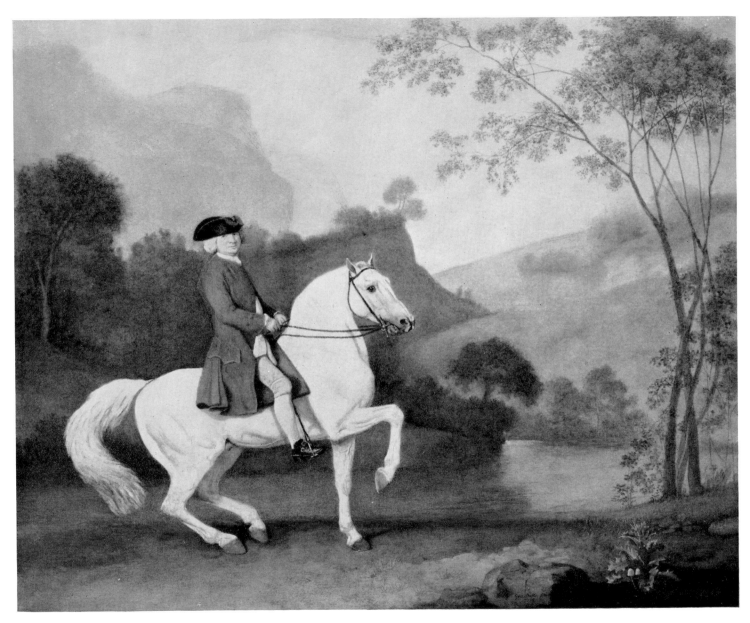

180

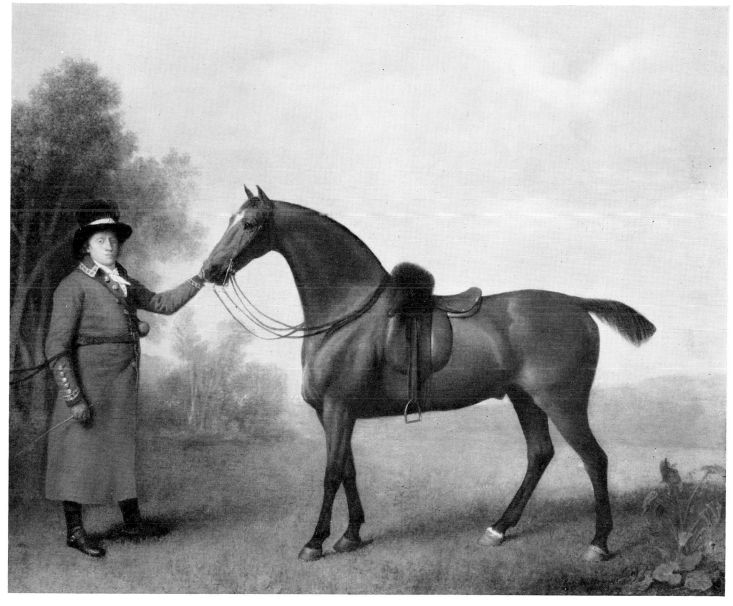

a portrait of a favourite horse. The trouble had arisen because Mr Dan was not satisfied with the picture and had refused to pay more than 15 guineas, instead of the originally agreed figure of 25 guineas. Stubbs and John Hoppner, the portrait painter, appeared for Garrard. Stubbs gave his opinion of the picture to the Court, where it was exhibited for all to see. He praised the painting, though he said that he could not vouch for the likeness, as he had not seen the horse. He said that the painting had some defects, but that he had yet to see a painting without any; he had never thought any work of his own perfect. Hoppner entirely agreed with Stubbs, who then said that he would have charged 35 guineas for doing the commission. Finally, Lord Kenyon decreed that if Mr Dan had thought the portrait such a bad like-ness he should have returned it to Garrard, and that by accepting the painting he had subjected himself to the price of it.

Later, in 1804, Stubbs was again involved with a court case; this time he appeared in defence of the American-born Academician, John Singleton Copley. Lawrence and Benjamin West, who were not particularly friendly to Copley, appeared for Sir Edward Knatchbull. Sir William Beechey, Stubbs, and a number of other painters rallied round Copley. The trouble had arisen over the enormous family piece, over 17 feet long. There had been no very definite arrangement over terms. Copley wanted £1,800 when he had completed the picture, but Knatchbull only offered him £1,200. Most of the artists, not unnaturally, were in favour of higher fees.

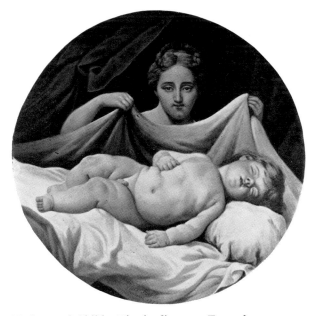

Mother and Child. *12in. in diameter*. Enamel on copper.
The Tate Gallery, London.

Sixteen · The Comparative Anatomy

By the 1790s Stubbs had worked his way through four of his scientific and experimental projects. His researches into the chemistry of pigments suitable for enamel painting, and into the composition and technique required to produce ceramic grounds on which to paint, had occupied both time and money for many years. It had proved a disappointment for him, both financially and artistically. So, in a different way, had the venture with the *Turf Review*. It was now just about thirty years since the publication of *The Anatomy of the Horse*, and though all the indications in the various accounts of Stubbs's life infer that he started to work on his book of comparative anatomy—the comparison was between a human, a tiger, and a hen—in 1795, it seems remarkably unlikely that a man of Stubbs's calibre would have completely stopped his anatomical interests for so long and then suddenly embarked on an enormous project. It is far more plausible to suppose that he had been working towards the idea ever since he had recovered from his labours over the dissection and investigation into equine anatomy. He must have made quite a deep study of human anatomy as a young man, to have achieved the reputation that he held at York Hospital. He had received commissions from the Hunters, both deeply concerned and interested in this kind of project. He was living in London at a time when biological and anatomical studies and research in general was moving forward in thought and deed. Knowledge

was expanding rapidly and many remarkable men were at work.

Once again, the cost in time and money for such studies was vast, and Stubbs was already in his seventies. No wonder Mary Spencer says that he frequently worked at it 'from the dawn of day till midnight'. Only a man of prodigious endurance and overwhelming interest in the subject could have amassed so much material in one life-span.

He must also have worked on the study and anatomizing of tigers during the period between the books. This animal, so obviously one for which he had great sympathy and admiration, was not likely to be available easily, or often, for dissection. When one died, as in the story of Mr Pidcock's tiger, see page 86, it was very much a question of dropping all other work and dashing off to collect the corpse, rushing it home so that preparations could be started for dissection immediately. The skinning, disembowelling, and cleaning of the subject had to be carried out extremely quickly; even the actual process of dissection and note-taking had to be hurried through before too much decomposition set in. He had had vast experience of all this at Horkstow, but whereas procuring an old or dead horse was not particularly difficult or expensive, it was a very different matter when dealing with a rare and valuable wild animal such as a tiger. It must have entailed many all-night sessions, frantically trying to get as much information out of the royal remains as possible, before they literally fell

183

to bits from putrefication. He did not have the privacy of the remote farmhouse in which to perform this smelly and unpleasant business, so it all must have been done in the confined conditions of a London house, with neighbours in close proximity. And also he would have had at the same time, to cope with commissions from clients who were more than likely to be exacting and in a hurry for their paintings.

He had worked seriously and hard on the book for eleven years when he died, and had accomplished a great deal. The similarities of the structure of man, beast, and bird had not really been fully investigated before. That there was a certain parallelism between them had been well known since the Renaissance, if not earlier, but no detailed and accurate comparative anatomy had been recorded graphically. The interest had always been in the classification of zoology and the description of each species, rather than a systematic comparison of their anatomical structures.

Stubbs apparently intended to carry his investigations into the vegetable world as well. In the note by Mary Spencer it says: 'The last exertion of this truly great man was a Comparative anatomy, shewing the analogy between the Human frame, the Quadraped and the Fowl, giving also an accurate description of the bones, cartileges, muscles, facias, ligaments etc. (He intended to carry it on to the vegetable world) a work truly philosophical in which his Assiduety and perseverance are unexampled in the annals of mankind, he frequently working at it from dawn of Day, in summer, till midnight, so great was the Ardour with which he engaged in this grand undertaking. Indeed the enthusiasm which supported him with spirits and strength throughout this arduous task left him not till the latest hour of his life.'

In a final note she says that 'he had when he died published the first three numbers of his Comparative Anatomy. All the Drawings were finished and the explanations wrote of the three, which only want the Engravers and Printer to finish the work, which will be done.'

The book was to be called *The Comparative Anatomical Exposition of a Human Body with that of a Tiger and a Common Fowl* and was designed to show the variations and similarities of their structures. It was to consist of a series of engravings, starting with the three skeletons, then going on to the fowl without feathers, the tiger without fur and the naked human. Following that, there was to be a series of four stages in muscular dissection of the three subjects. This was one less stage than in *The Anatomy of the Horse*, which shows five stages of dissections and omits the plates of the subjects in bare skin. As the man was shown in three views, front, side and back, and the tiger and the fowl were only shown from the side, the number of plates was to have been thirty.

The first indications of Stubbs's progress with the work comes in July 1802, when the Royal Academy's Council records in the Minutes that they would subscribe towards the book: 'From the well-known abilities of the author, and the recommendations of the gentlemen present who had seen the drawings—it was unanimously resolved that the Royal Academy do subscribe; to be deposited in the Library.'

The next information comes from a note by William Upcott, who says that on 31st August 1803, 'I called upon my friend Stubbs this morning, to whom I went wth. a view to introduce to him **Mr Samuel Daniell** one of the nephews of my friend Thomas Daniell R.A. We found Mr Stubbs engaged in engraving his series of anatomical plates, of which he had just completed his first Number.'

The arrangement of the plates of the book was the same as in *The Anatomy of the Horse*, pairs of plates, consisting of a simple line engraving, or diagram, giving the lettered and numbered key

to the text, and accompanied by the fully modelled and more complex illustration. The Royal Academy Library received two of the numbers in 1804, in January and December. There were ten illustrations altogether, of the front, back and side views of the man, and the side view of the tiger and the fowl. The first number was of the skeletons, the second was of the next stage, that of the naked man, the tiger without fur, and the fowl without feathers. These two numbers were apparently unaccompanied by any text. The R.A. Library still has them, and though they have been bound there is absolutely no text. It seems likely that the third number would have been available, but there is no record of the Royal Academy having received it.

When Stubbs died, in 1806, the drawings and manuscript were kept by Mary Spencer. She gives the impression that she intended to see that the work was completed and published, but in fact the work was never published in its entirety. The three completed numbers were published, with text, by Edward Orme, after her death in 1817. The 'Author's Advertisement' in the front of the book mentions that he has given 'The proportions marked by dotted lines from centre to centre of motion of each joint: because from these points the proportions will never vary, whether the joints be bent or straight.' This idea, which he thought would be helpful to painters and sculptors, occurs in the brown ink drawings of the skeleton of the horse at the Royal Academy, but was not included in the plates. He was evidently happier about his skill as an engraver, as he says that 'He has executed the whole himself from nature, the Injection, Dissection, Explanation, and Engraving. He has taken particular care to represent each thing in its proper place, not loose or irregularly hanging.'

The actual engravings are quite different in technique to *The Anatomy of the Horse*; instead of hatching, or small straight strokes, the plates are stippled—the tonal differentiation being produced by means of many tiny dots. This gives a smoother and softer quality to the plates, and could easily have become woolly in the hands of a lesser draughtsman. Stubbs manages to keep a crisp tautness to his engravings, while achieving an extremely delicate and precise effect. The surface quality of the plucked fowl is a delight,[1] every tiny goose-pimple is beautifully expressed, without losing the main forms of the bird. The feet and legs with their intricate patterning of scales are most precisely drawn, yet keep within the sculptural unity of the whole design of the plate. His technique may have developed through using mixed methods, including mezzotint, in his pictorial engravings. The development from *The Anatomy of the Horse*'s plates is quite logically in sequence. His paintings also tended to a smoother softer quality over the years.

The engravings of the man have the rather curious proportions that occasionally appear in his paintings. The hands and feet are small and tapered, the fingers are delicate to the point of femininity. The torso is given a pear shape, pinched at the shoulders and broad at the pelvis, another characteristic of the female rather than the male. The heads are also very small, giving the impression of great height to the rest of the figure. These proportions are particularly noticeable in some of the drawings for the *Comparative Anatomy*.

These drawings came to light in 1957, in America. It seems that when he died Stubbs had produced a mass of work for the book, certainly over 800 pages of text and 124 drawings. This material, like everything else, went to Mary Spencer, with whom it remained till it was sold by Phillips the Auctioneers, in 1817, after her death.

Some time after this the work came into the possession of Thomas Bell, F.S.A., 1792–1880, who was an anatomist and dental

[1] Illus. p. 186.

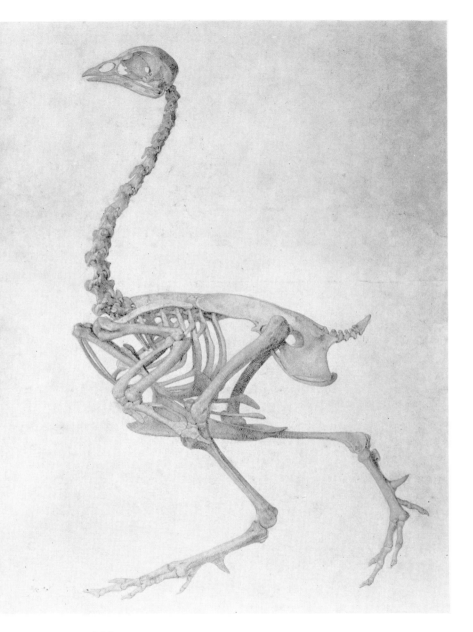

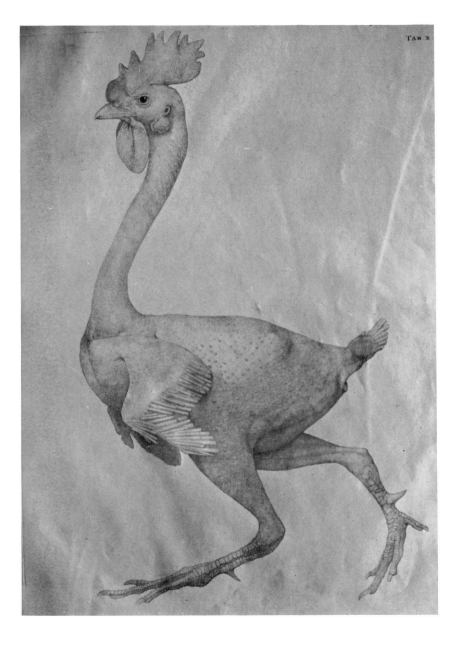

186

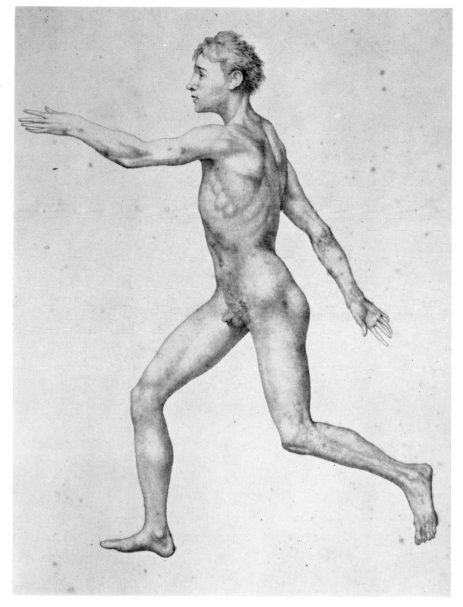

Drawing of a Domestic Fowl (Shaded Skeleton). *21½in × 16in.*
Worcester Public Library, Worcester, Massachusetts.

The Fowl (from the 'Comparative Anatomy'). Engraving. *21½in × 16in.*
Royal Academy of Arts, London.

A human body (from the 'Comparative Anatomy'). Engraving.
21½in × 16in.
Royal Academy of Arts, London.

surgeon. This is known because the manuscripts were bound in four volumes at some point, and these contain his bookplates. He had been a lecturer in comparative anatomy at Guys Hospital as well as a dental surgeon, and he was also Professor of Zoology at King's College, London. He was Secretary of the Royal Society from 1848 to 1853 and a President of the Linnaean Society. Bell must have parted with his Stubbs drawings and manuscripts quite a long time before he died, because they are next heard of in the 1860s in the library of Dr John Green of Worcester, Mass. It is not clear how he acquired them, as there is no record of his having been to England. In 1859 he donated his collection of 7,000 books to found the Free Public Library in Worcester. The Free Library accession date in the four volumes of Stubbs's manuscripts, on Dr Green's bookplate, is 1st January 1863. There they remained, more or less unknown, till 1957, when the Free Library were recataloguing their books, and they were rediscovered. Very much as the Royal Academy were to find the extra drawings for *The Anatomy of the Horse* a few years later. In 1958 a selection of fifty-five drawings were lent from Worcester, and were shown at the Arts Council Gallery in London.

The text is written in pencil and is divided into four, and bound in book form. Particularly interesting and rather surprising is the fact that about half the text is written in French. Fifteen 'parts' relating to the drawings, or plates, are given in two of the volumes, in French, and a further sixteen are in English. It will be remembered that as a young man Stubbs was said to have been studying French while he was working in York. Presumably, the book was intended to be published both in England and France, to give it a far wider European circulation.

It seems likely that the Free Library does not have the whole text that Stubbs had completed. The paper on which he wrote was watermarked with a date, and these tend to confuse rather than clarify the situation. Volume one is dated 1800, volume two A is watermarked 98, as is volume three, though volume two B is two years earlier, 1796. Volume one and two B have the French text containing the parts relating to all the plates of the skeletons and to some of the muscles. The text of the Orme publication also relates to the skeleton, so, either Stubbs had written a text in English, or it was translated specially for the 1817 book. It seems probably that Stubbs wrote an English and a French version himself, it also seems likely that the material left by him was not quite as advanced as Mary Spencer says, and for that reason there is a muddle over the numbering of the plates, which do not entirely correspond to either of the texts, nor do the texts themselves quite agree. The Orme edition gives two title-pages, first, 'The Anatomy of the Human Body particularly adapted to the use of artists the whole executed by George Stubbs Esq R.A. author of the Anatomy of the Horse accompanied with fifteen large folio engravings.' Then, much later in the book, the following title occurs, 'A Comparative Anatomical Exposition of the Tiger and the Fowl exemplefied on Twelve large Folio engravings the whole executed by George Stubbs Esq R.A.' This gives the impression that twenty-seven pairs of plates or tables were available, but in fact, only three numbers, or fifteen tables were published in the book. This agrees with Mary Spencer's statement that three were completed and engraved by Stubbs before his death.

The Worcester drawings, in two folios, containing in all 124 drawings, all relating to comparative anatomy, were rediscovered at the same time as the volumes of manuscript. Thirty-two of them correspond with the fifteen engraved tables and their accompanying diagrams. These are pencil studies on cartridge paper, their size is 21 inches by 16 inches. The rest of the drawings are either preparatory studies, or are studies of, for example, the

human skeleton walking on all fours[1] or of a tiger standing up on two legs like a man. Some, as in the studies for *The Anatomy of the Horse*, are in ink, and some are in red chalk, with ink or pencil.

Stubbs mentions that both 'Leonardo da Vinci and Michael Angelo de Bonaroti were excellent Anatomists'. Did he, perhaps, have the chance of seeing Leonardo's anatomical drawings in the Royal Library at Windsor. He was working for the Prince of Wales quite frequently in the early 1790s. Stubbs's work in this field is rather different in aim from Leonardo's, as all his studies were intended towards the production of scientific illustrations, designed to clarify the text. As in *The Anatomy of the Horse*, the drawings are calm, detached, and unemotional. He was com-

pletely unmoved by the drama, or butchery of his subject, yet the studies are by no means coldly correct; they are sensitive, warm, and very expressive.

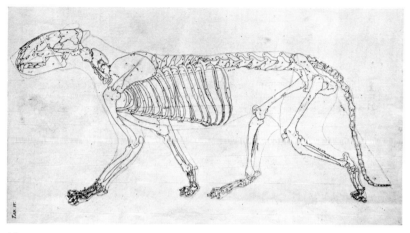

Skeleton of tiger (from the 'Comparative Anatomy'). Engraving. *21½in × 16in. Royal Academy of Arts, London.*

[1] Illus. p. 11.

189

Seventeen · Late Paintings and Death

Stubbs was an indefatigable worker, and it is obvious that he was not happy unless he was occupied every minute of the day. The *Comparative Anatomy* was by no means the only thing he worked on during his last years. His huge portrait of 'Hambletonian Rubbing Down'[1] is one of his greatest achievements. It is an extremely memorable painting of a horse; perhaps it would not be too much of an overstatement to say that it is the most magnificent horse-portrait of all time, certainly of one on that scale.

It is possible that Stubbs, while he was in Italy, could have gone to Mantua, though it is not recorded, and if he did, he could have seen the life-sized portraits of the favourite stallions of Frederico II, from the Gonzaga Stud, in the Palazzo del Te. These portraits in the Sala dei Cavalli are set in the painted decoration of the main hall, against landscape backgrounds, and framed by trompe-l'oeil designs of statues in niches, in elaborate architecture. They were painted by Rinaldo Mantovano, after designs by Giulio Romano, in the sixteenth century. The horses are treated as portraits in their own right, not as part of the equipment of a rider, and set a precedent for the Diepenbeck portraits of the Duke of Newcastle's horses in the seventeenth century, probably the earliest horse-portraits in England. The twelve horses he painted for the Duke at Welbeck must have been known to Stubbs, who worked there, and earlier may have influenced Wootton. His huge portraits in the hall at Althorpe also reflect the conception of the Sala dei Cavalli.

At this point one might quote the often-repeated remark that 'Horse-painters can be divided into two groups, those that came before Stubbs and those that came after'. He brought a completely fresh mind to equine portrayal, uninfluenced by any artistic or superstititious preconception of what a horse *should* look like. He knew what it *was* like, from the inner basic structure, outwards, so that, at the end of his life, after a career of over fifty years, he was able to paint this majestic canvas, and reach with it, the height of his powers.

When it was shown at the Royal Academy, in the 1950s, in the exhibition of 'The First Hundred Years', 'Hambletonian' was hung centrally on the end wall of Gallery IV and was visible for the whole length of the back range of five galleries at Burlington House. In this vast setting its powerful and brilliant composition came over with enormous impact. Stubbs was able to exercise such control over his tones and his paint surface that whether the picture was viewed from three feet away or from sixty yards it was equally readable. He was also able to treat the forms with the minutest detail, and yet retain the over-all simplicity that is so moving.

The horse is shown, like Gimcrack, exhausted after the race, held by his trainer, and being rubbed down by his stable-lad. The head of the trainer has been referred to on page 109 as all-important to the composition and as a wonderfully penetrating characterization. The lad, too, watching somewhat anxiously, as the horse stamps fretfully, is another portrait worth studying.

[1] Illus. p. 194.

Great emphasis was laid by Mary Spencer on the super life-like picture, and she was much preoccupied by tales of the deception of animals by Stubbs's paintings, most of her added notes deal with these stories. In one of them, she says: 'We read of painters whose excellence in representing still-life has been such as to deceive Birds, which have even come and pecked at the painted grapes. Stubbs's animals have deceived both Men and Brutes. When painting Hambletonian as large as life (for Sir Henry Vane Tempest) with two Grooms, one holding him and one Dressing him, the Horse cringing and threatening to Kick, a gentleman who came with others to see this picture, after having looked at it for some time, was much engaged in looking at a smaller picture, which was placed upon the ground near, and opposite the heels of the pourtrayed Horse, being so low it required stooping to see it properly, which the gentleman did for some minutes, when on getting up he gave a violent spring to avoid the threatened kick from the supposed Horse, what is still more estraodinary the same thing occurred a second time within a quarter of an hour.'

Stubbs painted two portraits of Hambletonian for Sir Henry Vane Tempest, and they were exhibited in 1800 at the Royal Academy. One was the life-sized portrait, showing the horse after his celebrated win over Mr Cookson's Diamond, and the other, presumably the smaller picture which was placed upon the ground, referred to above, of Hambletonian actually winning the race. As a three-year-old, he won the St Leger. He was by King Fergus and his dam was Highflyer Grey. He was foaled in 1792, and was descended from Herod and Eclipse.

Sir Theodore Cook says in *A History of the English Turf*:

'It was at the Newmarket Craven Meeting of 1799, that Sir Harry Vane-Tempest matched Hambletonian (with Frank Buckle in the saddle) against Mr Joseph Cookson's Diamond (Dennis Fitzpatrick up) for the three-thousand guineas over the Beacon Course. Buckle (at 8 st 3 lbs), who was considerably cooler-headed at the crisis than his employer, managed to gain some ground between the Ditch and the Turn of the Lands, which compensated for the pace of the smaller horse up the hill, and after a rousing finish, which Sartorius has brilliantly dipicted, the Eclipse blood just asserted its superiority by a head . . . The St Leger winner held the lead until Diamond challenged in the last half mile, and from then on both horses seem to have been cruelly punished, Hambletonian being only just lifted in ahead by Buckle's splendid riding in the last few strides. The distance is said to have been done in "About eight minutes and a half," and the Newmarket people lost fairly heavily, though the betting varied from six to four on Hambletonian to evens. Sir Harry Vane-Tempest determined never to race him again.'

The time factor involved in these paintings is interesting, if it is correct. In an advertisement in the *Sporting Magazine* dated 31st May 1799, and put in by Sir Henry Vane Tempest, is the following statement: 'Hambletonian and Diamond. There having been circulated a printed proposal for publishing by subscription two prints of the late race at Newmarket, between the above-named horses, to which I have given sanction, I think it my duty to apprise the public that engravings by the ablest artists will be made from two pictures of Hambletonian, by Mr Stubbs, drawn from life. The one represents Hambletonian winning the race, and is a remarkably fine likeness of the horse and of the rider, Buckle. The other represents the horse rubbing down after the race, and is as large as life. These pictures are finished, and engravings will be made of them as soon as possible, and I think it necessary to add that no artist whatever, excepting Mr Stubbs has had my permission to take any likeness of Hambletonian since he was in my possession.'

As the race was run on 25th March and the advertisement, dated 31st May, says that 'These pictures are finished', it would appear that Stubbs had only taken slightly over two months to complete two paintings, one of which was a canvas large enough to take a life-sized horse and two men. A very big undertaking to have accomplished in so short a time, but even in the 1760s, when he was painting for Lord Rockingham, he was able to produce life-sized canvases, in addition to a great deal of other work, in a relatively short time.

There was a fuss about the payment for the picture of 'Hambletonian Rubbing Down', for Farington records in his Diary for 9th April 1801: 'Humphry and Lawrence told me that about three weeks ago they attended as witnesses for Stubbs at a trial between him and Sir H. Vane Tempest for payment of a large portrait of a horse, for which Stubbs demanded 300 guineas. Garrard also appeared for him. On the other side Hoppner and Opie appeared, and the former was very violent against the claim of Stubbs, for whom, however, a full verdict was given.' This was probably the reason why the advertised engravings were never published.

Another late painting by Stubbs is that of 'Freeman, Keeper to the Earl of Clarendon'; painted in 1800, this may have been exhibited at the Royal Academy with the title 'A park scene at the Grove'. It is an interesting composition, the group is made up of the Keeper, with a deer and a hound. The setting is in the depth of a wood, with a dark, dank and gloomy background of heavy foliage, and just a glimpse of light showing through the tree trunks on the left. The general effect of light on the group is from beneath, or at any rate, from very low down. The composition is based on one of Stubbs's favourite shapes, the triangle, Freeman's head being the focal point, as he bends over to separate the two animals. The arrangement of the legs of the hound

and the dying deer are particularly satisfying in design.

Stubbs did quite a lot of work for Lord Clarendon at this time; in fact, he was one of his last distinguished patrons. Upcott records, in 1803, when Stubbs was seventy-nine years old, that he 'still enjoyed so much strength and Health that he says within the last month, having missed the stage, he has walked two or three times from his own House to the Earl of Clarendon's at the Grove, near Watford, Herts.—a distance of sixteen miles carrying with him a little trunk in his hand!'

He must have been a remarkably tough man, physically, as well as mentally. He seems to have lived a sensible life, working hard, but also taking care of himself. He drank mostly water, and ate simple food. He believed in plenty of exercise, and even after he reached his eightieth year his regular walks covered quite a number of miles each day. In his obituary, the *Gentleman's Magazine* says that 'He was always an early riser and long after he was four-score, he has often walked from Somerset Street to Fleet Street and back again before the regular hour of breakfast'.

Upcott found him very well, in August 1803, when he called on him, but by 25th January 1804 Farington had been told by Dance that he had met Stubbs and was 'shocked at his appearance, so aged, so in-jawed and shrunk in his person.' Dance should have known Stubbs's face well, for he included him in the collection of drawings he made of the Royal Academicians some ten years previously. He would have been sensitive to any significant changes in Stubbs's face and figure.

As has been said earlier, Stubbs was no longer receiving the same number of commissions, and his circumstances were very changed. He was becoming more and more pinched financially, and by the time he died he was really short of money and things were extremely difficult. In fact, Nollekens said that 'When Stubbs died there was no money in the house, but about £20 was

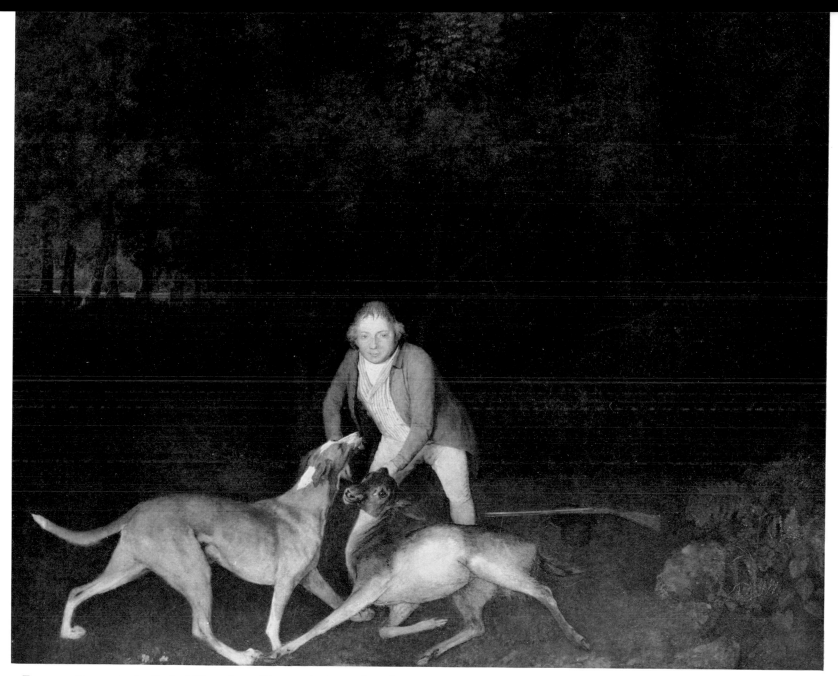

Freeman, Keeper to the Earl of Clarendon. *40in* × *50in. From the collection of Mr and Mrs Paul Mellon.*

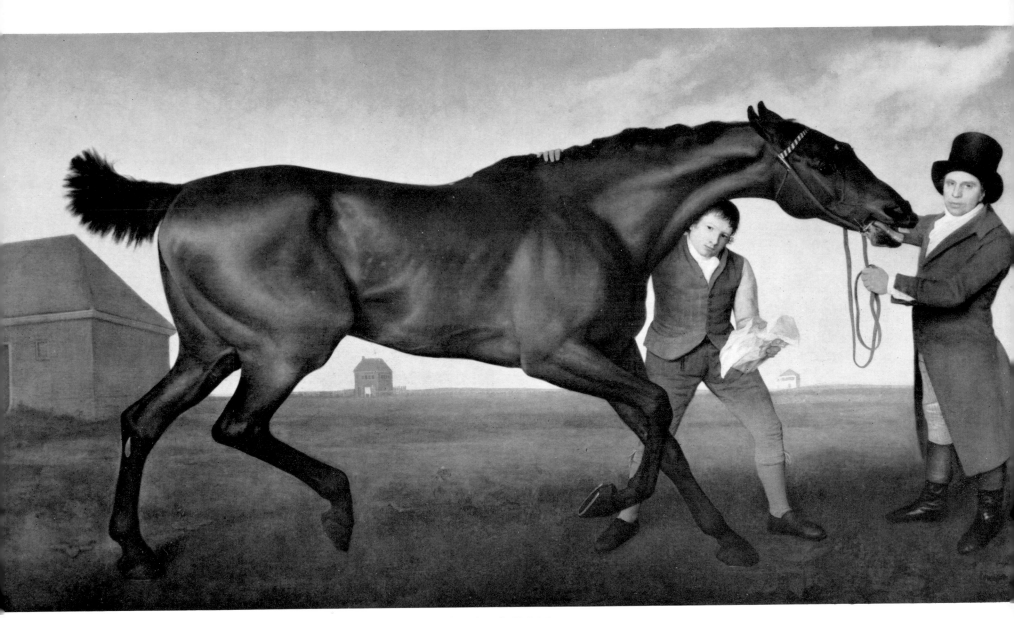

Hambletonian, rubbing down. $82\frac{1}{2}in \times 144\frac{1}{2}in$. By kind permission of *Lady Mairi Bury.*

194

owing to him by a person'; he also said that 'Stubbs's house was mortgaged to a lady, a friend of his, and he owed her money besides'. So, it is clear that he must have had considerable worries over how he was to manage to keep going. Yet, during his long career he had received quite surprisingly high prices for many of his works, and should have been able to manage without reaching a state of near poverty. The lady in question was Isabella Saltonstall, whom Stubbs had painted twice, once as a child in a family group, in 1769, and again as 'Una, from Spenser's *Faerie Queen*, in 1782. She was, at the end, appointed a joint executor, with Mary Spencer, of his will.

This will was drawn up in 1794—twelve years before his death—but was changed in his last hours.

THE LAST WILL AND TESTAMENT OF GEORGE STUBBS

In the name of God Amen, I George Stubbs, painter in the Parish of St Mary-le-Bone in the County of Middlesex make this my last will and testament this thirty-first day of June in the year of our Lord one thousand seven hundred and ninety four. First, I do hereby ~~give and bequeath~~ (crossed out) direct my debts to be paid, and after the payment thereof, then I do hereby give and bequeath all the last residue and remainder of my estates and assets of what kind so ever unto Mary Spencer ~~George Townley Stubbs and Richard Spencer.~~ (crossed out) for ever ~~to be equally divided amongst them~~ (crossed out) and I do appoint Mary Spencer and ~~George Townley Stubbs~~ (crossed out), and inserted in pencil, in a rather shaky hand) 'and I. Saltonstall' joint executors of this my last will and testament.

(Thos Ricketts)
(10th July 1806)
(John Deane)

GEO. STUBBS

It can be seen from this that George Townley Stubbs and Richard Spencer were cut out of the will immediately before his death, and Isabella Saltonstall added, and Mary Spencer received the whole estate, such as it was. However, Miss Saltonstall had, according to the picture dealer, Segar, a Bond of Security which gave her claim to his paintings, as well as the mortgage on his house, so it seems likely that, though Mary Spencer was left everything, she did not receive a great deal. The sale of Stubbs's pictures and effects was on 26th and 27th May 1807, at 12 noon. The Auctioneer was Peter Coxe, and the auction took place at 24 Somerset Street. Nollekens said that the sale brought in 'upwards of £4,000, but the lady had been ill-advised and bought in pictures for which high prices were bid: one in particular for which Mr Thomas Hope bid upwards of £200, yet she would not let it go'. The lady here was Isabella Saltonstall, for Segar told Farington that 'the prices were kept up by her agents and many articles were bought in. It is understood that after her debt is paid there will be little left'.

The *Gentleman's Magazine* remarks that 'Miss Saltinstone [*sic*] possesses a great many of Stubbs's pictures including several enamels, a portrait of himself on horseback among them'. This must have been 'No. 97, Portrait of Mr Stubbs on a White Hunter—a most excellent likeness of the great painter'.

There was a great variety of work in the sale, from the later pictures, such as the *Turf Review* paintings and a good many enamels, to 'Sketch of the lay figure of Alice Atkinson, who died at York, aged 110, being the Study of the large picture which Mr Stubbs painted for Dr Drake of York', and Lot 42, 'Two embryos ptd. in oil. 5 views of the bones of the pelvis in oil', which must have dated back to his stay in York, at the beginning of his career. There were also paintings that would be extremely interesting to see now, such as studies and paintings of fruit and

of flowers and birds. Among his portraits of birds were a swallow, green woodpeckers, and ravens. Others that would add an unfamiliar facet to his reputation were the number of scriptural and mythological subjects, including such items as: 'Hercules capturing the Cretan Bull', 'The Choice of Hercules' and The Rape of Dejanira', 'Two Infant Bacchanalians' and 'The Infant Christ treading on a Serpent'. It would be most illuminating to see and to know the date of Lot 44, 'A black horse in a landscape—the first horse painted by Mr Stubbs', so it was even earlier than the grey mare, so much admired by the London dealer, and referred to in Chapter Three.

Even though Miss Saltonstall bought in quite a few of Stubbs's paintings, there was still a large quantity of stuff left, which Mary Spencer kept. The *Sporting Magazine* of November 1809 says that 'She had for disposal a great many pictures by Stubbs, including a large one of "The Labourers" and a very fine painting of "Tigers Fighting".'

It was sad for her to realize that the works of her 'Valuable Man' were not saleable and were no longer wanted because fashion had moved on to other styles. Her final note in the memoirs is a touching account of Stubbs's last few hours, and is a concluding tribute to him.

'. . . Within an hour of his Death he sayd to his surrounding friends "perhaps I am going to die," but continued he "I fear not death, I have no particular wish to live. I had indeed hoped to have finished my Comparative Anatomy eer I went, but for other things I have no anxiety." Here then do we see an example of the mind in the most trying period of human existence, rising superior to the selfish ideas incident to such moments. Anxious only to promote the knowledge, and welfare of his fellow creatures. He accustomed himself to long walks by way of exercise and on the 9th of July 1806, he as usual walked eight or nine miles, came home in very good spirits, went to bed about nine o'clock and at three next morning awoake, as well, he said, as ever he was in his life. On getting up in bed, he was struck with a most excrusiating pain in his brest, and by the moaning he made, was heard by his female friend (who slept in next room) on interrogation, he said the pain would kill him, at four o'clock he got up and dressed himself, went down stairs, and up again, several times, to Arange some papers, his friends, who were assembled, all thought him a great deal better, he left them at breakfast and returned to his bedroom. One of the party immediately followed him, and by her screams soon brought up the rest of the company, who found him sitting in an arm-chair, another chair he had placed so as to rest his legs upon, wrapt himself in his Gown, and the moment she arrived breathed his last. Thus on the 10th of July 1806, at 9 o'clock in the morning, closed the career of this celebrated Artist, a genius unexampled in the annals of history: in his profession unequalled, in his private life exemplary, for honour, honesty, integrety, and temperence (his general beverage water, and his food simple), possessed of a firm and manly spirit, yet with a heart overflowing with the milk of human kindness, beloved by his friends, feared by his enemies and esteemed by all who knew him. By the multiplicity and excellence of his works, he has raised a monument to himself, that will vie with time."

Stubbs was buried eight days after his death in the St Marylebone Cemetery.

Works exhibited by Stubbs

The Society of Artists

1761
115 A stallion called Romulus; in the possession of the Rt Hon. Lord Viscount Spencer.

1762
109 Phaeton.
110 A brood of mares.
111 A Portrait of a horse, call'd Tristram Shandy.
112 Its Companion, Molly Long Legs.

1763
119 A horse and a lion.
120 It's companion.
121 The Zebra.
122 A horse belonging to the Rt Hon. the Lord Grosvenor, called Bandy, from his crooked leg.

1764
110 Phaeton.
111 A Tyger and Lion.
112 A hunting piece.
113 A Lion seizing a horse.
114 Brood Mares and Foals.
115 Antinous, a horse belonging to Hs Grace the Duke of Grafton.

1765
126 Portrait of a hunting tyger.
127 Brood mares.
128 Portrait of a hunter.

1766
163 Brood mares.
164 A lion and stag.
165 Two hunters, with the portrait of a gentleman and dog.
166 An Arabian horse.

1767
156 A nobleman on horseback. (*Duke of Portland.*)
157 Two gentlemen going a shooting, with a view of Creswell craggs; taken on the spot.

1768
165 Brood mares and foals.
166 Landskip with cattle.
167 Two gentlemen going a shooting.

1768
(*Special*) 110 Colts.
111 A horse frightened by a lion.
112 Brood mares and foals.
113 A lion and stag

1769
175 A tyger.
176 A lyon devouring a stag.
177 Two gentlemen shooting.
178 A horse and mare.
179 A gentleman and lady.
180 A cat.

1770
132 Hercules and Achelous.
133 A conversation.
134 A repose after shooting.
135 A lion devouring a horse, painted in enamel.

1771
153 A lion and lioness.
154 A lioness and tiger.
155 A horse and lion; in enamel.
156 A portrait of the famous horse, Eclipse.
(Elected F.S.A. Treasurer.)

1772
301 The portraits of two horses, Snap and Goldfinder. (*A barn.*)
302 The portraits of three colts.
303 A portrait of a gentleman on horseback.
304 The portrait of a pointer.
305 The portrait of a dog.
306 A den of lions.
307 The Centaur, Nessus, and Dejanira.
308 Hope nursing Love.

1773
314 A lion and lioness.
315 A portrait of a greyhound.
316 Ditto of a pointer.
317 Ditto of a horse turning to pasture.
318 Ditto of the Konguoro from New Holland, 1770.

319 Ditto, a large dog.
320 A portrait of a gentleman on horseback, with a dog.
321 Ditto.
322 { A landscape, a farmyard with cattle.
 Two views of the torpedo, male and female.
459 A hunting piece.
1774
269 A portrait of a horse.

Works exhibited at the Royal Academy
1775
301 Portrait of a horse named Euston, belonging to Mr Wildman.
302 Portrait of a Pomeranian dog belonging to Earl Spencer.
303 Portrait of a Spanish dog belonging to Mr Cosway.
304 Portrait of a monkey.
1776
293 Tygers at play.
294 Mares and foals.
295 Portrait of a dog.
296 Ditto.
1778
298 Ditto of a horse.
299 Ditto of a dog.
300 Ditto of two dogs.
301 Ditto of a gentleman preparing to shoot.
405 Portrait of a dog.
406 Ditto.
1779
319 Ditto of a mare and dog.
320 Ditto of a dog.
321 A gentleman on horseback.
322 Labourers.
1780
110 Portraits of horses.
137 Ditto of two heifers.
176 Ditto of hunters.
183 Portrait of a dog.
191 Portraits of figures and animals.
326 Portrait of a horse.
1781
17 Two horses; in enamel.
1782
32 Portrait of a dog.
70 Ditto of a young lady in the character of Una, from Spencer's Fairy Queen.
79 Portrait of a young gentleman shooting (Enamel).
120 The farmer's wife and raven (Gay's Fables) (Enamel).
173 Portrait of an artist (Enamel).
209 Portraits of a very old horse and dog.
363 Portrait of a dog (Enamel).

1786
77 Reapers.
94 Haymakers.
1787
83 Fighting bulls.
95 Fighting horses.
116 Portrait of a hunter.
1789
33 Carting of corn.
1790
112 Portrait of the Lincolnshire ox, now to be seen at the Lyceum, Strand.
448 Portrait of an Arabian horse.
1791
7 A Pomeranian dog.
91 H.R.H. the Prince of Wales.
275 A shepherd's dog from the South of France.
391 A Buffalo.
1799
41 A trotting horse.
177 A monkey.
1800
222 Hambletonian beating Diamond at Newmarket.
744 Hambletonian, rubbing down.
1801
120 Portrait of a mare, the property of the Earl of Clarendon.
175 A park scene at the Grove, near Watford, Herts, the seat of the Earl of Clarendon.
1802
208 Portraits of two horses and dogs in the possession of G. Townley Stubbs.
1802
866 Portrait of an Indian Bull in the possession of the Earl of Clarendon.
1803
183 Portrait of a Newfoundland dog, the property of H.R.H. the Duke of York.

The British Institution
1806
3 (South Room.) A landscape.
27 (Ditto.) A horse and lion (Enamel).
49 (Ditto.) Haymakers (Enamel).
56 (Ditto.) Harvest (Enamel).
64 (Ditto.) Haymakers (Enamel).
83 (Ditto.) Two horses fighting (Enamel).
84 (Ditto.) The fall of Phaeton (Enamel).
86 (Ditto.) The farmer's wife and raven.

Index of Works by Stubbs

Figures in italic refer to plates

General Index